The
CAVE ARTISTS

Ann Sieveking

The
CAVE ARTISTS

WITH 155 ILLUSTRATIONS,
14 IN COLOUR

THAMES AND HUDSON

THIS IS VOLUME NINETY-THREE IN THE SERIES

Ancient Peoples and Places

GENERAL EDITOR: GLYN DANIEL

© *1979 Thames and Hudson Ltd, London*

Filmset and printed in Great Britain by BAS Printers Limited, Over Wallop, Hampshire

Colour illustrations separated by Cliché Lux SA, La Chaux de Fonds, Switzerland, printed in Great Britain by George Over Ltd, Rugby.

Contents

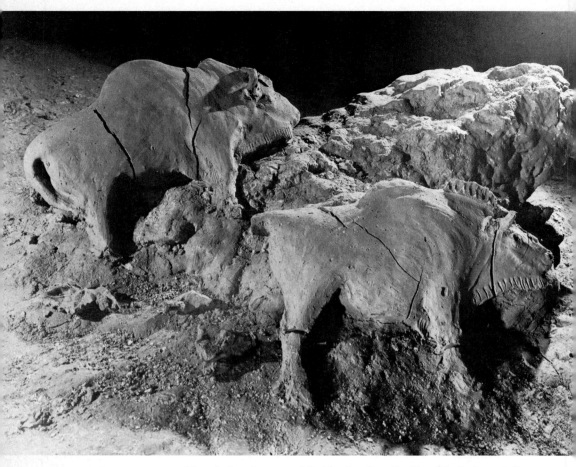

1 Bison bull and cow, modelled in clay, from Le Tuc d'Audoubert, Ariège.
The right-hand figure measures 61 cm.

1
Introduction

If one were to compile a list of wonders for the Prehistoric World, on the model of the seven wonders of the Ancient World, it would have to include Palaeolithic art. If a single example of this were chosen, it might be the Hall of Bulls at Lascaux in Dordogne, the painted ceiling at Altamira in Spain, or the two clay bison in Le Tuc d'Audoubert in the Pyrenees. Any art from a period so remote would be of interest, but the attraction that Palaeolithic art exerts upon public and scholars alike is probably a reflection of its quality. Not only are the paintings and engravings of animals often beautiful in themselves, but they have the element of the wholly unexpected, for naturalistic art is rare among primitive people and Palaeolithic art is both the earliest and the greatest achievement of its kind. We know that the men who lived in Europe in the millennia between 30,000 and 8,000 BC lived a nomadic or semi-nomadic life, hunting and gathering their food with tools made of flint, bone and wood and that they had the use of fire; that they had an art of such sophistication seems almost to be an anomaly. However, the fact that it is evidence of magical or mythological beliefs that defy our comprehension should make us very cautious in classifying such a society. To present-day anthropologists the people of the Upper Palaeolithic appear as the original 'affluent society' and both this assessment and the evidence of their art make one hesitant to use epithets such as savage or primitive when describing their status.

V, 141
II, 30, 123

Palaeolithic art is rightly described as naturalistic, but it has a strong schematic element also. It is represented by sculpture, both three-dimensional and low relief, by engraving and painting and it is usually classified by twentieth-century writers in two categories, those of mural art and of portable miniature pieces found in actual habitation sites; the second being a category described in French as 'art mobilier'. It is doubtful if its creators would have recognized any such division, for the

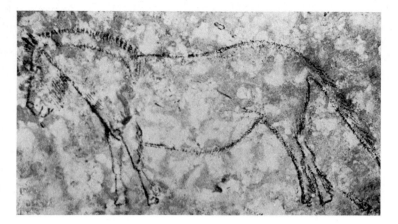

2 Horse outlined in black from the painted ceiling in Rouffignac, Dordogne. Length 170 cm.

difference between the groups is one of location or media, rather than content, but it is a convenient division for study. Here only the mural art is under discussion and the miniature art pieces will be referred to only when they are relevant to the dating or style of the art on rock walls.

VI The content of mural art consists of drawings of animals, principally horse, bison, mammoth, reindeer and other large herbivores, but also some carnivores, such as bears and lions and occasionally, but rarely, birds and fish. There are, in addition some human figures, often far less realistically drawn, quite numerous hand prints, and a great number of signs that appear wholly schematic but which may possibly have been naturalistic in origin also. These forms of art are found both in daylit situations, that is in rock shelters and shallow caves that were

3 Four life-size hands, painted in negative from Gargas, Hautes Pyrénées. The hands at top and left of the picture have truncated fingers

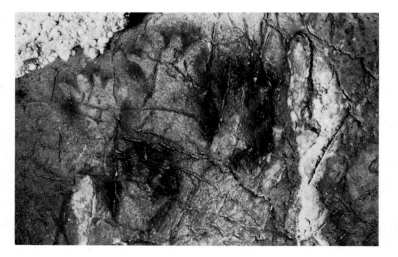

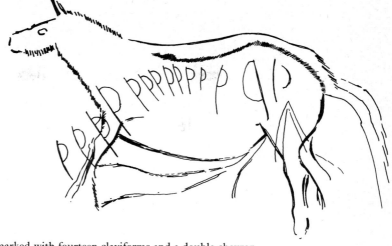

4 Engraved horse marked with fourteen claviforms and a double chevron, from the Sanctuary, Les Trois Frères, Ariège. Length 49 cm.

5 Group of tectiforms in a small side gallery in El Castillo, Santander. The largest measures 63 cm.

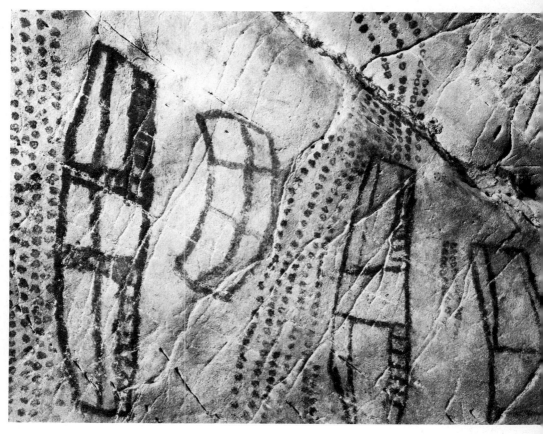

6 Panel of superimposed engravings on the right-hand wall of the Sanctuary in Les Trois Frères, Ariège. Width of panel, 285 cm.

often inhabited, and in deep underground caves that had no other use than as sancturaries. Preservation has determined that only sculpture and occasionally engraving survive in the open air, but painting has been preserved in deep caves where both temperature and humidity can be very constant. Manganese, carbon and natural ochres are the pigments used, producing a palette of blacks, reds, browns and yellows that harmonize well with the cave walls, and the style of drawing, whether early or late, is direct, assured and idiomatic. Colours were applied by

XII brush, in line strokes, in daubs or in flat wash, perhaps by spraying. Engravings were cut with flint tools, most probably burins or finely trimmed points, and the depth of line is very variable. The way in which paintings and engravings are distributed on the cave walls is surprising. One might have expected the most accessible, or the visually most effective areas to have been used, but often this is not so: drawings are hidden in awkward recesses and deep narrow galleries or clustered in one

IV corner of a large underground chamber. In addition they may be superimposed, upside down, of a size varying from a few centimetres to over a metre, or incomplete. In spite of the perfection of some individual figures one must conclude that the general visual effect was not important.

There is an overall similarity in Palaeolithic cave art: the content, the basic style and the utilization of space are the same, but within this canon no two caves are exactly alike. In fact this is a generalization that applies to Palaeolithic art of every form, for with the exception of a very few groups of miniature art objects we have no series of copies. There appears to be a basic formula governing cave art, but it is always re-expressed. This leads one to wonder who was responsible for the paintings and engravings; not, perhaps, a group of specialists perpetuating a family tradition but more probably a specialist in each group. It is known that within the historic record a group of Australian Aborigines, living in a much poorer environment than prevailed in France in the Upper Palaeolithic had enough surplus food to support one man whose only responsibility was to make and repair their tools (Sahlins 1974). On this analogy an Upper Palaeolithic group could have supported one man whose primary duties were as tool-maker and decorator and whose work might have included painting a nearby cave, or carving the rock shelter wall. The quality of Palaeolithic art is variable and there are incompetent drawings but that these are an exception in caves, rather than the rule, suggests that the decoration of a cave was

7 Headless horse from Bédeilhac, Ariège. Length 130 cm.

the work of a specialist rather than an ordinary member of the tribe. There are many incomplete drawings, but these should be distinguished from incompetent ones.

Palaeolithic cave art has been known to civilized man for nearly a hundred years but, although in that time we have learnt a great deal about its incidence, its content and techniques, we still know little more about its meaning than the first discoverers surmised. Altamira was the first cave to be discovered or, since one cannot exclude the likelihood of such discoveries in earlier centuries (Niaux, for example, was visited by a Roman, leaving the imprint of his sandals on the sand banks of the underground stream), the first to be recognized as prehistoric. Don Marcellino de Sautuola, who discovered the painted ceiling in this cave in 1879, saw in the paintings of bison there a likeness to the engraved and sculptured miniature pieces that he had seen in an exhibition in Paris the year before. The Palaeolithic age of these miniature pieces was accepted but Sautuola could persuade few of his contemporaries to share his convictions about Altamira; many people, without visiting it, dismissed it as a modern forgery. The scientific world was violently divided on this matter and Sautuola's difficulties with his learned contemporaries are described in the present English version of a small guide to Altamira: 'A veritable shower of misunderstandings, from more or less interested people, of open denials and even facetious taunts did Don Marcellino (de Sautuola) have to live through, year after year. In some periods, even the honour of the illustrious Santanderian was in jeopardy when, without very good reasons, the paintings were attributed to a French painter

123

called Retier, whom Sautuola had welcomed in his house and who, being dumb, made the affair even more difficult.' Sautuola died without seeing his belief in Altamira vindicated but in the space of a few further years its age was accepted. Discoveries of other caves in France either totally sealed with quaternary deposits, such as La Mouthe, or in which the engravings were buried under soil horizons containing Palaeolithic artifacts, as at Pair-non-Pair, convinced prehistorians that the antiquity of painted caves, although astounding, was incontrovertible.

Today, when more than two hundred Palaeolithic decorated caves are known, Altamira remains one of the most beautiful. Ironically, it was probably in some degree the quality of the paintings at Altamira that made them unacceptable in 1879, for they were so far from what nineteenth-century prehistorians expected as the work of 'primitive' and 'savage' people. Altamira still remains a curious case though, suggesting great prejudice, for many of the miniature art objects shown at the Exposition Universelle in Paris in 1878, and accepted as prehistoric, were of equal sophistication. In fact many of those who were most powerfully opposed to Altamira were also those least qualified to judge, having no interest, or training, in art. Interestingly Edouard Piette, who excavated many rich miniature art sites in the late nineteenth century and studied his collections with care, shared Sautuola's views on Altamira; in 1887 he wrote to Cartailhac, the leader of the opposition to Altamira, that he believed the paintings to be Magdalenian in date (late Upper Palaeolithic) and in 1895 he suggested that the newly found and authenticated engravings at La Mouthe were comparable to Altamira but, in spite of Piette's promptings, Cartailhac did not accept Altamira, by that time almost forgotten, until 1902.

The achievement of Palaeolithic artists, considered simply within the field of artistic representation, gives it a general appeal; anyone who is interested in painting will appreciate this 'Prehistoric carnival of the animals' (Levine 1957) without regard to its age, but this is not to deny its historical interest. Obviously, for an historian or an anthropologist the greatest claim that Palaeolithic art has for attention lies in its context. This book is called 'The Cave Artists', which might suggest that the complete life pattern of these people is under consideration, but this is not its aim. The intention is simply to describe one aspect of their lives, that is their art and, in fact more narrowly still, only one form of this, their mural art. However there seems some need to include an outline of their way of life and history,

the archaeology of the period in fact, if only because it is so remote and so different from anything we know today. If one is to understand Palaeolithic art one should have some idea of its context, simply in order to see it in perspective.

Palaeolithic art is the work of *Homo sapiens*, that is fully modern man, more properly called *Homo sapiens sapiens*. By the middle of the last major glacial phase (here called the Würm, according to the Alpine terminology), at a date about 40,000 to 30,000 years ago, *Homo sapiens* had become dominant in the world, but art is not a concomitant of the extension of *Homo sapiens*. Many areas inhabited by modern man and having characteristic Upper Palaeolithic industries have no art; there is in fact only one example known in the southern hemisphere and none, as yet, discovered in the New World. Carved and engraved or painted objects of Upper Palaeolithic date, here described as miniature art, are known from south-west Europe to Siberia, and from South Africa (Wendt 1976), but the habit of painting caves is much more restricted. Decorated caves and shelters, the subject of this book, are found only in the limestone areas of Spain, France, and Italy, with a particular concentration in Spanish Cantabria, the Pyrenees and the Périgord region of France. There is a solitary example, entirely characteristic in style, from Kapovaia in the Urals, but in other areas, for example in central Europe, no painting or engraving has yet been found although plenty of suitable limestone caves exist.

To speak of the middle stage of the last (Würm) glaciation with regard to the arrival of *Homo sapiens* is a generalization. It is probable that *Homo sapiens* had reached, even achieved dominance in, some areas of Europe before this date but its particular importance is that this is the stage at which Upper Palaeolithic industries first appear in Europe. Various components of these characteristic industrial assemblages occur in the Near East before this date but what is significant is that after it both they and *Homo sapiens* become onmipresent in Europe. This is not to say that the industrial techniques used in the Upper Palaeolithic were at all stages peculiar to *Homo sapiens*, or even that he was solely responsible for introducing them to Europe; in fact there is little to support such a simple explanation but, when skeletal remains are so few, it is difficult to assess the contribution of Neanderthal man who was his immediate forerunner in these regions.

Industry is the archaeological term given to a group of stone and bone implements of recognizable type that are consistently

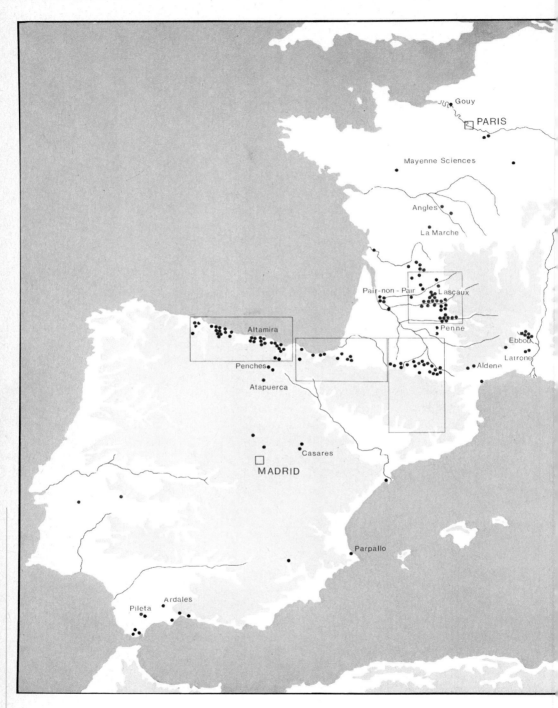

Gouy

PARIS

Mayenne Sciences

Angles

La Marche

Pair-non-Pair Lascaux

Penne

Ebbou

Latrone

Altamira

Aldene

Penches

Atapuerca

Casares

MADRID

Parpallo

Ardales

Pileta

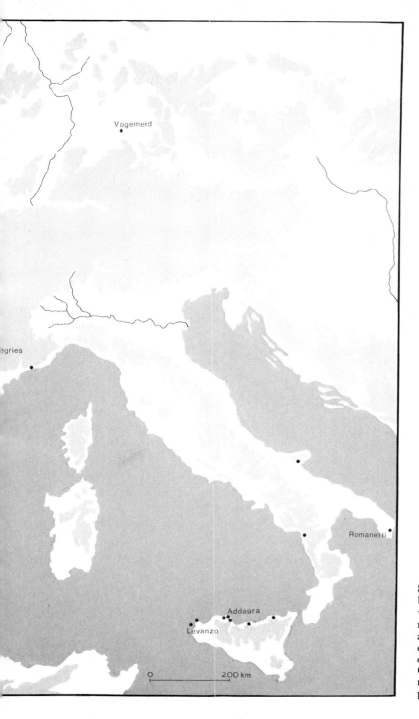

Vogelherd

egries

Romanelli

Addaura
Levanzo

0 200 km

8 Map showing the distri-
bution of sites in south-
western Europe with
mural art of Palaeolithic
age. Vogelherd is an ex-
ception to this, having
only miniature art pieces.
Contour: 500 m. (Detailed
maps of framed areas on
pages 105, 134, 141, 176)

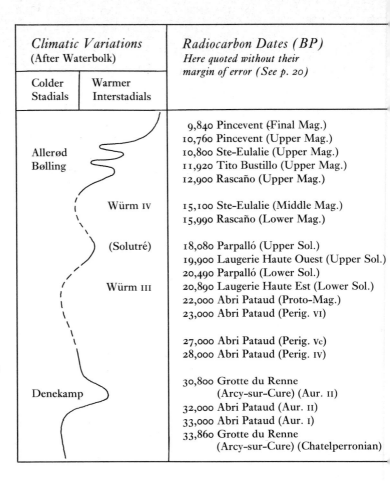

Climatic Variations (After Waterbolk)		Radiocarbon Dates (BP) *Here quoted without their margin of error (See p. 20)*
Colder Stadials	Warmer Interstadials	
Allerød Bølling		9,840 Pincevent (Final Mag.) 10,760 Pincevent (Upper Mag.) 10,800 Ste-Eulalie (Upper Mag.) 11,920 Tito Bustillo (Upper Mag.) 12,900 Rascaño (Upper Mag.)
	Würm IV	15,100 Ste-Eulalie (Middle Mag.) 15,990 Rascaño (Lower Mag.)
	(Solutré)	18,080 Parpalló (Upper Sol.) 19,900 Laugerie Haute Ouest (Upper Sol.) 20,490 Parpalló (Lower Sol.)
	Würm III	20,890 Laugerie Haute Est (Lower Sol.) 22,000 Abri Pataud (Proto-Mag.) 23,000 Abri Pataud (Perig. VI)
		27,000 Abri Pataud (Perig. Vc) 28,000 Abri Pataud (Perig. IV)
Denekamp		30,800 Grotte du Renne (Arcy-sur-Cure) (Aur. II) 32,000 Abri Pataud (Aur. II) 33,000 Abri Pataud (Aur. I) 33,860 Grotte du Renne (Arcy-sur-Cure) (Chatelperronian)

9 Table showing climatic variations in the Upper Palaeolithic, the principal cultural stages, Leroi-Gourhan's classification of Art Styles and a selection of absolute dates based upon radiocarbon estimates. The dating and nomenclature of the cultural stages is based upon Leroi-Gourhan's own modification, but in France many prehistorians use the term Perigordian, divided into early and late stages, in place of Chatelperronian and Gravettian.

found together. Those of the Upper Palaeolithic are notable for a great expansion in the use of bone and antler and for a new method of flint flaking that produced long narrow blades, often used to prepare further tools in bone or wood. In addition a greater variety of tools was made; in flint and similar materials, for example, there are chisels, points, awls, engraving tools and a variety of scrapers, while spear points, harpoons, foreshafts, needles, spear throwers, spatulae and polishers were made from bone and antler. We depend almost entirely upon the recognition and proportional frequency of such categories of imperishable objects when trying to group people at this stage in history, whether it is geographically or chronologically. Differences in tool types have been made the basis for differentiating people culturally and, although this is not an ideal system, we must use it because we have very little other evidence at present. The dangers implicit in such a classification are twofold; firstly, differences in tool types between two sites that

Years before present	Cultural Stages (After Leroi-Gourhan)	Art Periods Leroi-Gourhan's classification
10,000	Azilian	
15,000	Late Magdalenian VI V Middle Magdalenian IV III	Style IV Classical
	Early Magdalenian II I Late Solutrean	Style III Archaic
20,000 25,000	Middle Solutrean Early Solutrean Late Gravettian Middle Gravettian	Style II 2nd Primitive phase
30,000	Early Gravettian Aurignacian	Style I 1st Primitive phase
35,000	Chatelperronian	Prefigurative period

perhaps reflect seasonal occupations may be translated as evidence of two human groups when, in reality, they only represent one; secondly, it is possible that changes in weapons to which we attach much importance, may represent no change other than fashion. Changes in tools do not need to represent conquests, invasions or mass movements of people, although archaeologists are very prone to explain changes in tool assemblages as a change in the human population.

Using these tool-type groupings for both their chronological and geographical implications, the Upper Palaeolithic in S.W. Europe has been divided into a succession of cultures, some of which seem to follow a direct chronological pattern and some of which coexist, at least in some areas (Sonneville-Bordes 1960). The earliest of these is the Chatelperronian, followed by the Aurignacian, the Gravettian, the Solutrean and the Magdalenian; in France the Chatelperronian and Gravettian are more often referred to as the Lower and Upper Perigordian. All these

names are taken from type sites in France from which this classic sequence was constructed a great many years ago: attempts to apply it outside the south-west European region have been more often confusing than rewarding and even inside this area it needs some modification. Some of the stages in this sequence may have originated in areas outside south-west Europe; others, such as the Magdalenian, appear as a local phenomenon that subsequently spread outside this area. Their duration and distribution are not uniform, but if one regards them strictly as technological indices this is not surprising. We have a little evidence for human group size in the house and settlement plans that have been discovered in recent years but the only clear evidence in a sociological dimension that exists for the Upper Palaeolithic is its art. Two of the principal characteristics of Palaeolithic art are its homogeneity over a vast area and its durability, both of which tend to support the view that there were probably no great social upheavals in this period. The technological record, with its changing fashions in tool types, is just that and not an index of conquest and colonization, except colonization in the sense of adding new regions to those already occupied. This is very clearly put by a leading French archaeologist, 'In the life of a society models of weapons change very often, models of tools less often and social institutions very seldom, while religious institutions continue unchanged for millennia.' (Leroi-Gourhan 1968, p. 48). Art in this context is a religious institution.

The duration of the Upper Palaeolithic in France is approximately 25,000 years; a date of 34,000 years ago has been suggested for the Chatelperronian (early Perigordian) and 10,500 years ago for the last Magdalenian stage. These dates are obtained from radiocarbon estimates; the more recent are the more reliable, but in the absence of any other absolute dates, even the earliest are usable. In dates for samples 4,000 years old the margin of error may be expected to be ± 40 years but with age this increases. The margin of error for a sample 20,000 to 30,000 years old is usually between 700 and 1,500 years but may be more. This degree of error reflects not only the age of the sample but also the fact that in an older sample the amount of $C14$ is less and therefore the probability of accurate measurement is decreased.

The final stages of the Magdalenian coincide with the end of the Würm glaciation which means that all stages of the Upper Palaeolithic are found within a glacial period, but the climate

during this phase was far from uniform either in temperature or humidity. There were in fact four glacial maxima in the Würm, the third and fourth of which were coincident with the Upper Palaeolithic and were also the most severe; they were not 9 however of long duration and climatic amelioration produced long warmer interstadial periods in between. These climatic changes promoted shifts in the habitat of flora and fauna. The proximity of the ice sheets in Würm III, for example, turned Belgium and the Paris basin into a polar desert, where neither animals nor men could live, while the topography of south-west France ensured that this region was at no time uninhabitable. The Upper Palaeolithic people here seem to have adapted themselves to recurrent changes in climate and food supply, without altering their habitat. Many habitation sites, for example, show a continuous occupation, at least occupation at all cultural stages, while environmental change is registered in the differing species of animals eaten and left as food debris. Another factor that probably contributed to the continuous presence of men was that wood for burning, building and making tools seems always to have been available; even in the coldest periods this region was not treeless. In fact an arctic type of tundra probably never existed in south-west France, the latitude being so southerly as to preclude it. In the very cold and dry phases of Würm III and IV there were probably large areas of open grass steppe here while in the wetter interstadial periods forest species spread, covering the countryside with woods and hazel copses, with willow and alder beside the rivers and grassland with heather and bilberries on the higher land between the forest zones and thickets. From the evidence of food remains reindeer, mammoth and woolly rhinoceros inhabited the open steppe in the coldest phases, with horse and bison in the less extreme, and in the warmer interstadials reindeer and mammoth were replaced by forest species such as red deer and wild oxen.

Whether the climate was extreme or mild there seems to have been an abundance of game available for hunters; nevertheless it is unlikely that Upper Palaeolithic people lived off game alone. Ethnographic analogies suggest that hunting and gathering is a more reliable basis of subsistence than hunting alone and that only extreme conditions such as face the present-day Eskimo will dictate a complete reliance on hunting. The evidence of Upper Palaeolithic occupation deposits and, as stated above, of their art, suggests a stable population. We can reasonably assume that their food supply was varied and included, in addition to meat,

10 Horse painted in black outline with its coat markings shown in red wash. Sinhikole-Ko-Karbia, Pyrénées-Atlantiques. Length 140 cm.

nuts, fruits, berries and fish. The rivers of Dordogne, the Pyrenees and Cantabrian Spain were all in historic times very rich in salmon, until overfishing, mill dams and hydro-electric schemes ruined this particular supply. It is probably not without significance that Upper Palaeolithic living-sites are so often clustered along the river systems.

The accumulation of rubbish in habitation sites, often several metres deep, suggests a certain degree of settlement. However, this was most probably seasonal, for resources such as nuts or dead wood to burn tend to run short after a prolonged stay in one place. In addition many of the animals hunted, such as bison and reindeer, are migratory species and the men who hunted them were probably equally nomadic. It is relevant that their domestic or portable art is of so small a size, for to a nomad all sizeable possessions are a burden. In fact all the art of the period supports this view, namely that the people who created it moved about probably over a considerable region during one year, or a span of years. The homogeneity of Palaeolithic art, both in time and space, indicates that the ideas that inspired it were at all times known and observed over a very large geographical area. The proposition is that isolation would produce regional variation and that a lack of marked regional styles suggests a community of ideas. At a cultural stage such as this, communication must mean an interaction of people. This situation is particularly clearly shown by the miniature art pieces. Objects entirely similar in style and subject are known from the western and central Pyrenees, from Dordogne, Tarn-et-Garonne and even, in one

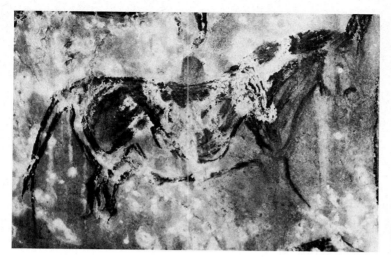

11 Horse comparable to that from Sinhikole (Ill. 10), except that here black paint is used for outline and shading, from Niaux, Ariège. Length 75 cm.

instance, from Kesslerloch in Switzerland (Sieveking 1976). The sites in the western and central Pyrenees are approximately 200 kilometres apart, the west Pyrenean group is about 250 kilometres from Périgord, taking Les Eyzies as the central point for this last region, and the central Pyrenean a little over 200. The sites in Tarn-et-Garonne are almost equidistant from both of these last two groups, while Kesslerloch is a little over 600 kilometres from Les Eyzies and a little under 750 from the central Pyrenees. Miniature art pieces may have been traded, or taken by individuals who moved from one group to another, perhaps as a result of a marriage contract, but in either case they show contact between groups from widely separated areas. If the inhabitants of the caves near Arudy in the Pyrenees, for example, or those near Les Eyzies in Dordogne, had spent the whole year in their respective localities such a distribution of objects could never have occurred. Furthermore, to look at this from another standpoint, if a small group is not to become biologically inbred which will possibly prove disastrous to its survival, its members must look for mates outside their own number. For this and other reasons, such as communal hunting or ritual ceremonies, all present-day hunting and gathering groups join into larger aggregates from time to time, usually annually, and one may conjecture on the evidence of their art, that this was so among Upper Palaeolithic people also. The similarities of art forms in regions that are geographically distant from each other are most clearly illustrated by the miniature art pieces, but it can be demonstrated as well in cave painting. The closest analogy to

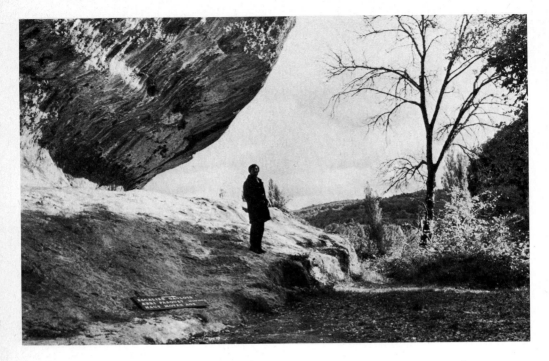

12 View of the Abri Lartet, Dordogne. This magnificent overhang provided shelter for people from the Palaeolithic to Medieval times

10, 11

a painted cave is often not one of its neighbours, but another cave hundreds of kilometres away. For example, there is a horse with a certain stance and a shaded coat in the newly discovered cave of Sinhikole-Ko-Karbia in the Pays Basque that is as closely paralleled by another horse in the cave of Niaux in Ariège as by any other paintings in the Pays Basque, and this is only one of many instances. This unity in Palaeolithic art is a very remarkable phenomenon.

In so far as it is possible to reconstruct a period so remote as that of the millennia between 35,000 and 10,000 years ago, we can conjecture that Europe was inhabited by small, nomadic bands, each band probably consisting of about twenty-five people, both adults and children, who, it is estimated, cannot have formed a total population in an area such as France of more than a few tens of thousands. This estimate is, in fact, made for the late Magdalenian, a period in which the proliferation of new habitation sites suggests a considerable expansion of population, and is much too high for all the earlier stages. All the evidence we have suggests that such numbers put little strain on the environment, in fact the Palaeolithic world has been described, rather enigmatically, as 'A human desert swarming with game' (Bordes 1968). For the few people who inhabited it, food was

apparently abundant and easily acquired and their life was relatively secure. The climate was periodically very cold but they had the use of fire, they had animal furs for clothing and they constructed houses for shelter, both in the open air and under the jutting overhangs of limestone cliffs. If this description creates a picture too reminiscent of the Garden of Eden there is, on the reverse side, accident, disease and, probably, a high rate of infant mortality. Nevertheless the archaeological data for the Upper Palaeolithic period show a record of a stable population that is quite at variance with the nineteenth-century concept of primitive man perpetually threatened by starvation and struggling to survive. To quote a modern American anthropologist, 'A people can enjoy an unparalleled material plenty, though perhaps only a low standard of living' (Sahlins 1968), and this seems to be a reasonable description of the Upper Palaeolithic. Some, at least, of these people were accustomed to spend a part of the year in the shelter of the shallow limestone caves and rocky overhangs that are to be found in valleys such as those of the Vézère, the Aveyron or the Ariège. They they left among their rubbish a few decorated objects, often broken, a number of tools, the bones of the animals they ate and the charcoal of the fires around which they sat and cooked. Some of the shelters they lived in they decorated also with painting,

13 Two megaceros deer from Cougnac, Lot. Their withers are accentuated with black paint and the incomplete outline of a mammoth is drawn on the shoulder of the leading figure, the length of which is 158 cm.

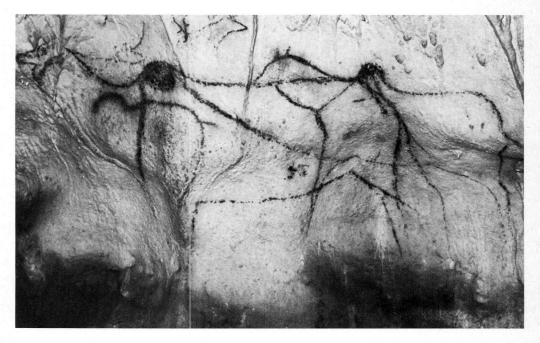

engraving or low relief sculpture and in some of the deeper caves near to their living-sites they created painted and engraved sanctuaries.

Most present-day hunters and gatherers spend their leisure, which is a surprisingly large part of their time, in dancing, singing, gambling, or conducting elaborate rituals and ceremonies. Obviously we have no record for any of these activities from the Upper Palaeolithic but, owing to a remarkable chance of preservation we know at least a part of what these people chose to paint and where. If we knew why they painted this particular selection of subjects in such carefully chosen places we should perhaps understand their social customs or their religion, but we still have almost no idea of these. The individual images of Palaeolithic art - an animal, or a fish - are like letters of the alphabet, instantly recognizable; but in relation to each other, like letters in an unknown word, they are incomprehensible. The location and the quality of the art suggest it was of great importance, its duration suggests it was supported by a social sanction of great strength but its interest for us still lies more in the actual paintings than in any insight they give into prehistoric beliefs. That this is not a disappointment is a measure of the achievement of Palaeolithic artists. They could perfectly conceptualize and execute a formula, not pedantically but with a new interpretation each time; they had mastered nearly all the problems of presenting three dimensions in two, whether it was in creating form by light and shadow or in giving a sensation of movement, and they could instantly create an image by an ideogram. They established a tradition that lasted for about twenty thousand years; in the ten thousand or so years between its disappearance and the present day a great many other such traditions have grown up and declined but artistic comprehension and sensibility seem not to have changed, for to a twentieth-century visitor one of the horses in Niaux, for example, is instantly comprehensible and wholly appreciable.

140

71

IX

2
Early Twentieth-Century Interest in Palaeolithic Art: The Establishment of its Authenticity, Age and Chronology

The preoccupations of modern scholars when studying Palaeolithic art reflect in part their own choice and in part a position forced upon them. In the nineteenth and the early twentieth centuries archaeologists were interested as much in the authenticity of this art as in classifying it in a chronological manner. They were also interested in its meaning, but here they encountered certain limits determined by circumstance. When anthropologists first turned their attention to contemporary Australian Aboriginal art there were, in a few regions, one or two old men alive who still knew the meaning of their native art forms, why certain figures were painted in certain locations and for what purpose. The art itself is not very sophisticated, in fact compared with that of the Upper Palaeolithic it is crude and of a totally different quality, but its meaning was found to be far less simple than its expression. We lack this lifeline to the Palaeolithic and this means that our comprehension of Palaeolithic art will inevitably remain incomplete.

In fifty years of study these preoccupations have changed little, except that the layout of painting in caves, which was considered by Breuil and his contemporaries as haphazard and probably meaningless, has latterly become a focus of interest. Otherwise interest in the study still concentrates upon style, technique, content and date; except in the case of newly discovered caves the question of authenticity is less absorbing and, interestingly, the distribution of the art is still not a matter for research. Of course new caves have in most instances been found by chance, by local farmers, or boys playing on the hillsides. Early archaeologists learnt about caves by hearsay, and this still persists. Nowadays speleological clubs find many of the most inaccessible caves but in many areas the specialists who are interested in Palaeolithic art work in the universities, or in museums in large towns, and there is a lack of informed local interest in the countryside where caves are most likely to be

found. Latterly, finance comes into the picture also. It is not unknown that a 'new' cave will be hushed up while its discoverers endeavour to buy the surrounding property, in the hope of procuring themselves a goldmine, such as was Lascaux in the period when it was open to the public. This touches upon the most recent of all twentieth-century preoccupations with Palaeolithic art: how it shall be preserved and who and how many people may visit the caves. Finance is again instrumental in this, for painted caves are a huge tourist attraction.

Although style constitutes the best guide to authenticity in painting for an art historian, it does not do so for a prehistorian. The story of the discovery of Altamira reflects this: there was no incontrovertible scientific proof of the age of Altamira and so it was not acceptable to scientists. As has been said, Altamira was an extreme case that provoked a great deal of animosity; in fact, the entrance to the cave was unknown until ten years before de Sautuola found the paintings. It is possible they could have been faked in that time, but it seems a very extreme proposition to have made. Most decorated caves have no traces of habitation in them and even in those few that have there is usually no direct connection between the habitation debris and the paintings or engravings. These stand on the walls clear of the deposit and they may, arguably, be of any date. Even today the number of incontrovertibly dated murals is very small and nearly all are in daylit locations. The entrance to a cave may have been sealed when found but it is not always possible to prove that this was the only, or original, entrance. Paintings and engravings in caves are dated by analogy to the few examples with a fixed date and by stylistic comparison to miniature art pieces, the dating of which is, of course, a much simpler matter. They are found incorporated in habitation deposits, associated with flint tools, datable charcoal and the bones of animals many of which, if not extinct, are at least no longer native to Europe.

However, only a few absolute proofs are needed. The two most famous early discoveries were La Mouthe, in Dordogne, and Pair-non-Pair, in Gironde. The first is a long, narrow passage-like cave which was choked with quaternary infill, a fine sandy mud that left only a half to one metre of the passage unblocked above. The entrance, which is a useful-sized hall, now used as a potato store, was widened and cleared by the proprietor, M. Lapeyre, in 1895. In so doing he threw out the greater part of the archaeological deposit that was in it; he also revealed the gallery beyond into which four boys made their way

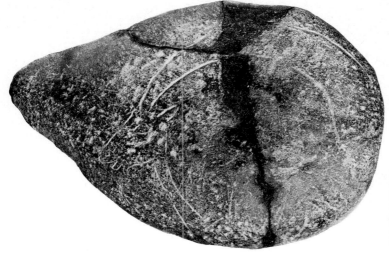

14 The lower surface of the stone lamp from La Mouthe, Dordogne, decorated with an engraved ibex head. Length 17 cm. Musée de Saint-Germain-en-Laye

in April of that same year. They wrote their names and the date (April 8th) on the wall of the main gallery but one of them, Gaston Berthoumeyrou, did also notice some curious drawings engraved on the walls. He told the prehistorian, Emile Rivière, of these and Rivière embarked on a long and careful excavation of the cave, emptying approximately two metres depth of deposit, mostly sterile, from the entire length of the main decorated gallery, about a hundred and twenty-eight metres in all. He also, in 1899, found in the cave a stone lamp that is the best known example of its kind. It has a shallow round depression for fat or oil on the upper surface and an ibex engraved on the lower one.

Rivière published a first note on La Mouthe in 1896 and news of his discoveries reached François Daleau, a native of Bourg who, since 1883, had been excavating the cave of Pair-non-Pair, near that town. Pair-non-Pair is a dome-shaped cave that is lit both from the entrance and by a hole in the roof. It was stuffed with archaeological deposits of many periods, indeed when Daleau began to excavate there was a gap of only seventy centimetres at the top of the actual cave. The highest levels are Upper Perigordian with Aurignacian beneath and Mousterian (a middle Palaeolithic industry) below that. When Daleau first started to clear the cave he noted some possible drawings on the walls, 'Je vois sur cette même paroi, à la hauteur des couches nos. 6 - 7 qui ont été déblayées il y a déjà quelques jours, plusieurs lignes s'entrecroissant formant presque des dessins. Ont-elles été tracées par les troglodytes? - à la prochaine visite je porterai une brosse, pour enlever la terre et voir ces *dessins* de plus près' (an entry in his notes, 29 December 1883. Cf. Roussot 1972a).

However, he did not apparently bring the brush for no further mention is made of these drawings until 1896 when, inspired by Rivière's discoveries at La Mouthe, he took another look at the walls of Pair-non-Pair armed, this time, with a pump from his vineyard. As he points out in his notes for the 13th July 'Ces dessins gravés, s'ils remontent au temps de l'occupation de la caverne comme je le crois, présentent un très grand intérêt.' Over the next few years he deciphered and copied a great many

15, 36 animals; they are engraved all the way up the walls, even near the roof and by their relationship to the archaeological levels that Daleau dug out they can be dated to the Aurignacian period, at the earliest, and also to the Upper Perigordian. Their style supports an early date, being simple and archaic. Save for Le Tuc d'Audoubert in the Pyrenees, found by the Bégouën brothers in 1912, in which two stalagmite pillars had to be broken

1 in order to reach the clay bison, La Mouthe and Pair-non-Pair still remain the best examples of incontrovertibly dated caves. In some cases a sheathing of stalagmitic deposit may occur overrunning the surface of paintings or engravings. If thin, they

98 may be visible through it, but if thick it may obscure them completely though it is possible, as has been done in the cave of Villars in Dordogne, to take infra-red photographs of the hidden paintings. Such a covering is often quoted as a vindication of age, and so it is, but it is no guarantee of Palaeolithic age: it was found at Lascaux that such a deposit could form in a few years (Sarradet, private communication).

In daylit sites frost and water action may on occasion loosen a part of the overhang and the detached block will fall on to the deposit below and subsequently be buried in it. If the deposit contains archaeological material the block may be dated and if there is painting or engraving on it a date may be given to this also. Such a date can only be *ante quem*, that is, before its fall and inclusion in the deposit. There is no way of determining *how much* before, but as a proof of authenticity such discoveries are very convincing. Two examples of this were found in rock shelters at Sergeac, in Dordogne. In one, the Abri Labattut, a large block with a cervid painted in black was sandwiched between two Perigordian levels, and thus attributed to the earlier; in the other, the Abri Blanchard, a block with red and black painting was found buried in a late Perigordian level, but lying on the surface of the Aurignacian layer below. Some of the low relief friezes in rock shelters may be fairly reliably dated also. At Le Roc de Sers, in Charente, the frieze was composed of

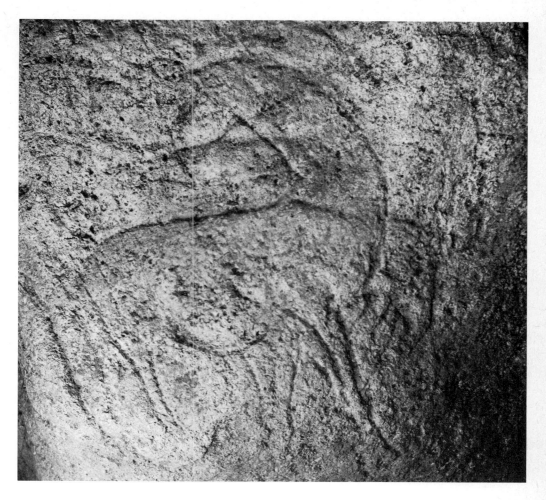

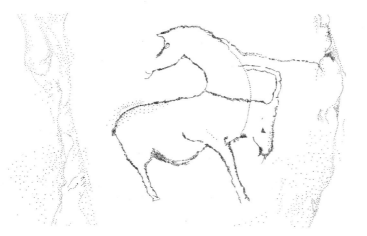

15 One animal with two heads, or two separate engraved figures of ibex and horse (see drawing) originally called the 'Agnus Dei', from Pair-non-Pair, Gironde. The height of the postulated figure with turned head is 63 cm.

50

57

9

separate blocks that originally stood on a low ledge at the back of the shelter; one was found in position during the excavation but the others had fallen and were incorporated in a Solutrean occupation level. At Bourdeilles, in Dordogne, the sculptures were covered by the Upper Solutrean deposit but when excavated stood clear of the Lower Solutrean, while at Angles-sur-l'Anglin, in Vienne, the frieze stood clear of the Magdalenian III occupation level and was covered by the Magdalenian VI. (For stages of the Magdalenian, see Table.)

15, 36

As can be seen in the case of Angles the relation of deposits to sculptures not only authenticates the frieze but gives it a probable and close date. Such evidence is, however, even more scanty than are the proofs of authenticity, and when trying to establish the chronology of Palaeolithic art stylistic comparisons remain the most reliable guide. These may be comparisons between one cave and another, for example the early 'archaic' engravings of Pair-non-Pair serve to date all other such drawings, but more often the comparisons are with miniature art and the dating, of course, is again relative, not absolute. Carbon 14 is a reliable method of absolute dating, that is in actual years, but as yet it has helped very little with mural art. Charcoal fragments, probably the remains of wooden torches carried there, have been found in a number of caves, and dated for some, but the results in many cases are at variance with the chronological position suggested by the style of the paintings. For example, three dates have been produced for the newly discovered gallery in Niaux, the Reseau René Clastres, respectively for 9,900 years, 10,150 years and 10,200 years ago (Clottes & Simonnet 1972), which are unacceptably young. The

16 Low relief sculpture of two ibex confronting each other from Le Roc de Sers, Charente. The block is 110 cm. in length. Musée de Saint-Germain-en-Laye

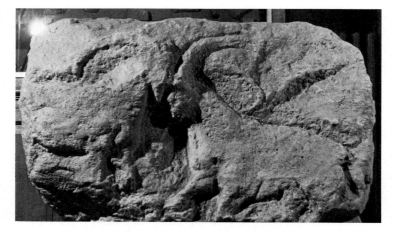

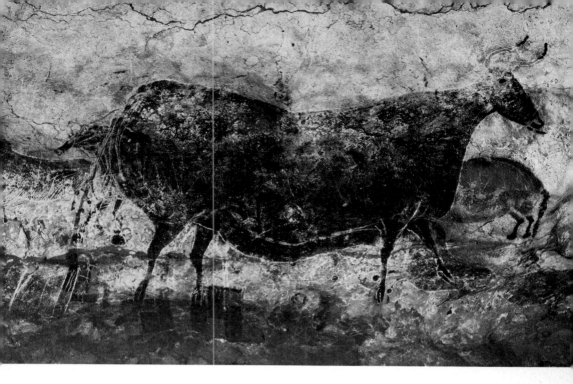

style of the paintings is very characteristic, belonging to a phase of the Magdalenian that existed approximately fourteen to twelve thousand years ago. There is no need to suggest that the C14 dating is faulty, but it seems very probable that the charcoal was not from torches used by the painters of the gallery, but from those of later visitors. This example pinpoints the difficulty of dating caves in this way. It is not the actual paintings that are being dated, but objects left in the cave that have no direct relationship with the mural art at all. Any such objects could be later than the paintings and might conceivably even be earlier so that if the evidence of style and C14 dating are in conflict, that of style should be preferred.

There are, however, limitations to dating by style, whether between one cave and another, or by analogy to miniature art pieces. In the first category, while it is true that Palaeolithic art is generally homogeneous and uniform and shows a succession of styles throughout its geographical territory, it has nevertheless some slight regional variations and these tend, as is shown in the Lascaux and Quercy group, for example, to perpetuate as a local style a tradition that has been superseded elsewhere. Thus, geographical location is a factor that must be taken into account when relating caves by style. Secondly, with regard to dating cave paintings and engravings by analogy with miniature art pieces: this, it seems, should be very straightforward but,

98–100

17 Cow with disproportionately large body, if delicate features. Painted in black and outlined with engraving, from Lascaux, Dordogne. Length 215 cm.

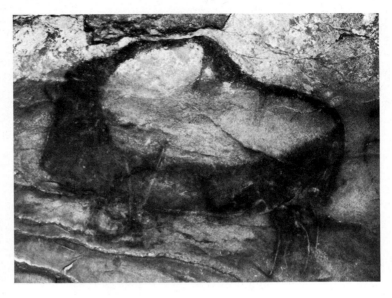

18 Bison, heavily outlined in black paint, accentuated by engraving from Le Portel, Ariège. Such a schematic treatment is used only for this species. Length 63 cm.

although it is quite feasible, there are difficulties. One is that by far the greater proportion of naturalistically decorated miniature art objects are of middle or late Magdalenian date, so we are short of data for comparison before this stage: the other difficulty is that Palaeolithic artists were much addicted to formulae. A particular animal, in mural art, may be depicted with a particular stylistic convention for coat and mane and there may, in fact, be more difference, stylistically, between different species of animal at the same period, than between periods. The same applies to miniature art: particular animals are used for the decoration of particular tools and certain species, as in mural art, have

18 characteristic conventions of depiction. Also, certain categories of object for decoration, such as reindeer palmates, seem to command a particular style of drawing: in this instance a very free, undetailed outline, which in this group is not limited to any chosen species of animal. The conventions, or formulae, of the two groups (miniature and mural art) do not necessarily coincide, which is where the difficulty of using one to establish the stylistic chronology of the other arises. However, both follow a recognizable pattern of development that in outline is very similar. The earliest, disproportionate figures in cave art are

33 followed by the synthesized, static but restless, figures that are very characteristic of the archaeological stage of Magdalenian IV. In this stage some animals are still not drawn in proportion, although this seems more a matter of exaggeration than

ineptitude, but in the final stages of the Magdalenian they are succeeded by figures that are entirely life-like and relaxed. Since, as already stated, more than eighty per cent of naturalistic miniature art is of middle or late Magdalenian date, it is not possible to find parallels to the early cave art stages. Magdalenian IV miniature art shows the same general characteristics as mural art, however, and so do the final stages with life-like, accurate figures, many of which are beautiful but appear unsprung by comparison with the taut drawings of Magdalenian IV.

However, as in any artistic tradition, once a particular achievement is made, its impact remains recognizable and, except with poor examples of a period or style, it is quite easy to place a particular drawing, though this is perhaps more a matter of eye than of rule. Palaeolithic artists were not repetitive but inventive, so that in miniature art, as in cave art, there is an infinite variety of forms within each canon and when no two objects are exactly alike it is less surprising to find so few exact parallels between cave and miniature art. Nevertheless, occasionally though exceptionally, these do occur. The most famous examples are the engraved hinds' heads found at Altamira, near Santander in Cantabrian Spain, both on the walls and in the habitation deposits accumulated at the mouth of the cave, in this second instance drawn upon the shoulder blades of the deer. Similar engravings were found in the archaeological levels at Castillo, not far distant, and the date of the two groups is

61

19

37

19 Three-dimensional sculpture of a horse in ivory, with coat and shoulder markings shown by engraved shading, from the Grotte des Espélugues, Lourdes, Hautes Pyrénées. Length 7.5 cm. Musée de Saint-Germain-en-Laye

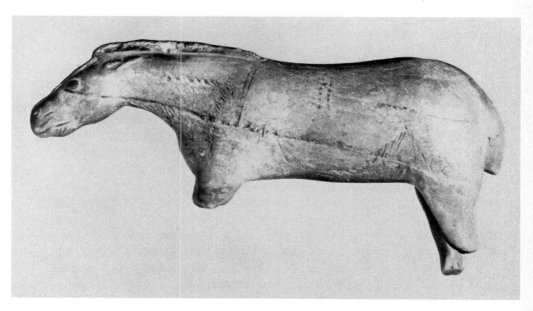

20
21
9

of interest. At Altamira, the engravings of hinds' heads were all in the Upper Solutrean level; at Castillo, in the lowest Magdalenian recovered there (Magdalenian III, see Table). It so happens that there was no Magdalenian III at Altamira and no Upper Solutrean at Castillo, but the similarity between the two groups of engraved omoplate (shoulder blade) bones suggests these two stages must have been closely related in date as, in fact, they appear to be in France. The majority of rock-cut friezes in Charente, Poitou and Vienne are of late Solutrean or Magdalenian III date, and again show a steady gradation of development between the two.

Using evidence such as that from Pair-non-Pair and the hinds' heads from Altamira and Castillo, the Abbé Breuil, over a number of years, built up a chronological scheme for cave art. The Solutrean/Magdalenian date of the hinds' heads, for example, served as a fixed point before and after which certain figures might be grouped. Superimpositions were the guide to such groupings: for example, red frescoes and some black paintings were found at Altamira to underlie the engraved hinds' heads on the wall, while the polychrome frescoes at frequent points covered them and are never cut through by them. A comparative study such as this, relating successions from one cave to those from others, rather in the manner of dendrochronology, involved a very great deal of work. It occupied Breuil, although it was not his only interest, throughout his adult life. The first cave he studied was La Mouthe, where he started to work in 1900 and the last, Rouffignac, which he visited in 1956: in addition to studying the paintings and engravings he made copies of a great many of them, using transparent talc and tracing the original drawings from the wall. The position of many of the drawings made this very arduous and the decipherment

89

of some of the panels of superimpositions, particularly of engravings such as Les Trois Frères, in the Pyrenees, was very difficult. Breuil's knowledge of cave art was unrivalled and probably will remain so and, although some of his deductions are now no longer accepted, the data that he built up remain the basis of all modern study. There are hazards in copying a drawing on a wall. If it is worn or entangled with other drawings its decipherment must, to some degree, be subjective and for the public to see Palaeolithic art only in the form of copies has an effect of distortion. However faithful the copy may be, the hand and style of the copyist have intervened and altered the original: one does not, for example, expect that a tracing of a Matisse

20 Hinds' heads engraved *a* on the gallery walls and *b* on fragments of deer shoulder blades, found in the Upper Solutrean levels at the cave mouth, Altamira, Santander. Length of *a* approx. 36 cm., length of *b* 11 and 13 cm. (The engravings on bone were in the Alcalde del Rio Collection, now dispersed)

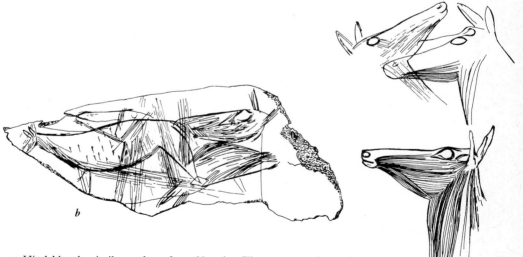

21 Hinds' heads, similar to those from Altamira, Ill. 20, engraved *a* on the wall of the cave of El Castillo, Santander, and *b* on a deer shoulder blade from the lowest Magdalenian levels of the habitation deposit at the entrance to this cave. *a* is an artificial grouping. The length of the largest head is 20 cm. *b* Three heads may be seen on this piece, one upside down. Length 16.3 cm. Museo Arqueológico Nacional, Madrid

drawing will have the impact of the original. However, when Breuil made his copies there was virtually no other way of recording the caves completely. Photography is now more versatile and the difficult locations of so many of the figures no longer present such a problem, but it is still not possible to avoid certain distortions and some wall surfaces, such as the myriad superimposed engravings in Lascaux, cannot be deciphered by photography and still await publication.

46

Breuil's work was essentially based on a study of technique: in the case of superimpositions it was crucial to determine which painting overlay another; in the case of engravings, which line was the more recently cut. The second is the more difficult to determine for a deep cut may look more recent than a shallower, simply because it is more heavily marked. It is relatively easy, though, to distinguish painting over engraving, in which case the engraved line will be choked with paint, or engraving over painting, where the paint will simply be cut away. Breuil took into account fashions in the use of colours and techniques of shading, infilling and schematization, although for him, perhaps, the style of the drawing was of less relevance. In fact, his detailed observations on the manner of depicting feet, or horns, do constitute the elements of style but he preferred to classify the art according to archaeological terminology, that is as Aurignacian, Magdalenian and so forth, rather than by descriptive categories. This is the principal difference between his method of classification and that of Leroi-Gourhan, who is the foremost authority on Palaeolithic art at the present day and whose classifications depend more upon the visual, linear character of a drawing than upon whether it is in red, perhaps, or black. Leroi-Gourhan's classifications do not conflict with Breuil's: they are simply reassessed from a different viewpoint, applying additional criteria.

Breuil's first ideas concerning the development of cave art were put forward in 1902, in conjunction with the prehistorian Capitan, and were added to and emended in subsequent years. With the publication of *L'Evolution de l'Art Pariétal dans les Cavernes et Abris Ornées de France* in 1934 he reached his final and definitive assessment; in his *Four hundred centuries of Cave Art*, for example, published in 1952, this earlier scheme is very little changed. The development of painting and engraving he treated separately but both, in his opinion, followed a two-cycle pattern. Breuil's twofold scheme is no longer accepted, nor are many of his attributions to specific cultural stages, but since his

22 (*opposite*) Large black bull with horns drawn full face – in 'perspective tordue' – from Lascaux, Dordogne. The complete figure measures nearly 300 cm.

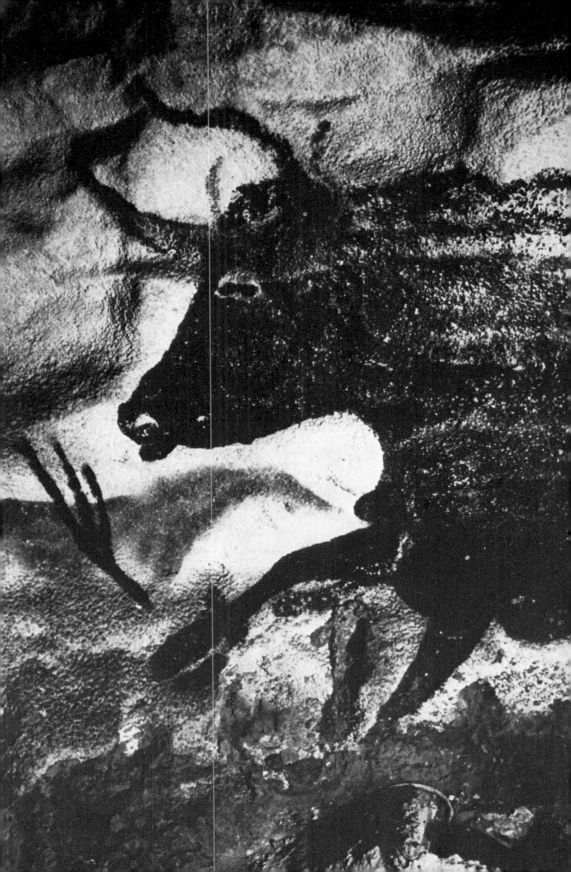

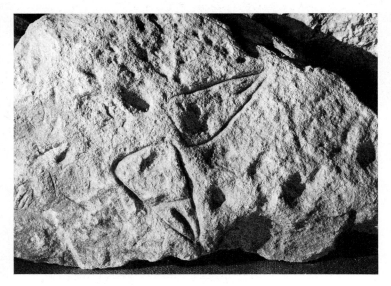

23 Engraved vulvae of Aurignacian date from La Ferrassie, Dordogne. The block is 55 cm. long. Musée des Eyzies

94

22

15, 36

24 (*opposite*) Low relief Venus, known as the 'Femme à la Corne' from Laussel, Dordogne. 46 cm. high. Musée d'Aquitaine, Bordeaux

chronology is based on associations and is still useful, an outline of his scheme is relevant here. It is as follows: in painting, the earliest manifestations are hand prints and finger meanders, followed by yellow drawings, then red, at first drawn with fine lines and then with bolder, arriving at flat shading, most usually in red, and elementary bichromes. After these (and marking the end of Breuil's first 'Aurignacian' cycle) come black linear drawings. A characteristic of these early stages is the use of 'perspective tordue', a phrase used to describe antlers or horns drawn full face on an animal head in profile. His second cycle ('Magdalenian') begins with simple black line drawings, at first hatched and then stumped, which are followed by plain flat brown paintings and then by polychromes, at first imperfectly and then entirely outlined in black. A few red linear drawings and signs occur last of all. In these later stages antlers and horns are shown correctly in profile, one aligned behind the other.

Engraving and sculpture begin, as did painting, with finger drawings, but here drawn in mud. These 'macaroni' are accompanied by elementary animals, then by deeply incised representations of vulvae and wide-cut animal engravings, such as those at Pair-non-Pair, and in the 'Middle and Upper Aurignacian' low reliefs of men and women occur, such as the famous group from Laussel. Breuil thought little of the capabilities of the Solutreans in either painting or engraving but allowed them some fine low reliefs (attributing these, however, to Magdalenian influence). In Magdalenian III, engravings

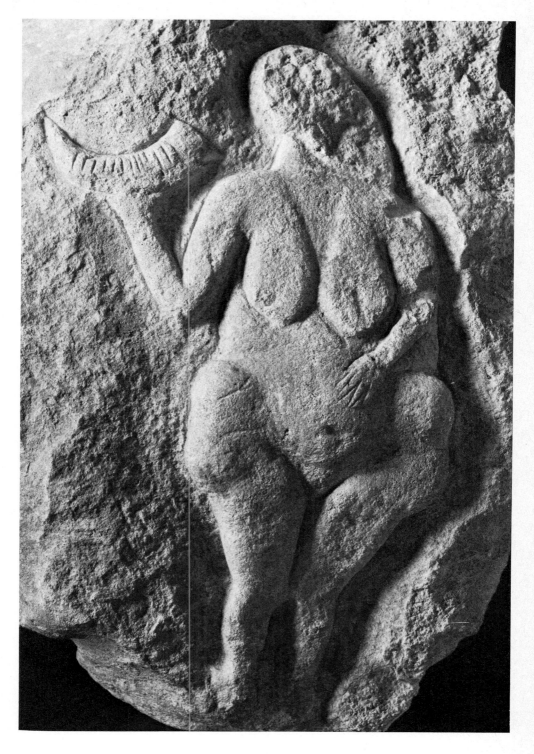

51, 55
90, 60, 1, 84

are found infilled with parallel hatching and beautifully executed high relief sculptures occur in rock shelters. Magdalenian IV to VI shows very delicate engraving and some clay modelling. In reality, Breuil's observations on the succession of engraving and sculpture suggest a continuous line of development but he insisted that 'although a relationship exists between the two groups, the one Aurignacian, the other undoubtedly Magdalenian, they form two blocks different enough for the origin and transformation of one into the other to remain a problem to be solved' (Breuil 1934). Having deduced a repeat development in painting from linear outline to bichrome or polychrome infilled painting, he was committed to a two-cycle system. The development of miniature art does not, however, support this: it has, very clearly, a single cycle and, in fact, with very little adjustment Breuil's scheme for mural art may be made to do the same. The appearance of black line drawings after bichromes is not necessarily a return to the beginning of painting but may, more simply, be seen as a stylistic fashion. The time-span involved in decorating caves is enormous: some paintings and engravings, for example, are undoubtedly Aurignacian in date, but the tradition did not perhaps last so long as Breuil supposed and the main period of cave decoration, at least of deep caves, was perhaps comparatively short-lived. It began, in all probability, in the stage of Magdalenian III, to which Lascaux may be attributed; was much practised in Magdalenian IV, the period to which belong most of the decorated caves that are very difficult of access, and was, at least in some areas, no longer in fashion in the late Magdalenian. Neither the archaeological nor the stylistic evidence of the paintings themselves demand a repetition of the sequence. This was, however, only a deduction made by Breuil from the material he amassed. His data remain unimpeachable and from them we have not only an understanding of the relative chronology of Palaeolithic cave art, but also a very comprehensive inventory; this was, of course, Breuil's aim in copying and publishing with accurate plans as many as possible of the major caves found in his lifetime.

Apart from stylistic sequence what we know, on the basis of Breuil's work, about Palaeolithic cave art can be summarized as follows. As stated briefly above, the greater part of cave art is naturalistic and the species shown are primarily the large herbivores. Horse is by far the most common of these and is followed, numerically, by bovines, that is bison and oxen, the former being the more often represented. These two categories

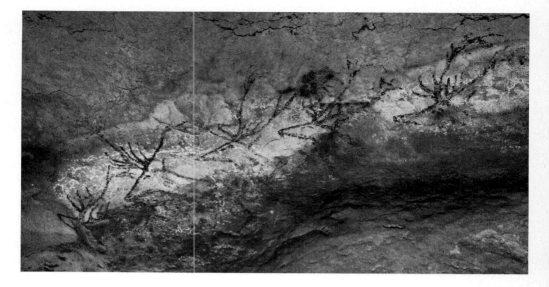

25 Line of deer heads,
sometimes described as of
animals swimming, from
Lascaux, Dordogne.
Length of panel 500 cm.

form sixty per cent of the total animal representations in cave art, the remaining forty per cent comprising principally deer, mammoth and ibex and in much smaller numbers reindeer, chamois, Saiga antelope, boar, rhinoceros and carnivores, that is bear, hyena, fox and wolf. In addition, in still smaller numbers, there are male and female human representations which, although they must be included in the naturalistic group are anomalous in that they are nearly always unnaturally represented, some composite or unreal animals, some fish, a few birds and a number of hand prints. The animal inventory does, to a certain extent, reflect a regional fauna, but it is selective since birds and fish are far less well represented than they would have been in their natural state while reindeer, which we know to have been the basic supplier in some stages of the Upper Palaeolithic both of meat and raw materials in the form of antler and bone, is very little represented in mural art. The relative proportion of animals depicted does vary from cave to cave but not in a way that we can explain by climatic variation; for example, Rouffignac, in Dordogne, is a cave with a great many re- 65 presentations of mammoth but other caves, such as La Baume Latrone in the Rhône valley, that also have a bias towards 135 mammoths, do not belong to the same period: in addition, the drawings of reindeer appear early and late in the record of mural art but not in the 'classical' period in between, although it is in this classical period that their bone and antler is extensively used for miniature art pieces and tools and in which their bones often

account for ninety per cent of the food debris in habitation deposits. In general only four or five amongst all these species listed will be drawn in a single cave.

With regard to the depiction of the animals, although many are incomplete, enough is usually drawn of each animal to establish the species and they are usually shown in a standing position, although no backgrounds or lines to indicate the ground surface are ever shown. Occasionally a pair or a group of animals are drawn in relation to one another, perhaps a male following a female or two males confronting each other, or more rarely a group such as the line of deer heads at Lascaux, but most usually each animal exists without zoological relation to any other. If they are drawn on a ceiling, it is more difficult to determine their orientation for, depending on your viewpoint, they may appear different ways up. A few animals on cave walls are drawn vertically, that is to say they are not drawn in the attitude of falling but in their natural stance, only placed at 90 degrees to the horizontal. Interestingly, the animals drawn in this way are most often bison (Ricol 1973), while horses are sometimes turned completely upside down. Amongst the incomplete figures a mammoth or bison may be suggested by the line of its back, in both cases unmistakable in outline, while a horse or deer may be represented by a head alone. More curiously, headless animals occur; these are not examples of imperfect preservation where the head has been destroyed, perhaps by water action, leaving the body behind, but are figures clearly outlined with the outline stopping abruptly at the base of the neck. Relative size is a matter of no importance: a horse may have a tiny bison placed among its hooves or, as in the main hall at Lascaux, huge bulls, three metres in length, may dominate oxen and deer of a moderate size with tiny ponies below. All figures, large or small, have one characteristic in common, however: they are observed with extreme accuracy and are represented in the drawing by those details that are most characteristic of the species concerned. In this way a synthesis of a particular animal is developed and an almost idiomatic style of drawing achieved. The care taken in producing a lively, recognizable and elegant drawing does not extend, though, to preserving it intact in its finished state, for engravings and paintings are often superimposed. To twentieth-century eyes this is one of the most puzzling aspects of Palaeolithic art, that a drawing should be created with such care and then obscured or obliterated by another, particularly when the walls to right and

61, 16
25
I

110

13

7

96, VI

V

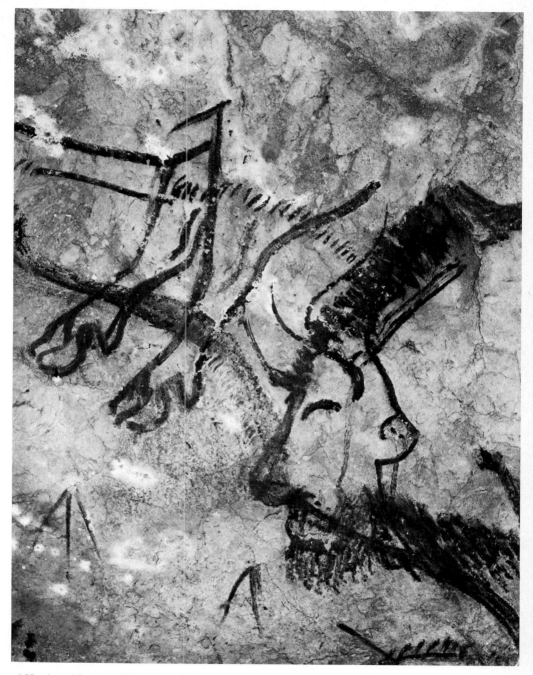

26 Heads and hooves of bison superimposed without regard to pre-existing figures, Niaux, Ariège. This is an enlargement of part of Plate VI

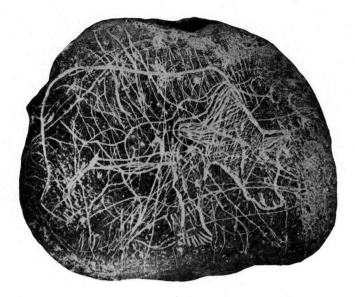

27 Pebble with a bear and other animals engraved in a palimpsest, from La Colombière, 9 cm. in length. Faculté des Sciences, Lyon

53, 54

28 'Sorcerer', in reality a half figure both engraved and painted with a broad outline in black, from Fontanet, Ariège. Height of figure approx. 50 cm.

left may be quite free of decoration, but it is a persistent characteristic of all aspects of this art. Palimpsest engravings on pebbles are found in living-sites and at Angles-sur-l'Anglin (Vienne) some of the better preserved fragments of the low relief frieze show engravings on the sculptured figures themselves.

Hand prints may be either positive, that is made by a hand dipped or coated in paint and pressed on the wall, or negative, created in outline by placing a hand on the wall and blowing a fine spray of paint around it. Many of the prints at Gargas (Hautes Pyrénées) appear to be mutilated, with one or a number of fingers truncated. When first found these aroused considerable speculation as to whether Palaeolithic people removed the joints of their fingers for a ritual purpose, or whether they suffered from leprosy. Both explanations seem far-fetched but it is no more possible to deny such conjectures than it is to prove them. Human representations, altogether, constitute a very problematic category. With very rare exceptions the anthropomorphs in deep caves are, in contrast to the animals, ill-drawn, schematic and fugitive objects. If their artistic quality alone were taken into account, they would be of little importance but, on the analogy of modern aboriginal art, it would be unwise to dismiss them so. One can assume that if they were ill drawn this was not from incompetence but intention, though one can only guess why this was done. The majority are masculine but are usually only recognizable as such because of their pronounced ithyphallic character.

Lastly there are the signs that are schematic in design, perhaps representing, as Leroi-Gourhan has suggested, a masculine or feminine element, according to their shape; or perhaps naturalistic in origin, as Breuil thought, deriving from representations of huts, traps or weapons. They have a great variety of forms ranging from quadrangular chequerboards to elaborate tent-shaped devices, brace- and winged-shaped forms, clubs, lines and dots. They are more susceptible to regional and chronological grouping than are the animal drawings in caves, but it is difficult to see what relationship they have to these. Some caves have many signs, some few or none, and in the caves where they occur they are often scattered about amongst the animal drawings. It has been suggested that their layout is no more haphazard than is that of the animals; certain signs are restricted to certain zones of a cave, dots, for instance, marking the beginning and end of panels of decoration. In some cases they are very elaborate, for example in Castillo in northern Spain a whole diverticule is decorated with red signs of considerable size and complexity. Although the quadrangular signs have been said to represent traps they do not seem to be strategically placed to catch the animals and in general the appearance of the signs seems almost to represent a second, alternative iconography. The mixture of realistic representations (animals) and abstract signs is unexpected and puzzling. The signs may have naturalistic origins, but if so they have become ideogramized in a way the animals have not and show a quite different pattern of artistic

5, 39–44, 63, 64

5

29 Lines of red dots on a gallery wall at El Castillo, Santander

development. They do, perhaps, have a parallel in the 'Venus' figurines in miniature art that first occur in the early stages of the Upper Palaeolithic as naturalistic, three-dimensional models but achieve a variety of beautiful and formalized schematizations in later stages. Here, however, we can trace the connecting stages, but for signs there is no such record. Club-shaped signs in caves may be the last manifestation of the Venus figure, but the connection is rather tenuous. As with the animal drawings, no two signs are exactly alike, excepting the simplest, either in a single cave or between one cave and another.

Obviously the topography of the cave itself is important in determining the distribution of paintings and engravings in general, while smaller natural conformations can be very suggestive and were exploited with much imagination by Palaeolithic artists. The ceiling at Altamira, in Spain, decorated with polychrome figures of bison and other animals is probably the most remarkable example of this use of natural shapes; here the rounded bosses on the ceiling have been used to create an animal's body in relief, most typically a bison lying down, curled on to the shape of the rock. Sometimes a projection on the rock will form an animal's head and the body behind will be added with drawn lines, or a crack in the rock may be used as the line of a back. At the most minimal, eyes or ears may be added to a suggestive lump, to produce a face. Graziosi (English edition 1960) suggested that the stalagmitic formations in Pech-Merle (Lot) were evocative of mammoths with long trailing coats and round domed skulls and that the mammoth drawings here were a copy of these, or at least inspired by them. If one considers the lights that Palaeolithic artists used, which from archaeological evidence we think to have been shallow stone lamps, probably containing animal fat and a wick, one can appreciate that, like a candle, they would produce shadows and shapes from every wall, particularly to a suggestible eye.

Using materials already available in a cave may be considered as another aspect of utilization. One might here include 'macaroni' drawings on the damp mud coating of a wall or engravings made in mud on the floor, but most particularly one may cite modelled figures such as the clay bison in Le Tuc d'Audoubert in the Pyrenees, which were made with mud scooped up from a hollow in the floor nearby. In contrast, materials for painting were taken into the caves; the pigments may have been mixed with water or fat and applied with fingers, brushes, perhaps daubers of hair or skin, or blown through a

49

78

4

31, 32

14

68
87
1, 84

30 (*opposite*) Two recumbent bison painted on the natural rock bosses of the ceiling. Altamira, Santander. The length of the nearest figure is 185 cm.

3

tube in a spray. One can only deduce the methods from the results: flat washes of paint suggest the wall was damped and paint applied with some dauber or broad brush; negative hand prints suggest paint blown in a spray, while lines and fine stippling suggest the use of a brush. No traces of such tools remain although at Gabillou (Dordogne) the excavator found a shallow stone palette showing splodges of red, yellow and black pigment, arranged as on a modern palette (Gaussen 1964). A flint blade with traces of ochre was also found, used perhaps to scrape the colour up on the surface of this stone. Gabillou is a cave almost entirely decorated with engravings, although it has enough paintings to account for the palette, but while numerous lamps and a quartz hammer for dressing the walls before engraving were found, no burins were recovered; in fact none of the very few flints found here showed any trace of use. Flint burins are assumed to be the tool used for engraving, having a chisel-shaped point, and are often found in engraved caves. Low

31 Stalagmitic formations that suggest the shape of mammoths with long, trailing coats. Pech-Merle, Lot

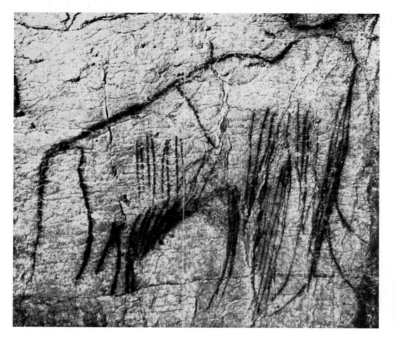

32 Black outline painting of a mammoth from Pech-Merle, possibly inspired by the natural shapes of Ill. 31. Length 60 cm.

relief carving requires a heavier tool and at Cap Blanc (Dordogne), for example, and at Angles (Vienne) a great number of flint picks were found, presumably used for roughing out while burins were probably used for the final dressing of the stone.

The method of decoration used is always suitable to the location; low relief stone sculpture, which must have been arduous and time-consuming to produce, is only found in daylit sites, while the reliefs in deep caves, such as Le Tuc, are made of mud that is easily and quickly shaped. It would not have been practical to decorate, with a slow technique, a gallery that it took several hours to reach and leave and, interestingly, none of the really elaborately decorated halls are very inaccessible. Niaux and Les Trois Frères, in the Pyrenees might at first sight appear as possible exceptions to this rule; however although the original entrance at Niaux was a long way from the main painted hall it was not a hazardous walk and a fairly rapid technique and execution is demonstrated by the character of the paintings themselves. This cannot be said of Les Trois Frères which has a small chamber containing some of the most elaborate and delicate engravings known. It is probable, though, that the original entrance was quite near this chamber and has since fallen in. The galleries that are most difficult to reach, such as the

6

98–100 newly found Reseau René Clastres in Niaux, show very rapid work: outline drawings which although beautiful are not the result of much time spent, but rather show the expertise of a very good craftsman. Equally, superimpositions are seldom found in the deepest recesses of caves but more commonly occur in often frequented, easily visited locations.

Since the Abbé Breuil's death some twenty years ago, the material available for the study of mural art has not changed radically, nor been greatly augmented. In Périgord and northern France some systematic search has been made for new sites and a number have been found, both in the classic area and far to the north of this, but in the Pyrenees and Cantabrian Spain few people are involved in such activities. The exploration of deep caves is obviously a matter for speleologists, but not all Palaeolithic art is in deep caves and a study of the distribution of known sites on a map suggests that the pattern we have is still incomplete. There is known to have been considerable colonization of high altitude areas in the late Magdalenian, as has been very clearly demonstrated in Haut Quercy, for example, (Lorblanchet 1968) and new decorated caves have been found here; if here, why not in other similar areas such as around Limoges, Montluçon, Nevers, or Moulins? It has always been thought that Palaeolithic decorated caves were not to be found

66 north of Périgord but the discovery of Gouy near Rouen and La Dérouine near Mayenne in northern France has shown this view to be mistaken.

More than in France, however, it is in Spain that the distribution seems unrealistic. Plenty of caves have been found in the low-lying foothills, accessible from the coastal towns, but the occurrence of a group such as that comprising Covalanas, Sottariza, La Cullalvera and La Haza, high in the hills in a valley-head basin, makes one wonder if there are not many more at such altitudes. The location of Covalanas suggests the valley was a high-level summer pasture; in the Palaeolithic perhaps for migratory herds of deer, since it is deer that are drawn in the cave, and until the beginning of this century, probably for sheep. Seventy years ago, after the vindication of Altamira, the interest in finding other such caves in Cantabria was intense. Alcalde del Rio and other prehistorians found Covalanas, La Haza, Hornos de la Peña, Castillo, Santian, Venta de la Pera, Sottariza and El Pendo in the space of two or three years, more probably by asking the local people than by actually tramping the ground. Nowadays many of the high-level pastures are no longer grazed,

local shepherds no longer explore the surrounding hill-sides, the old men have died and caves will have to be found by walking and searching, but there are probably many to be found, were interest to revive again. It seems significant that the Covalanas group is near Ramales and that three further sites are known between here and Burgos, an area more accessible in the twentieth century than some, because of the existence of a main road. Breuil considered Penches, near Ona, with ibex paintings, and Atapuerca, to the east of Burgos, painted in a style reminiscent of La Haza and Covalanas, as undoubtedly Palaeolithic. They are at a very much higher altitude than most Palaeolithic decorated caves and their existence is very provocative. In fact, in the last few years a speleological group from Burgos has begun to explore the region around Ojo Guarena, said to be the largest subterranean karstic complex in the Spanish Peninsula, and have found a number of decorated galleries. To date, none of these may be conclusively claimed as Palaeolithic, although some of the paintings in the Cueva Palomera may be and others may yet be found. If decorated caves exist here at such an altitude, that is between five hundred and a thousand metres above sea level, and so far inland, what of the Ebro valley at Logrono or the Arga running up to Pamplona and what of the Spanish side of the Pyrenees? This last is a limestone area that is now very dry but must, in the late Würm, have received meltwater from the Pyrenean glaciers. In miniature art there is an unsolved problem in the similarity of art forms from El Pendo and El Valle in Spain and those from Mas d'Azil on the French side of the central Pyrenees. The topography of the north (French) face of the Pyrenees makes east-to-west traffic almost an impossibility, but there are fewer barriers on the south side and it is perhaps not idle to suggest that if Palaeolithic groups travelled to and fro along the foot of the Pyrenean chain they may have camped and decorated cave walls as they went. At least, until further search is made, one may speculate upon the possibility.

115

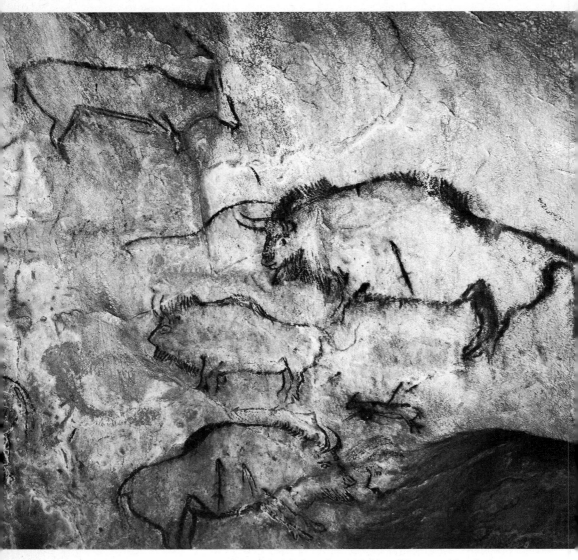

33 Panel of figures in black outline with bison, ibex, cervid and a horse which is indicated only by the line of back and neck. Two of the bison and one small ibex are marked by arrows on the flank or back. Niaux, Ariège. The bison at the bottom of the panel measures 100 cm.

3
Present-Day Preoccupations with Palaeolithic Art: Leroi-Gourhan's Theories on the Layout of Sanctuaries

For Breuil the meaning of cave art was simple: it was an expression, in various forms, of sympathetic magic and had a practical, magical aim. Hunting magic was represented by large game animals, some even conclusively marked by arrows on their flanks or bellies, reproductive magic by cows in calf, mares in foal or even by cow and bull drawn as a pair, and destructive magic by drawings of beasts of prey, who formed another target for the hunter. To quote from his *Four hundred centuries of Cave Art* (1952, p.23): 'that the game should be plentiful, that it should increase and that sufficient should be killed were the chief aims'. These deductions Breuil made from the paintings themselves, but to explain the disguised anthropomorphic figures, for example, he drew widely upon comparisons from any ethnographical source; it might be the Shamanistic tribes of Siberia, the Australian Aborigines or the Bushmen. The signs, which he considered to be representations of huts, or spirit houses, he described as tectiforms, again using ethnographic analogies. To some extent his views reflect nineteenth-century thinking for, although primitive man is no longer seen as rude and barbarous, he is still conceived of as engaged in a perpetual struggle with nature to obtain sufficient food for survival. His art might be marvellously drawn but, in keeping with his status, it was still a simple pragmatic exercise. Since Breuil formulated these views, doubts have crept in. If, as is now thought, the Upper Palaeolithic was a period of plenty, if there was no shortage of game and no stress in survival, at least with regard to food, then there is no reason to suppose that animals were painted in caves to ensure success in the chase. Even today, in circumstances that compare ill with the economic advantages of the late Pleistocene, most hunting and gathering people are singularly free of cares about food for the future; in fact to some anthropologists many of them appear unconcerned to the point of being feckless (Woodburn 1968). In addition, while it is true that some animals

<div style="text-align:right">1, 61
76</div>

in Palaeolithic art are marked by arrows as though destined for slaughter, it is a surprisingly small proportion that are so marked (approximately eleven per cent), and in any case, as has been stated above, the animal species most frequently drawn are not those which we know from occupational debris to have been most frequently eaten. If the animals represented food magic such a discrepancy would need explaining.

Reassessments of primitive man and a reappraisal of the superiority of civilized man have both combined to produce a new respect for the Palaeolithic forerunner of both; his circumstances seem, if not altogether enviable, at least far from contemptible and more regard is now accorded to people who, with so little equipment, ordered their lives in what now appears to have been a very efficient manner. Equally, we wonder whether simplistic interpretations of cave art are adequate. We have no reason to suppose that the intellectual capacity of Upper Palaeolithic man was less than our own and therefore no reason to prefer simple to complex interpretations for his art. Ideas such as these underlie the new thinking on Palaeolithic art and the source for many of them has been anthropology and perhaps, more simply, the crisis of confidence that distinguishes the twentieth century from the nineteenth.

The leading protagonist in a new assessment of Palaeolithic art is André Leroi-Gourhan who combines (as did Breuil) an

34 Animals of differing sizes. The horse in the centre has smaller ponies below and, not completely included in this photograph, a very big bull in front of its head. Lascaux, Dordogne. The central horse measures 280 cm.

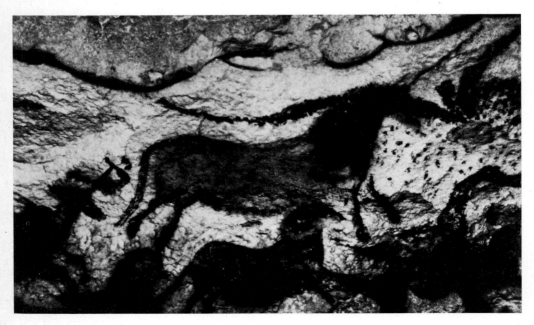

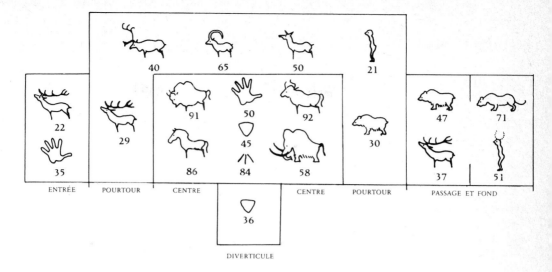

ENTRÉE POURTOUR CENTRE CENTRE POURTOUR PASSAGE ET FOND

DIVERTICULE

anthropological training with the disciplines of archaeological technique. The first of these perhaps influences his reassessment of the purpose of the art and the second accounts for his interest in its layout. It had previously been assumed, mainly because one painting is so often obscured, even to the modern eye spoilt, by another superimposed on it, that only the creation of an individual figure had importance and that their agglomeration on the cave walls was accidental and purposeless. Leroi-Gourhan and Annette Laming were the first to question this and their interest sprang in great part from the discovery of Lascaux. This cave, found during World War II and opened to an admiring and devouring public in 1947, is small and almost totally decorated; palpably it was decorated as a unit, or units, and once one has seen Lascaux, other caves, or galleries in other caves, take on a certain unity that was not apparent before.

Originally, in a major work published in 1965, Leroi-Gourhan contended that the spatial organization of Palaeolithic mural art depended on factors of opposition; these he chose to characterize as masculine and feminine, with various animal species grouped into each category. Thus the horse and other animals of secondary importance to it, are male, the bison with its constellation, female. Neither element will ever be found without its counterpart, although the relative numbers of each may vary very much. In some instances one bison may stand against ten or eleven horses, and so forth. Further, certain areas of, or positions in, a cave are chosen for masculine or feminine representations; one must therefore envisage that the decoration of a cave depends on a preconceived spatial plan. Seven zones of

35 Leroi-Gourhan's diagram to illustrate the ideal arrangement of a Palaeolithic sanctuary. The numbers below each drawing are percentages based on 865 subjects in 62 caves. The subject is here counted once each time it is represented regardless of the *number* of times it may be repeated in the same panel

V, I

decoration were differentiated in Leroi-Gourhan's scheme, such as connecting passages, end situations, central and marginal panels and he considers that the distribution of figures and signs among these zones is of great importance. In addition to grouping the animal figures into masculine and feminine categories, the signs were so divided also. Feminine figures, vulvae and, less convincingly, hands and wounds form the feminine group (signes pleins); harpoons and arrows, because of their postulated relation to the penis, are grouped with the masculine figures (signes minces). Actual feminine representations are generally in central positions, actual masculine examples in marginal and end situations. Bison and oxen, consistent with their 'feminine' grouping are in central positions, opposed to the horse which, although masculine, does predominantly occur in central situations also. Leroi-Gourhan's statistics are based simply upon the occurrence of a subject; the number of individuals represented, their size, colour, or quality are not taken into account and the application of statistical analysis is made more difficult by the fact that out of a not very great variety of species represented, only a selection – usually four or five species in all – may be represented in a single cave. In addition, by far the greatest number of figures drawn are of horse, bison and oxen anyway, thus further reducing the possible permutations. There are as many horses as bovines and together they form sixty per cent of the total.

Obviously, it is easiest to recognize associations or juxtapositions in caves that have been decorated in a single period, that are in fact short-term caves. However, if you accept that a cave is decorated to a preconceived plan you may also accept that over a period of long usage such as many of the famous caves attest, subsequent additions may be made, while respecting the original layout. Leroi-Gourhan considers that this was the case and that additions and superimpositions do not contradict the first spatial scheme even though in much-decorated caves the panels and zones become confused and overlaid. Also, while some caves divide naturally into zones, with halls and narrow connecting passages, with others the matter becomes more subjective so that, for example in a long gallery cave, such as Combarelles (Dordogne), the occurrence of certain figures has to become the criterion for distinguishing the zones, rather than this being determined by the topography of the cave itself.

A chronology of the paintings is imperative to the decipherment of their layout. Leroi-Gourhan, using style as his principal

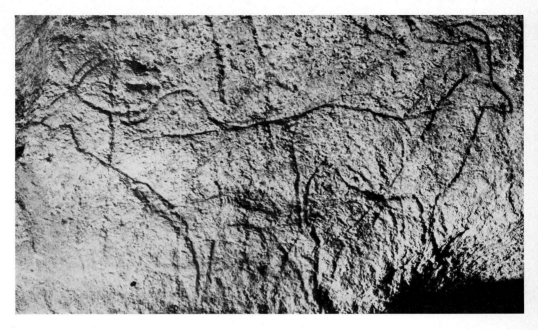

criterion, divides mural art into four main categories. Styles I and II are described as the first and second Primitive phases, Style III as the Archaic period and Style IV as the Classical period. (Style I is equated to the Aurignacian and early Gravettian stages, dated by Leroi-Gourhan from 34,000 to 25,000 bc; Style II covers the stages from middle Gravettian to middle Solutrean, 25,000 to 19,000; Style III, the late Solutrean and early Magdalenian, 19,000 to 16,000; and Style IV, the middle and late Magdalenian, 16,000 to 10,000 bc.) Style I has few claims to fame, a confusion of jumbled lines and some vague outlines are its contribution; Style II is clearly recognizable, it is free and strong, animal heads and forequarters are drawn or, if complete, the figures are based on an S-shaped cervico-dorsal line and have overdeveloped forequarters. Style III is transitional; its earlier (Solutrean) components are primitive, its later (Magdalenian) introduce a little detail. Style IV is subdivided into early and late. It is the early phase of Style IV that is marked by a great increase in decorated objects and, in general, paintings and engravings are detailed, shaded, formalized and uniform. This is the quintessential Palaeolithic style and is rightly named Classical. At the end of the Magdalenian in the late phase of Style IV a more realistic, almost photographic style develops; conventionalized details disappear and figures become more lively, only to degenerate finally.

36 An ibex facing to the right and a deer facing left superimposed on one another. Outline engraving typical of Leroi-Gourhan's Style III from Pair-non-Pair, Gironde. The length of the two figures is approx. 100 cm.

13

IX, 96

60, 61

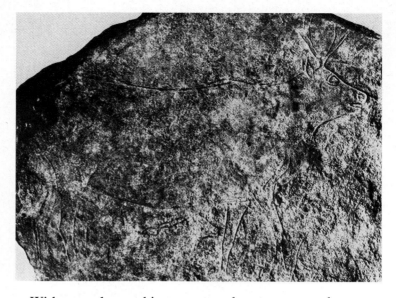

37 Female reindeer and her fawn engraved on a stone block. Such careful and realistic representation is typical of Leroi-Gourhan's late Style IV, from La Madeleine, Dordogne. 65 cm. in length. Musée de Saint-Germain-en-Laye

With regard to subject matter, the same general content persists in all periods and styles but Leroi-Gourhan thinks it possible to distinguish certain themes, that is a preference for certain animals, or combinations of animals, at different periods. Styles II and III show the greatest variety, Style IV is devoted almost exclusively to the theme of bison and horse, while mammoths, reindeer and bears reappear in the late phase of Style IV. Furthermore he thinks that certain locations are preferred at different periods. In his opinion daylit shelters and caves are the first places to be decorated as sanctuaries and with time ever deeper caves are used. The period of deep-cave decoration is not very long however (about five thousand years, from mid-Solutrean to mid-Magdalenian), for at some point before the end of the Magdalenian such underground locations are abruptly abandoned in favour, once again, of daylit sanctuaries, but this time built up from 37 collections of engraved plaques. This chronology differs from that of Breuil, who considered that many of the deep caves had a very long history, showing decoration from Aurignacian to late Magdalenian. Since the chronology of cave paintings is relative, it may be somewhat contracted without altering the relationship of one drawing, or cave, to another. In fact the chronology of cave painting is still, to a certain extent, subjective.

The same criticism might be made of Leroi-Gourhan's division of Palaeolithic art into masculine and feminine. This aspect of his thesis met with considerable opposition when it was

first published, simply because, to many archaeologists, it did not appear demonstrable. Basically this sexual division depends upon the human representations themselves, but the number of these is small, not, in fact, sufficient to determine any sexual grouping. Leroi-Gourhan therefore resorted to signs to extend his categories and while the female signs are fairly acceptable as a group, the male are much less so. The attribution of arrows, lines and dots, for example, to the masculine principle is simply a matter of opinion. On this structure, which is already somewhat hypothetical, is built the division into masculine and feminine animals. Here again the evidence is not conclusive, for no satisfactory reason is advanced to explain why a male bison should represent the feminine principle or a mare the masculine. Equally 'masculine' symbols occur in central (feminine) situations. They are said to be there in a complementary position but they might equally be taken to invalidate the entire classification, as might the fact that in some caves certain species, such as the mammoth, fulfil the masculine role and in other caves, the feminine. It is not the statistical proportion of animals in various zones that is in question here, but simply the designation of certain species as masculine and feminine. The idea that different groups of figures are repeated in a cave is an innovation and demands explanation, but whether the occurrence of horse and bison in central zones has to represent the opposition of male and female is arguable. It has been suggested (Bandi 1972) that the placing of particular species might be connected with particular rites performed at certain points in the cave, or that their position might, more prosaically, represent the natural habitat of the animals concerned; paintings of lions and bears, for example, are found in end situations in decorated galleries, in the same location as that chosen by such animals in real life, while horse and bison are drawn in more open zones.

39–44

41

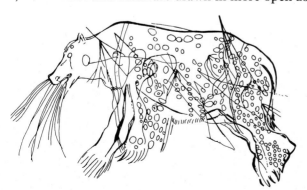

38 Engraving of a bear, supposedly covered with stab marks, from Les Trois Frères, Ariège. Length 60 cm.

39 Painted and engraved chequerboard signs peculiar to Lascaux, Dordogne. Each measures approx. 22 × 24 cm. This and the following five illustrations, Nos 40–44 are all signs of the female group, Leroi-Gourhan's 'signes pleins'

40 Tectiforms in red paint from La Pasiega, Santander. The largest is 40 cm. in length. See Ill. 46 also

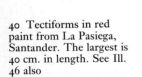

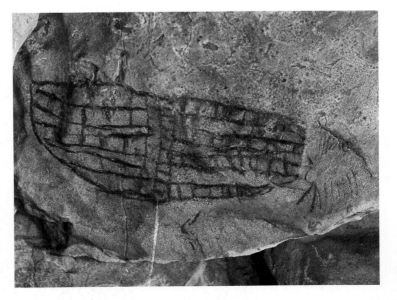

41 Large compartmented tectiform with a small 'porcupine' form to the right, from Altamira, Santander. The larger sign measures 40 cm.

42 Vulva-like signs in red, sometimes described as shield-shaped, with a feathered shaft in black, supposedly a masculine sign, drawn amongst them. El Castillo, Santander. The feathered shaft is approx. 80 cm high

43 Two groups of claviforms in red from La Cullalvera, Santander. The scale is given by the man on the right of the photograph

44 Two 'brace-shaped' signs in black from Cougnac, Lot, each measuring approx. 25 cm.

63

One cannot happily accept this sexual division of cave art; one may even have reservations about the supposed 'opposition' of species, for one animal painted in juxtaposition to another on a wall may as well be in conjunction as opposition when, as all scholars point out, one of the characteristics of Palaeolithic art is the self-sufficiency of each drawing. Annette Laming who, concurrently with Leroi-Gourhan, worked upon the hypothesis of a male and female division in cave art (choosing horse as feminine, however, not masculine as he did), later abandoned the concept altogether and in 1972 Leroi-Gourhan also made a reassessment of his position. He then said that although he himself still considered that the dualism of the art could be explained as a sexual division, it could also have another explanation. 'It is here that my ideas have changed in the last few years and I have come to regard the organized spatial representations of Palaeolithic art as an expression and not a content.' The words he uses are *contenant* and *contenu* for which it is not easy to find an exact English translation, although 'vehicle' or 'formula' might better convey the meaning of *contenant* than does 'expression'. This definition is in fact only a refinement of his original concept, for Leroi-Gourhan first put forward the idea of a masculine/feminine division in an attempt to find a metaphysical explanation for cave art, having pointed out that to regard such art as pictographic or narrative was incorrect. As such, it was an explanation at a more probably correct intellectual level than any advanced before, but to use the concept of male and female for the supposed dualism of the art was too provocative; it had the effect of taking away attention from the most valuable and innovatory aspects of his study, namely his observations on the spatial organization employed in the decoration of caves.

Leroi-Gourhan's work on Palaeolithic art has been accepted less critically abroad than it has been in England, for which reason, in an endeavour to readjust the balance, it seems opportune to summarize here his most recent considerations on spatial layout which he has based entirely on technical data, taking into account only the animal figures in caves (Leroi-Gourhan 1972). In effect this is to introduce the theories about cave art before the facts but it will perhaps give some coherence to the chapters on daylit or deep underground caves if they are approached with an idea of the possible principle upon which such decoration was constructed. The idea that Palaeolithic caves were painted to a formula seems at first astounding. That

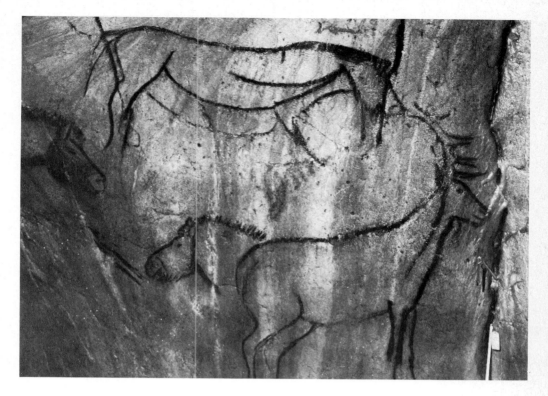

order exists is, in fact, statistically demonstrable (Parkington 1969), but if you remain sceptical, the most convincing evidence is probably in the caves themselves, particularly in the later decorated caves of the Pyrenees and Cantabrian Spain. Here, the acceptance of this concept is hard to avoid.

45 Part of a panel with horses and a stag on the periphery, painted in black outline. Niaux, Ariège. The stag measures 100 cm. from antler tip to hind hoof

Leroi-Gourhan suggests that the spatial arrangement of animal figures in caves should be compared to a fan. The central figures are ox or bison and horse and complementary to these and usually arranged in a lateral, or marginal position are deer, mammoth, ibex and reindeer with felines and rhinoceros as end figures; the position of bears is rather problematic, they occur in either of the last two groups, that is as peripheral or end figures. He classifies all these figures in four main groups A–D and has a number of minor groups also. A stands for horse, B for bovines, C for the marginal figures, D for the end figures; E represents monsters, H man, F woman, M hands, O birds, P fish, S signs (of various types). These classes correspond to the numerical densities of the species, A comprising twenty-seven per cent of the total, B twenty-eight per cent, of which bison form twenty-two per cent and oxen six per cent, and so forth; put simply,

35

47

46 Narrow 'diverticule' decorated with signs, La Pasiega, Santander. The longest tectiform measures 40 cm. and a drawing of this group is reproduced in Ill. 40

there are as many horses as bovines, three times fewer deer, mammoth and ibex and twenty or thirty times fewer carnivores and rhinoceros. Leroi-Gourhan reiterates that statistics are difficult to apply to spatial grouping in caves because when only four or five species are represented the possibility of chance combinations is much raised. Nevertheless, even if it is haphazard, an arrangement whereby the likelihood of bison and horse being found in central areas is thirty times that of feline or deer is of interest. If on the other hand they have been so placed intentionally their topographic position is much accentuated by their high numbers. Whether one regards the positioning as intentional, or determined by chance, it is remarkably stable. With very rare exceptions group B is always represented and always accompanied by A. (In a haphazard arrangement these two would, of course, have the greatest chance of being associated.) Group B also seems to be the central element and to be given the best locations. However, it is very rare to have only elements A and B; usually C, less often D, is present. This is why the animal inventory, allowing for regional substitutions of mammoth and deer, remains constant from one sanctuary to another. In effect the spatial distribution in a cave is more flexible than the inventory. Leroi-Gourhan points out that the animals are not a cynegetic inventory; as we have seen, they are not representative either of the contemporary fauna or of the diet of Upper Palaeolithic man, but are a selected bestiary. For him they are mythological, perhaps abstract symbols, 'the expression in a symbolic span of the dynamic perception of the Universe' (Leroi-Gourhan 1972, p.282).

To pursue the spatial distribution of figures, the configuration of a cave may be divided into three categories; firstly there are the Panels. These are surfaces with a centre and surrounds, occurring in a gallery or chamber, and may contain elements AB, AB + C, or ABC + D. Leroi-Gourhan insists that a panel must be coherent and delimited but, as with the closeness of figures within the area, no exact measurements are used and the establishment of coherence is simply a matter of discrimination. The second category he describes as Passages (a term deliberately chosen for vagueness) which are the transition zones between panels; they may be narrow constrictions, bends in a gallery, or entrances. They contain elements A, A + C or A + D. The third category is that of 'diverticules', or pockets, and according to their position they may be auxiliary to central or other areas. To quote (in translation): 'Caverns are painted

33,69
47
29

according to the measure of possibilities they offer. The positioning of signs or ibex or deer around the central panels, the clear polarization of bovines in the centre all suggest that what was prized was the setting in place of a certain arrangement of which the centre was not so much the panel but the bison or oxen with their satellites.' Leroi-Gourhan suggests that if one bears in mind that the significant assemblage of animals was perhaps copied from an engraved stone and then expanded to fit a cave this may explain the fact that classes C and D may be found both as complementary subjects in panels and as end subjects. The problem of adjustment between the formula and the structure of subterranean space is very important. He goes on to suggest that the inventory of the earliest sanctuaries, such as the Abri Blanchard, indicates that this formula with signs and particular animals existed from the beginning of the Upper Palaeolithic, but that its adaptation to caverns, with all the topographical opportunities they offered, was a secondary phenomenon. 'It seems that the mythogram remains fundamental and that "natural accidents" in caves, such as narrowings or niches, are incorporated in the assemblage in a measure compatible with their topographical position, which would explain the uniformity of structure of panels of assembled animals and the variety of spatial integration. This can be reduced to a simple layout of figures on a plan (Altamira ceiling) or lead to assemblages that are a highly decorative whole (Lascaux).' (Leroi-Gourhan 1972).

96

123
V, 34

Leroi-Gourhan insists that even in caves with the least natural divisions, such as Combarelles (Dordogne), the figures fall into topographical groupings, in this case fourteen series of bison and horse. (For a contrary viewpoint, see Ucko and Rosenfeld 1967.) Panels are repeated in a cave, sometimes very frequently, and may be added to in subsequent periods with the result that in some caves the repetitions are no longer very clear. However, what is surprising is not that confusion exists, but that it is minor in degree: for twenty thousand years and over the whole geographical area of south-west Europe no major departures were made from this basic formula. There are a very few caves that lack the element of A or B, there are two that lack both (Cougnac, in Lot, is one of these), while Covalanas in Spain is atypical in that it has a great many deer but only one horse and a rather hypothetical ox.

In fact, the elements A and B form the basis of the grouping, while the marginal figures C – deer, mammoth, ibex and

47 Leroi-Gourhan's diagram of the painted ceiling at Rouffignac, Dordogne, showing the grouping of species and thus also central and peripheral figures. A, horse; B¹, bison; C², mammoth; C³, ibex; D³, rhinoceros

reindeer—are interchangeable from one region to another. Panels, as stated above, are much repeated in a single cave, either in isolation on a wall or ceiling, or forming a group in a linear procession or even occurring as a suite of panels, offering different variants. Obviously a repetition of the formula is to be expected in caves where the decoration has been successively added to over a period of time (and in many cases also progressively added to in terms of penetrating into deeper galleries), but it is interesting and difficult to dismiss as fortuitous when it occurs in caves of small dimensions, or very brief use. The arrangement of figures on a continuous surface is a universal preoccupation in art. If it is in any way orderly it will, Leroi-Gourhan suggests, fall into one of two forms; it will be either pictographic, as is the later East Spanish art, or mythographic, that is, transcribed spatially according to a

130

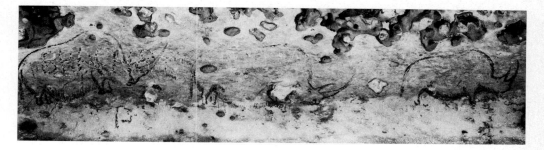

preconceived structural relationship. This second, he suggests, is applicable to Palaeolithic mural art.

With regard to the panels themselves, they are simply defined as surfaces with delimited proportions, occupied by an assemblage of figures forming a whole and their internal spatial arrangement may be simple, as in the grand panel at Rouffignac (Dordogne), or complex as in caves of long usage, showing many superimpositions. Assemblages are not uniform; one could hardly expect them to be for, in addition to the fact that all, or many, are the work of different craftsmen with a mental conception only of the basic formula, there is the varying influence of different cave topographies.

Preliminary studies suggest that the orientation of the animal figures themselves, that is whether they are facing towards or away from the cave entrance, has no relationship to their spatial layout, though it might be expected to have some significance. An analysis by species suggests that while whole groups may sometimes be in line, as are the rhinoceroses at Rouffignac, usually the orientation of each figure seems to be dictated by the contour of the wall, rather than by any other consideration. Leroi-Gourhan concludes by touching upon the occurrence of vertical figures and animals in pairs and upon the dimension of figures, all of which are aspects of spatial organization that call for further research. Furthermore, in this survey he does not consider the zones of unfinished lines, the 'macaroni' drawings, the human figures or the signs; the human figures and signs are explicitly excluded in order not to re-ignite the controversy over masculine and feminine. In all, Leroi-Gourhan's work on Palaeolithic art stands as a yet incomplete piece of research, but it is detailed, intuitive and, in many aspects, both revolutionary and convincing.

The decoration of cave walls has been studied from the point of view of its content and layout and latterly great care has been given to studying Palaeolithic caves as a totality (for example,

48 Line of rhinoceros, painted in file in Rouffignac, Dordogne. Each figure measures approx. 100 cm.

47

Lorblanchet *et al.* 1973). Such a study takes into account the geomorphology, palaeontology and climate of the cave as well as including controlled excavations. In an endeavour to recreate a sanctuary authentically there is perhaps one aspect that could still contribute and might be described as experimental archaeology, namely lighting. Twentieth-century studies of caves have been conducted under the best conditions possible with powerful, often electric, light, but this is an artificial situation and to recreate the impact of a Palaeolithic cave it should, if possible, be lit at the original level. One problem is that we know little about possible Palaeolithic methods of lighting: there is no evidence, in the form of charcoal, that fires were lit in these caves; smoke would probably have been an insuperable problem. Stone lamps have been found in some caves; Lascaux and Gabillou, for example, had a considerable number and La Mouthe a very beautiful example, but many caves have none, though this does not mean that they cannot have been used there. Breuil noted that smudges on the walls at Altamira coincided with charcoal fragments on the floor below, suggesting that wood torches had been used and he also mentions that Alcalde del Rio told him that the shepherds in the Cantabrian regions used rolls of birch bark for lighting. A number of sandstone slabs, blackened at one end, were found in Les Trois Frères and Breuil suggested that grease and a wick may have been fastened at one end of these. The only conclusion one may draw from all these examples is that the light was poor and restricted and, as it is unlikely that Palaeolithic people had any means of reflecting it, was probably also diffuse, rather than beamed.

14

The lighting used is clearly relevant to the size of the panels in a cave and to the distribution of decoration. Few halls are decorated totally or as a unit, Lascaux being the famous exception to this. It is perhaps simply a matter of dimensions, for one, or a group of grease lamps can only illumine a small area. The Rotunda at Lascaux was perhaps small enough to have been lit throughout by such lamps and so perhaps was the chamber at Altamira with bison painted on the ceiling, but it would probably not have been possible for Palaeolithic people ever to have seen the great hall at Niaux as a decorated whole because they had no form of illumination to throw light that far. This has relevance to the size of panels on a wall, also, for a candle type of lighting cannot illumine a large stretch of wall; usually only a group of figures of a certain quite limited extent can be seen in relation to one another. In fact many paintings and

engravings are in positions chosen to maximize a poor source of light; they are placed on low walls and overhangs and in passages where light would have been reflected from the wall behind. 'Diverticules' and apses have this advantage also, that they trap and reflect the light; even today with a torch you can experience this effect, on entering a hall the light appears to shrink while in narrow spaces it is contained and grows by reflection. The apse at Font-de-Gaume, or the narrow 'diverticule' at Castillo, crammed with tectiforms, are good examples of this. Palaeolithic caves must originally have been explored yard by yard; the walls progressively studied projection by projection, and then decorated according to their topography. Long friezes were probably never seen as a unit and in fact with the exception of those in the daylight, which rather supports this point, do not seem to have been conceived as such. As Leroi-Gourhan suggests, the decoration was probably built up of panels, additions, transitional zones and end groups, all positioned according to a preconceived scheme. The limitations of lighting perhaps account in part also for the perfection of each individual drawing and the apparent lack of regard with which each is placed in relation to figures nearby. The juxtaposition of animals may, as Leroi-Gourhan considers, have been important as a mythogram but the appearance of the cave walls confirms that it was not important visually.

IV

5

4

Decorated Shelters, in Daylit Situations

I Three cows and a pony on the ceiling of the axial gallery in Lascaux, Dordogne. The total length of the cow at bottom right is 200 cm.

II Bison painted on a natural stone boss on the ceiling in Altamira, Santander. Length of figure, 185 cm.

One aim of the previous chapter was to explain Leroi-Gourhan's recent theories regarding the layout of mural art, in the hope that a description of the individual caves would be illumined by these ideas. One may attempt a classification of Palaeolithic art sites in various ways, for example by chronology, location or technique: here they are grouped by location. Chronology is the most usual art historical method of classification, but is controversial in this context, while techniques are so frequently combined in mural art that to categorize caves as engraved or painted is often not feasible. Low relief sculpture is an exception to this confusion, though, and however you classify mural art, you may well begin here. In location it is confined and in technique, distinct, although in chronology its restrictions are less sharp. To be consistent with a division by location all daylit sites will be considered before deep caves. This produces a rather arbitrary chronological group, because the daylit shelters with engravings are mostly early or late but not 'Classical' in date. Whether this is an accident of preservation or discovery, or a vindication of Leroi-Gourhan's theory that the choice of location in mural art progresses from daylit situations to deep caves and then back to daylit sites again, may be a matter of opinion. However, as by far the greater number of decorated caves belong to the deep-cave group, it is more convenient to dispose of the small number of exceptions first. It would be entirely wrong, though, to regard the daylit low relief friezes as in any way peripheral to the study of mural art. In many ways they are of primary interest; they are, for example, probably the only large-scale compositions to have been seen as a whole and they are also by far the most securely dated group. The reason for this is simple; with the exception of a few engraved panels, they are the only form of mural art that is properly associated with habitation areas. They usually stand as a backdrop to an occupied shelter and with time, dateable domestic refuse has often piled up against them.

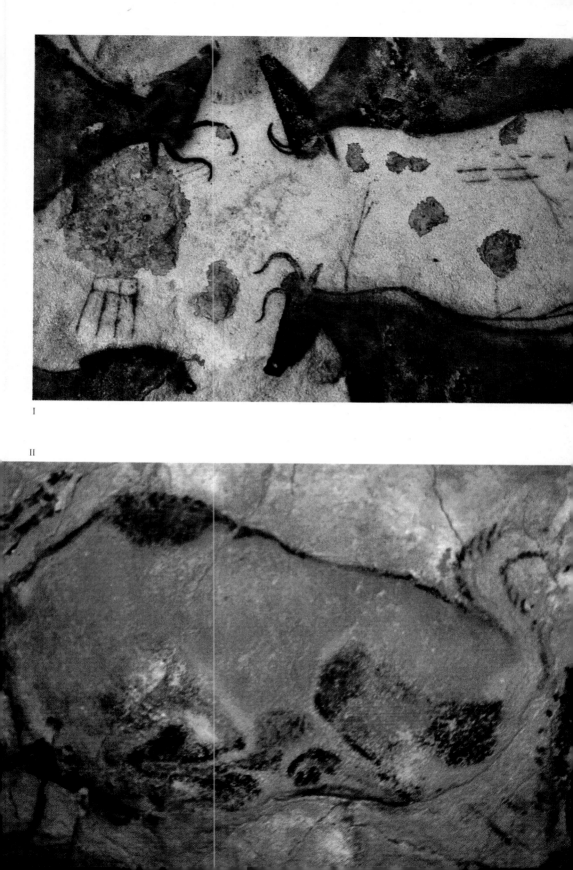

III

IV

With the exception of a single cave in the Beune valley, low relief rock carving is found only in daylit situations, presumably for the obvious reason that it is too time consuming and laborious a technique to have been employed in dark caves, needing artificial light, but we have no reason to suppose that it was the only technique used in the open air. Again it is obvious that paintings and engravings made in open rock shelters are far more vulnerable to weathering than either low relief sculpture in the same situation, or similar paintings and engravings in a more advantageous position, such as a deep cave. Such differential preservation now gives the impression that Palaeolithic men sculptured in the open air and painted and engraved in the remote galleries of underground caves but we have evidence to suggest that this was not originally so. Fragments of painting and engraving, fallen from the walls, are found in many open-air shelter deposits and one can suppose that originally the shelter walls were a riot of colour and animals, painted, engraved and sculptured. The low relief friezes of Laussel and Cap Blanc still show traces of red paint and a number of sculptured fragments from the 'Cave' Taillebourg at Angles-sur-l'Anglin have engravings cut on the low relief surface. These pieces were preserved in the deposit whereas other sculptures on the wall have lost their surface and they suggest that originally many sculptures may have been engraved, in the manner of cave drawings, with a superimposition of other figures.

Perhaps the best indication of the original appearance of an Upper Palaeolithic rock shelter site is given by Tito Bustillo near Ribadasella in the Asturias province of Spain. The recently X discovered mural decoration here is at the end of a long underground gallery, although actually quite near to the outside face of the hill; probably the original entrance was nearby, but it is now lost, closed, perhaps, by rockfalls or earth. It is very difficult to say whether, before this happened, the site had any daylight. There are a number of decorated caves, such as Bédeilhac and Mas d'Azil, in Ariège, where dark interior galleries were occupied and the hall at Tito Bustillo may be like these, but it is possible that a little light reached it either from the original entrance passage, or from the present (or another) chimney in the roof nearby, or even from the underground river that runs close to the hall. Whether this was so or not, there is a habitation site below the overhanging painted wall. The soil contained charcoal, fragments of bone and flint and pigments, some of which were found in the bottom of large barnacle shell

III Three human or 'phantom' heads and one of a stag on the wall in Cougnac, Lot. The stag is 53 cm. long

IV Interior of the cave of Ekain, Guipuzcoa. There are paintings on the lowest part of the ceiling, at the extreme end of the gallery

containers. The entire surface of the decorated wall above is red, painted or sprayed all over with ochre, and on this ground animals are engraved and painted in other colours. Horses and reindeer are the most commonly represented, some painted in polychrome or violet, and one can assume that if daylit, or even firelit, shelters were once all as colourful as Tito Bustillo, they must have been a remarkable sight.

The sites at Sergeac, in the Vézère valley, have been mentioned above (Chapter 2) because the engraved and painted fragments that fell on to the archaeological deposit here furnish one of the better means of dating and authenticating such work. In addition, although none of the shelters is now very rich they give, as a group, a good indication of the variety and duration of daylit mural art: the earliest decoration is Aurignacian, the latest middle Magdalenian and at a conservative estimate this covers a period of thirteen thousand years. To the west of the village of Sergeac there is a cliff, called Castel Merle, at the bottom of which is a very large shelter called Les Merveilles with vestiges of red colour and engraving still remaining on the walls; at the other side of this cliff there is a small ravine, Les Roches, which is full of Palaeolithic shelters. A large block in the Abri Blanchard, Aurignacian in date, has a horse in heavy black outline painted on a red ground and both this site and the Abri Castenet nearby contained slabs engraved with vulvae, which are a fairly common feature at this early date. On the opposite side of the valley are two further shelters, those of Labattut and Reverdit. The first had both engravings and paintings, amongst which were a deep-cut figure of a horse, found in the Gravettian deposit, a hand outlined in black and a group of painted blocks, one of which shows a cervid superimposed on other figures, perhaps mammoth, drawn in black line on a red ground; these are comparable in style, although rather later in date, with the block from the Abri Blanchard. The Abri Reverdit is still later in date and was decorated, apparently during a middle Magdalenian occupation, with a sculptured relief frieze. Five of the figures, amongst them one horse and two bison, are still in place although much spoilt, and some were recovered as fallen fragments. Other shelters are more beautifully decorated than these at Sergeac but here one may see painting, engraving, low relief work, superimpositions, the occurrence of female symbols, and the use of a red base ground, as at Tito Bustillo, all in the space of a few yards.

Visually, however, the most interesting examples of daylit art are the rock-cut friezes. Save for one or two exceptions, these are

23

confined to the regions of Dordogne, Charente and Vienne. It 8
has been suggested that they do not occur in the Pyrenees
because the limestone there is so hard and this view is perhaps
endorsed by the fact that at Isturitz in the Pays Basque some
figures were cut on a pillar of stalagmite, while in the Volp
caverns in Ariège low relief work is done in mud. It has been
stressed that because, on occasion, frost-detached fragments fall
into an accumulating deposit, or because with time such a
deposit may build up against the frieze, rock-cut figures are
comparatively easy to date. They appear to have been made
throughout the Solutrean and Magdalenian periods and the
earliest, such as Laussel, is perhaps Gravettian (Upper
Perigordian). The stylistic development is continuous; there is,
for example, no apparent break between late Solutrean work and
carving ascribed to Magdalenian III. The cultural stages of
Magdalenian I and II are usually considered to have a very
limited distribution, being confined to the Dordogne and Vézère
valleys, and continuity between the late Solutrean and
Magdalenian III is well attested elsewhere (Chapter 2). One may
consider either that the 'Magdalenians' learnt the art of
sculpture from the 'Solutreans', or, which is more feasible, that
the local Solutrean population adopted new Magdalenian
techniques in tool-making.

Low relief friezes are not numerous; there are only about a
dozen known at the present day, though it is probable that many
more are hidden, now buried under hillwash deposits, or other
natural accumulations. In most general respects, that is in their
content, in a use of superimpositioning and a disregard for
relative size in figures, the low relief friezes are comparable to the
panels engraved and painted on interior cave walls, but they
differ in one respect. Naturalistic human figures are more
common than in caves; as we shall see, this is perhaps a
concomitant of their situation, that is their association with
living areas. A description of each rock-cut frieze would be out of
place here but since, as a group, they show a very clear stylistic
development, four chronologically spaced examples will be
described, namely Laussel (Dordogne), Le Roc de Sers (Char-
ente), Angles-sur-l'Anglin (Vienne) and Cap Blanc (Dor-
dogne). Laussel and Angles are famous for their Venus figures,
and the latter is, with Cap Blanc, the most beautiful example of
its kind.

If the date ascribed to Laussel is correct, it would be the
earliest known example of a low relief frieze. However its date is

not altogether unassailable for, although the majority of the blocks that originally formed the frieze were found lying on a Gravettian deposit, with the exception of the Femme à la Corne, which was still standing upright, they were also in a part of the shelter where the Gravettian deposit was not overlaid by a Solutrean. The appearance of the sculptures is archaic, though, and one can accept that among low relief sculptures they are early. The most famous figures at Laussel are the six human representations, three 'Venuses', one male figure and one double-figure composition, but with these were a number of small blocks with deep-cut engravings of animals. The male figure, due to breaks in the stone, is lacking both head and feet, but his stance, with outflung arm, suggests he is drawing a bow, or throwing a spear. He is slim and wears a belt. The principal Venus, the 'Femme à la Corne', is forty-six centimetres high, broad-hipped, large-breasted and featureless. She is standing with her head turned to the right and her right hand raised sideways, holding a crescentic object that looks like a bison's horn. Her hips are cushion-like, her legs taper to blobs for feet and her hair or headdress is long, falling to her shoulders. The two further Venuses are in the same style but less complete, neither having legs. The double figure is more problematic. It looks, with a head at top and bottom, like the Queen in a pack of cards. If, as has been suggested, it is a childbirth scene, the child is disproportionately large; it might be a scene of intercourse but as such is even less convincing. Leroi-Gourhan suggests it is a re-cut figure.

The female figures from Laussel, with the exception, perhaps, of this last, belong clearly to a cult that is characterized by three-dimensional female figurines, rather generously called 'Venuses', which was widespread in Europe and the USSR in the Gravettian period. The cult appears to have originated in European Russia and spread from there both east and west; it is associated with houses, or other dwelling sites and is represented, typically, by very small ivory, stone or bone models of naked, often very obese, women. Certain of their sexual characteristics are carefully depicted, such as breasts, hips and the pubic triangle, while their facial features and feet and hands are omitted or indicated sketchily. Their appearance suggests they were fertility symbols, while their association with living sites, whether houses in the open air or dwellings in rock shelters, suggests they were there to endow a family, or tribe, with such attributes, or perhaps to safeguard people or house in some way.

49 (*opposite*) Venus statuette carved in ivory and now rather broken, from Lespugue, Haute Garonne. 14.7 cm. long. Musée de l'Homme

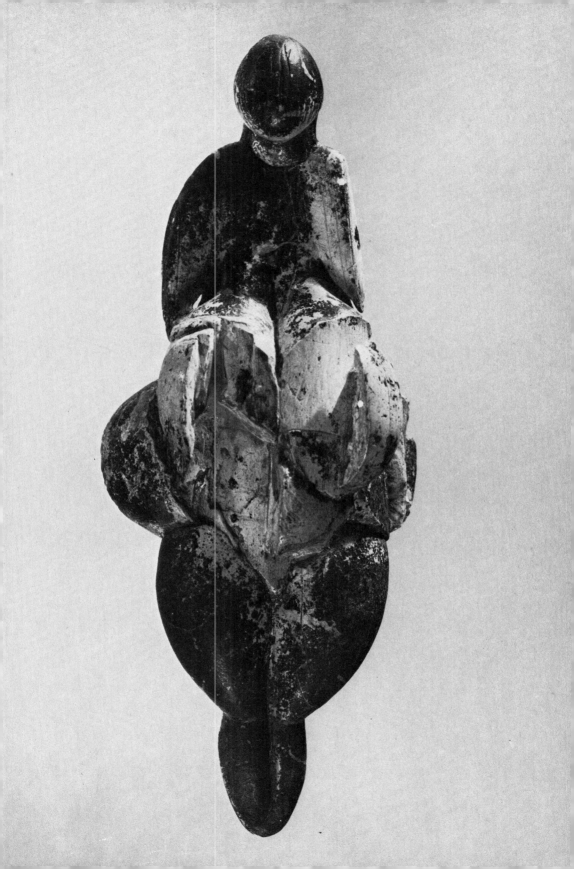

The cult appears in the Gravettian but persists in both Europe and Russia into later periods. Very occasionally examples of Venuses occur in caves, usually in the form of engravings, but these uninhabited underground sanctuaries are not their characteristic venue: they are associated with living sites and it is therefore not surprising that they should be represented in the daylit rock-cut friezes that form a backdrop to occupied shelters. While the Laussel figures conform generally to the Venus pattern they have some individual peculiarities. Two, even perhaps all three, of the Laussel Venuses are holding something and the blob feet and position of the left hand, laid across her stomach, of the Femme à la Corne, are unique. Also, although they are carefully carved they have a 'provincial' appearance and are quite without the elegance and symmetry of form that is often found in the three-dimensional figures.

Strictly speaking, Laussel should not be described as a rock-cut frieze, since it consists of free-standing stone blocks, some of which are small and portable. This seems, however, to be characteristic of the earlier examples, for the frieze at Le Roc de Sers was also built up from separate blocks. In the early excavations eight of these were found overturned and lying face downwards in the Upper Solutrean deposit of the shelter but further excavations in 1950 and 1951 disclosed a ledge running around the bottom of the rocky cliff with another two blocks still in position on it; presumably all were so arranged originally. The figures on the blocks at Le Roc range in length from forty to

50 Low relief of a horse and a bison reworked into a boar, from Le Roc de Sers, Charente. The bison/boar measures 164 cm. Musée de Saint-Germain-en-Laye

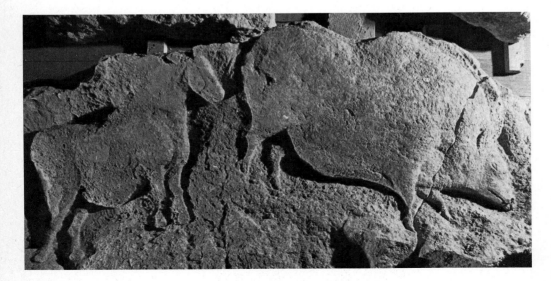

seventy centimetres and include horses, ibex (two of which are 16
males, fighting), deer, two men, a bird, a composite bison/boar
and an animal often described as a musk-ox, which is more
probably another bison. They are carved in a carefully rounded
high relief and although the style is still stiff, it shows an advance
upon that of Laussel. The roundness of the bodies suggested to
early investigators that four of the horses, for example, were
mares in foal, but this roundness is an attribute shared by the
male ibexes and should more properly be regarded as a stylistic
convention. Distended bodies with very short legs and a rocking-
horse stance, such as the Le Roc figures have, are typical of the
period classified by Leroi-Gourhan as Archaic (his Style III).
The frieze at Le Roc was re-cut, an undertaking that was
attempted at other sites also, and which accounts for the curious
composite animal. It appears to have been a bison, whose head
was modified into that of a boar and whose hump has been
trimmed a little to help in the transformation. In addition there
are traces of two bovines facing each other, one of which was later
incorporated into a horse. Both the human figures in this frieze
are masculine, one is rather rudimentary and said to be masked,
the second more finished. Here a man is shown with bent up legs,
apparently running at the double from a bison, or musk-ox,
which is pursuing with its head well down. The man is not very
well carved but the bison's head coincides with a corner of the
limestone block and is well represented in three dimensions.

In style the frieze at Le Roc de Sers is close to that of Angles,
although the first is associated with the Upper Solutrean and the
second with Magdalenian III. At Angles, however, the frieze has
taken to the wall. Some parts of it have now fallen but originally
it was a rock-cut frieze in the proper sense of the term. It is much
more extensive than Le Roc, the figures are larger and more
beautifully executed and the techniques more assured, but it is
clearly of the same tradition for the figures are still voluminous
and they still retain that very characteristic stiffness of stance.
The correct name for this site (which comprises two neighbour-
ing shelters, the Abri Bourdois and the 'Cave' Taillebourg) is 'Le
Roc-aux-Sorciers', the name being taken from the huge rock in
front of the shelter; Angles-sur-l'Anglin is the name of the
village about two kilometres away. In the 'Cave' Taillebourg the
frieze, with the exception of one bison, survives only in
fragments in the deposit; but thirty-five metres further upstream,
behind a large quantity of debris, the frieze was found *in situ* in
the Abri Bourdois. There are two levels of occupation here, one

of Magdalenian III date, which is below the level of the sculptures and one of late Magdalenian (VI) date which accumulated against them and, with later debris, covered and preserved them. The sculptures are therefore assumed to have been made by the Magdalenian III settlers.

For reasons of safety the frieze at Angles is not open to the public, but a brief description of the figures in the Abri Bourdois can be given. The shelter is about ten metres long in all and, starting from the left, the first figures on the wall are two bison (a female following a male), a mare with her head turned, a bison which is rather blurred in outline as it stuck out above the deposit, a very worn horse's head and a grazing horse. The last bison and the horse are approximately one third life-size. Next to this is a panel with three female figures drawn from waist to knee and designated as the three Venuses. The first of these is half in profile, the second three-quarters and the last in front view. They are very deeply engraved, rather than sculptured, and the pubic region is carefully marked on each; in contrast to most Venuses however they are relatively slender and well proportioned. Their position on the shelter wall, immediately beneath a sharp overhang, precludes their ever having been complete figures and it is interesting that truncated female representations are characteristic of the middle Magdalenian; one such figurine was found at Laugerie Basse, for example, and many are engraved, which endorses the dating of the sculpture at Angles. There is a bison beneath the feet of the third Venus figure which, in fact, is itself cut over another such animal and there is perhaps a fourth figure to the left of the group, but the wall is corroded and it is hard to determine exactly what was there.

Beyond the Venuses, in the direction of the 'Cave' Taillebourg, there is a spectacular panel of animals in three tiers, most notable for seven beautiful ibex cut over some pre-existing bison. No more of the bison has been obliterated than was necessary for the creation of the ibex and one very good head, in particular, remains. As at Le Roc a projecting angle on the wall has been used to give a three-dimensional effect, almost detaching it from its background. Amongst the seven ibex a female and her kid are particularly elegant. At the base of the frieze and beneath these last two animals there is a fourth Venus figure, even less complete than those in the central panel, since it consists only of a pair of legs, but quite sizeable. At what is apparently the end of the frieze there is a group of engravings, some verging towards a shallow relief, that include a bison calf,

51 (*opposite*) Fragment of a low relief sculpture of a grazing horse from the 'Cave' Taillebourg, Angles-sur-l'Anglin, Vienne. This block measures 68 × 24 cm. Musée de Saint-Germain-en-Laye

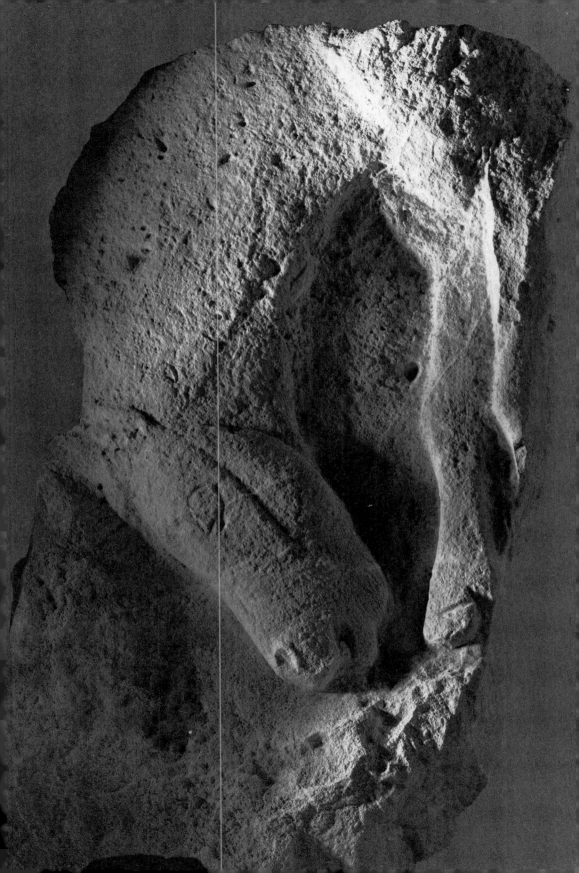

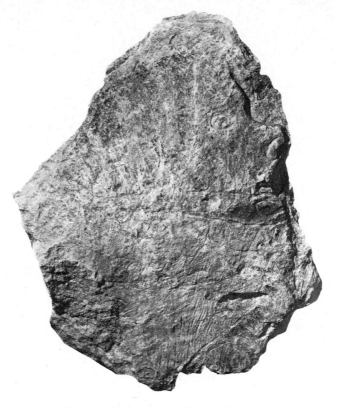

52 Head of a man, sculptured and painted in black and red from the 'Cave' Taillebourg at Angles-sur-l'Anglin, Vienne. 45 × 32 cm. The tip of this man's nose is missing, which alters his appearance. Another portrait from this shelter has a long, pointed nose. Musée de Saint-Germain-en-Laye

horses, a feline, a reindeer, a man's head decorated with plumes and a final ibex.

The fragments from the 'Cave' Taillebourg include a portrait bust of a man which is one of the very few Palaeolithic human heads that is neither distorted nor masked. It is cut in slight relief and engraved and painted and shows, in profile, a man with an upturned nose, an almond-shaped eye, a bushy beard and longish hair, who is apparently wearing a garment made of fur. In appearance he has a strong family resemblance to the engraved humans at La Marche, which is a contemporary and comparatively nearby site. La Marche has walls of spongy limestone that is unfit for engraving and a great many blocks of varying size were brought into this small cave and decorated. Since we have no evidence that any of these plaques were set up as a frieze they must be regarded, although some of them are large, as belonging to the group of portable art and therefore outside the scope of this book; however it is quite possible, and the suggestion was made by Breuil, that they are a late example of a cave decorated with a frieze of movable blocks. As well as the man's head there are fragments of horses, chamois, ibex and bison from the 'Cave' Taillebourg at Angles, amongst which are an

53 Small engraved plaquette from La Marche, Vienne, showing, among many other superimpositions, a man's head (which may be compared to that from Angles, Ill. 52) and a corpulent female figure. This plaquette measures 10 × 8 cm. Musée de Saint-Germain-en-Laye

54 Reverse side of the plaquette from La Marche, Ill. 53. Among a palimpsest of lines there is another female figure which may be seen as fat or slim, according to the interpretation given to the various lines

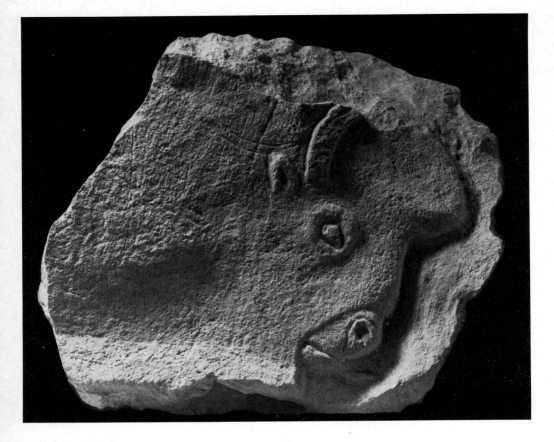

55 Sculptured bison's head from the 'Cave' Taillebourg at Angles-sur-l'Anglin, Vienne. This fragment, which measures 35 × 31 cm. is a masterpiece, regardless of its age. Musée de Saint-Germain-en-Laye

elegant head of a young ibex, some heads of horses whose bared teeth suggest they are grazing and a small bison with lugs cut in the stone at its head and hindquarters. This is not the only animal here with such attachments, although most of the other examples are broken, nor is this a feature unique to Angles. One of the horses at Cap Blanc (Dordogne) among many other examples, has such a ring cut above its back. It is difficult to guess what purpose these rings may have served: they are usually strongly made, but nevertheless are often broken which suggests that they were subjected to considerable strain; perhaps a heavy weight was hauled up or hung from them.

The valley of the Beune, near Les Eyzies, is very rich in low relief carving. Laussel is in this valley and not far from this large shelter is the much smaller one of Cap Blanc, while on the other side of the valley, beneath the ruined château of the same name is the shelter of Commarque and, on the north bank of the Petite Beune, that of Nancy. Both these last two are much spoilt

although there is one notable horse's head at Commarque, cut, exceptionally, in a dark interior gallery. The frieze at Cap Blanc has never been completely excavated but, even taking this into account, it is a far less considerable shelter than those of Laussel or Angles. In fact, in comparison, its sculpture appears disproportionately grand. A number of the figures here are difficult to classify, either because they are broken or because re-cutting has confused their identity, so that depending upon your attribution, you may consider the horses in high relief, which are the masterpiece of this frieze, to number six or five. It is probably least confusing to describe the figures and their possible alternative attributions, from left to right. The body of the first figure at the left end of the frieze is still hidden under the soil; its head suggests, according to different authorities, that it is a reindeer, an ox or a bear. Next to this is the first horse, nearly two metres long and described by Breuil as a mare in foal. Her hooves are omitted but her muzzle, which is superimposed on the hindquarters of the next horse, is carved with great care. This is the horse with a pierced lug carved above its hindquarters. The second horse is a little smaller and faces towards the third which is the largest and most beautiful in this frieze; it is also the only horse facing in this direction. The legs and most of the hindquarters of this third horse have flaked away but the carving of the head, neck and shoulder is marvellous. Ear and forelock are beautifully modelled, but unfortunately its muzzle has disintegrated. Traces of ochre were found on this figure which suggests the whole frieze was once coloured. The fourth, fifth

56 Horse cut in deep relief from the shelter of Cap Blanc, Dordogne. This is the largest and best preserved figure in this frieze and measures 215 cm.

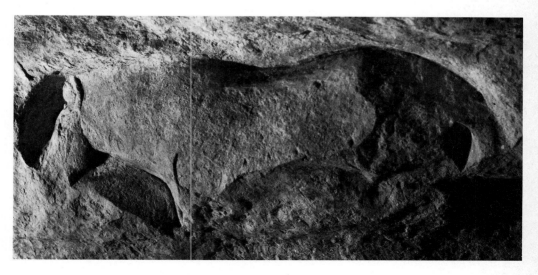

and sixth horses, (Leroi-Gourhan thinks the sixth figure is a bison), are grouped at the right-hand end of the shelter, the body of the fourth, possibly recut, is shown in relief with head and mane engraved on the hindquarters of the beast next to it which, like the last, is now rather broken. In addition to these figures, a possible ibex stands below the head of the first horse, two rather indistinct oxen or cervids can be deciphered on the wall above the third horse, two small bison only about nine inches long and cut in very shallow relief are placed between the legs of the fifth and sixth horses, a third bison (fallen from the wall) was found in the deposit and there are some rather indistinct animal heads. Except for Angles the Cap Blanc horse sculptures are without rival, they are exceptionally large and deep-cut, the relief at some points being thirty centimetres high and it is obvious they were made by someone who not only had a complete mastery of the material but also a perfect understanding of animal anatomy.

There was a habitation deposit in the Cap Blanc shelter; it contained a great many flint picks such as might have been used to peck out the low relief sculptures and it is claimed there was also a pavement of slabs laid beneath the frieze. The industry in the deposit is not very definitive, however; it was originally described as Magdalenian III but recent re-excavation has not confirmed this (Roussot 1972b). There is no more reason to ascribe it to this than to a later stage. On stylistic grounds it is hard to equate the sculptures at Cap Blanc with Magdalenian III; this would put them in the same epoch as Angles and they show a conceptual advance upon these. The Cap Blanc figures are in proportion, they are very naturalistic and the detailed modelling is reminiscent of some of the three-dimensional miniature pieces of Magdalenian IV, such as the ivory horse from Lourdes; they could belong to this period, or a later one.

19

The number of rock-cut friezes is small but two general deductions may be made from the examples we have. The first is that friezes were first constructed on free-standing blocks; apparently not until the Magdalenian were low reliefs actually cut upon the wall, though Le Fourneau du Diable at Bourdeilles, in Dordogne, is perhaps an exception to this. Here the low reliefs were cut upon two limestone blocks, the larger of which is associated with the Upper Solutrean level at the site, the smaller with a lower level, both of which stood against the back wall of the shelter. These are neither portable blocks, nor a part of the shelter wall and one may perhaps regard them as transitional. Secondly, figures in rock-cut friezes appear to increase in size, the

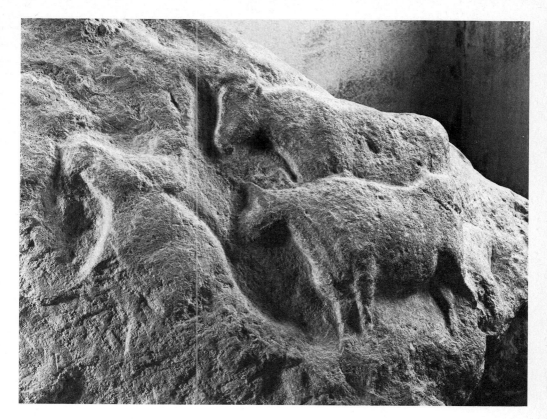

later they are in date. This is no more than an observable tendency but it is interesting that the Cap Blanc figures are large while the early figures such as Laussel and Le Roc are small and Angles is intermediate. The horse at Commarque, with a very fine head, is Magdalenian in style and is particularly large; its body alone is more than two metres in length.

Leroi-Gourhan's theories on the layout of mural art are based principally upon a study of caves but to be consistent they must be applicable to daylit friezes as well. Of the four sites here described it is possible to examine the spatial layout of only two, since the earliest (Laussel and Le Roc), were recovered only as blocks fallen and probably scattered about in a deposit. With regard to content, the three sites with a number of animals have the often encountered horse-bovid associations. At Angles and Cap Blanc the animals clearly have no more pictographic importance than they do in caves; they occur singly or in groups, but placed with the usual disregard for other figures in the same frieze. For example the horses at Cap Blanc are at varying

57 Oxen sculptured on a large block found standing at the back of the shelter of Fourneau du Diable, Bourdeilles, Dordogne. The right-hand animal measures 36 cm. Musée des Eyzies

heights on the wall and the bison with them have no relation in size. This of considerable interest because, while the pictographically disconnected layout in caves might be explained to some extent by the inadequacies of lighting, this cannot apply to daylit compositions. It would have been possible to have produced a continuous, coherent composition in a rock-cut frieze, but this was not done. One must conclude that their purpose, as in caves, was something quite other than this. There is, however, perhaps a slightly higher than usual proportion of narrative scenes in daylit rock shelters. At Laussel the man is apparently shooting or throwing something; at Le Roc a bison is pursuing a man and at Angles the panel of the three Venuses may also depict some ritual or myth, although the boy's head sometimes described as being here associated with the Venuses does not in fact exist. In whatever way you interpret this panel, there is no doubt that it has been placed in an important position; it is in the centre of the frieze and on a slightly projecting section of the wall. The Angles frieze is not singular in this respect, it has one possible counterpart in the frieze at La Magdeleine at Penne (Tarn), and may perhaps have had another at Laussel, though we do not know how the blocks here were originally arranged.

La Magdeleine is a small cave, containing four low relief figures, two being those of women, and two those of animals, characteristically a bison and a horse. Originally there were more, but they are now indecipherable. Although it is a cave, the figures are only about six metres from the entrance and are lit by daylight. The two female figures are naked and featureless and have large breasts, but their naturalistic reclining position, one lying on her right side, the other on her left and each with her head propped on one hand, is not typical of the Venus convention in Franco-Cantabria, although it is not dissimilar to some late Gravettian figures in Italy. The horse and bison at La Magdeleine are typically Magdalenian in style and are considered to be of the same date as the female figures, so one may regard these perhaps as a late, rather eccentric expression of this cult. Such panels of Venuses are not found in underground sanctuaries, although isolated examples of similar figures do exist, the probable reason for this being, if one may reiterate the point, that the cult is in some way closely associated with actual habitations. However, friezes such as La Magdeleine and Angles did provide Leroi-Gourhan with fuel for his male-female dichotomy of cave art. The female element is more in evidence than the male and in caves it was necessary to find a substitute, in

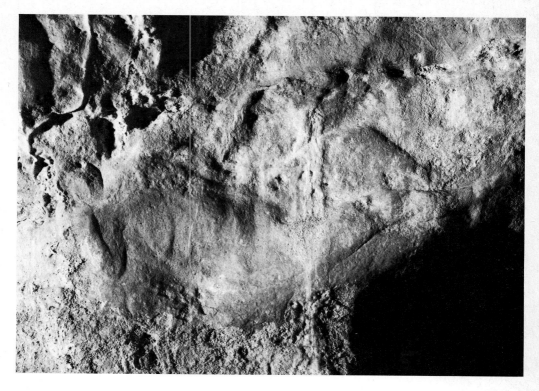

58 One of the low relief Venuses from La Magdeleine, Penne, Tarn, approx.
70 cm. in length

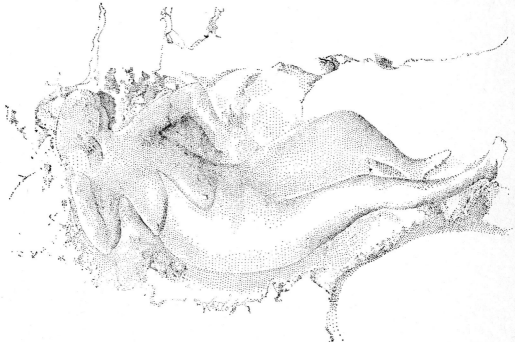

the form of signs or particular animal species, for both; nevertheless the rock-cut friezes remain some of the more tangible evidence for this much disputed theory.

Probably the few low relief friezes that exist today were at one time only a fraction of shelter decoration. There are indications that many shelters had engraved or painted walls but, as we have seen, very few examples of painting have survived. However, engraving does sometimes survive in small shallow caves that were used for habitation. To distinguish these from engravings in the dark galleries of deeper caves is somewhat arbitrary for, although the majority of engraved 'sanctuary' caves have no engravings near the mouth, this may in some cases be due to differential preservation and there are some transitional examples. Le Gabillou (Dordogne), which is a single-gallery sanctuary, is simply an elongated shelter. It is now much destroyed but the evidence suggests that the daylit and inhabited area at the entrance was decorated continuously with the gallery behind and the situation at Marsoulas, in Haute-Garonne, is similar. Here there is a long rock shelter, of which part is open to the daylight and part enclosed by a rockfall; there was a habitation in the daylit area and painting in the covered part, but no real gap between. In addition a number of deep sanctuary caves have traces of occupation in dark interior galleries where one would have expected the lack of daylight to have precluded habitation. The traditional picture of cave art in uninhabited deep sanctuaries does, however, apply in general and is not invalidated by some anomalous examples, nor need it be, if one accepts that daylit and underground mural art have a similar character and meaning.

Engravings in living-sites are comparatively rare; weathering has presumably effaced a great number and those that survive are deeply cut or have been buried under an accumulation of earth and rubbish. A few daylit engraved caves are known from the Rhône Valley and Italy, but these will be considered in a later chapter with other mural art from the Mediterranean region and only examples from France and northern Spain are enumerated here. The bison from La Grèze is justly famous. This is a deeply cut outline figure which was discovered underneath the habitation deposit on the back wall of a small cave in the same hillside as Cap Blanc. There are some other poor engravings in this cave and a very worn low relief of another bison. Two archaeological levels appear to have existed here, one is either Gravettian or Solutrean, the other Magdalenian, but as it was an

59

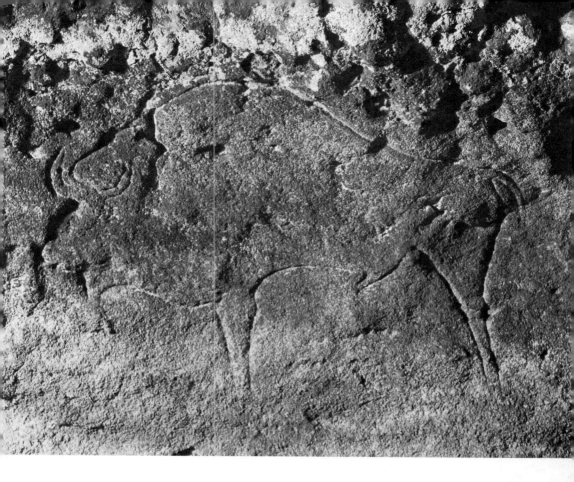

early and hasty excavation no closer attribution can be made. The beautiful engraved bison, covered by the deposit, is equated with the earlier levels and in style conforms to this, while the low relief bison is presumed to be Magdalenian.

Pair-non-Pair is a site famous in establishing the authenticity of Palaeolithic art (Chapter 2), but its engravings as well as being so conclusively buried under dateable deposits, are notable in themselves. By relation to the deposit the engravings are dated to the Aurignacian and Gravettian (Upper Perigordian) periods according to their height on the wall, and consist of three main groups. One is on the right wall facing the ground-level entrance, one on the left at the entrance to a side gallery and one on the right-hand wall of the side gallery itself. They are now rather corroded and this, in conjunction with the fact that many are in palimpsest, makes their decipherment difficult. Among the most easily recognizable are a stag with its neck outstretched and a horse, nicknamed the 'Agnus Dei'. Early reproductions of this figure showed it with a very long neck and head turned

59 Engraved bison, early in style, from La Grèze, Dordogne. 60 cm. in length

15, 36

15

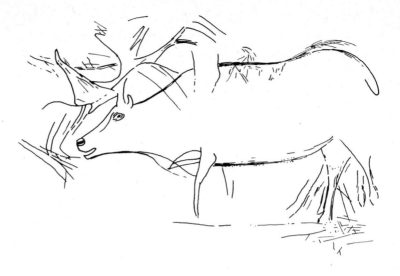

60 Engraved reindeer
from Ste-Eulalie, Lot.
Length approx. 40 cm.

backwards; subsequently this figure was dismissed as a
misreading of the superimposed engravings and it was suggested
that the lower body belonged to an ibex, the neck and head to a
separate horse but, faced with the figures in the cave, it is difficult
to determine which interpretation is correct. There are further
horses, deer, ibex, oxen, bison and mammoth and a number of
double circle signs. In style the engravings belong to Leroi-
Gourhan's second 'Primitive' phase (Style II) with an emphasis
upon the structural line of the back and the size of the shoulders.
They are simple outline engravings, with very little detail but the
line is fluent and sometimes surprisingly elegant, although, in
accordance with their age, the figures are fairly stiff.

The two other most important groups of engravings in
occupied caves are of Magdalenian date. These are at Teyjat, in
the north of Dordogne on the Charente border and at Ste-Eulalie
upstream from Cabrerets, in Lot. Both were originally described
by Breuil as late Magdalenian, the engravings at Teyjat being
ascribed to Magdalenian V and those at Ste-Eulalie to Magdalenian
VI, but this last attribution has recently been challenged (Lor-
blanchet et al. 1973). There are two galleries at Ste-Eulalie, only
one of which contains Palaeolithic industries or decoration. There
are a few traces of painted figures here and one low relief but the
now rather damaged and encrusted panel is mainly composed of
engravings. These are confined to the left-hand wall and to the
first thirty metres of a very extensive underground gallery. They
comprise twenty-eight animal figures, principally of horse,
reindeer and ibex, many of which are incomplete, and thirty-one

signs, which is an unusually large number for a daylit site. When first found this frieze was buried beneath a habitation deposit of Magdalenian VI date, which makes their attribution to this stage impossible. Beneath this there was a less well defined level, perhaps Magdalenian IV, beneath this again a considerable deposit of Magdalenian III, with a late Solutrean industry at the base. Lorblanchet wishes to ascribe the engravings at Ste-Eulalie to Magdalenian III; their height on the gallery wall relates best to this floor level although it would not be impossible to correlate them with the less well defined Magdalenian IV. The presence of a low relief and of reindeer, one of which is a cow with her calf, suggest affinities to a site such as Angles, which is Magdalenian III, but amongst the signs there are claviforms which are most usually encountered in assemblages of Magdalenian IV date. Stylistically, Lorblanchet considers that the engraving at Ste-Eulalie, which is anatomically correct and carefully detailed, is comparable to Combarelles in Périgord, or Les Trois Frères in the Pyrenees but, again, this is not altogether consistent with a date of Magdalenian III, for Les Trois Frères, in particular, cannot be dated to a period before Magdalenian IV. Apart from the fact that it cannot be Magdalenian VI in date, the chronological position of Ste-Eulalie remains debatable; its location, equally, is ambiguous, for it is a transitional example, being neither a daylit decorated shelter nor an underground sanctuary. The engravings are described as being in a penumbral light but, as in Tito Bustillo, they are associated with a living-site with a considerable depth of debris.

No such uncertainties attach to Teyjat. Here the engravings in the Grotte de la Mairie are cut on a cascade of stalagmite and on pieces broken off this, all of which now stand about ten metres

61 Stylistically late engraving of a cow and bull from the Grotte de la Mairie, Teyjat, Dordogne. The figures measure 50 and 55 cm. respectively.

inside a heavy, protective iron door, but must originally have been well lit. Some engravings still remain on the cascade and others, which in some cases join on to these, were found in the Magdalenian V deposit, directly beneath a Magdalenian VI level. It appears that some of the blocks had additional figures cut on them after they had fallen since the animals remaining on the cascade are all in the same plane, while those on the blocks are drawn all ways up, suggesting that the artist walked round and engraved them from different angles. In all there are nineteen reindeer drawn, although some are represented only by a head, eleven horses, ten stags, three oxen, three bison and two bears (one without a head). The figures range in length from about fifteen to fifty centimetres and the most beautiful amongst them are two cows and a bull, still in place on the cascade. The leading figure is a cow, followed by the bull and another cow. The first two of these figures are beautifully observed and drawn, although with very little detail. Being reliably dated, the Teyjat engravings have provided a type series for late Magdalenian style, they are characterized by a lack of infilled detail, by the flexibility of the figures, and by their almost photographically correct proportions.

The number of inhabited shelters or shallow caves decorated with engraving is so small that one hesitates to place much reliance on deductions drawn from them. There are, of course, other examples than those cired, for instance Hornos de la Peña near Santander in Spain, but they are very few, and most are poor. It is true that the engraved shelters we know are mostly either early or late in date but in so small a sample this could well be chance. The late example, Teyjat, contains a high proportion of reindeer and the reappearance of this subject is documented in miniature art also at this stage, both on bone objects and plaquettes. Some authorities think that certain caves were still being decorated in the last stages of the Magdalenian but in Leroi-Gourhan's opinion deep caves were at this time abandoned in favour of a return to daylit sanctuaries; typically sanctuaries composed of a collection of engraved plaquettes. However, while caves may have been abandoned in the late Magdalenian and replaced by plaquette collections, the converse is not true. For example, there is no evidence that plaquettes are only a late feature. They occur in a small number of sites throughout the middle and late Magdalenian. If they do not appear suddenly, in response to demand, one must also leave open the possibility that daylit shelters were decorated as

sanctuaries throughout the Magdalenian: Leroi-Gourhan himself stresses that the fashion for deep underground sanctuaries was short-lived. Tentatively, the evidence of the rock-cut friezes supports the idea of a continuous use of daylit sites. We have Angles in the middle Magdalenian (Mag. III), before the period of deep-cave use, but Cap Blanc is later, without being stylistically very late. Its figures in fact look 'Classical' and as such would be contemporary with much of the work in the deep underground sanctuaries. Ste-Eulalie also, in the position and date of its engravings, suggests that chronological or spatial divisions are not always clear cut; however, at present we simply have not enough evidence to settle these matters and the questions must remain open.

5

Underground Sanctuaries in Western France

A classification of Palaeolithic art by location may be used in different senses. Having reviewed the paintings and engravings in daylit situations, those in deep caves may be considered next; but location may be interpreted geographically also. There are three major centres of cave art in south-west Europe, Périgord, the central and west Pyrenees and Spanish Cantabria. The distribution of rock-cut friezes does not altogether overlap with that of decorated caves in Périgord, but it does to a certain extent; Cap Blanc, for example, is in Dordogne and many caves in this area show stylistic similarities to low relief work, for which reason this most northerly group will be the one described first.

The great majority of sites are in Périgord itself; Sarradet (1975) lists a hundred and twenty-seven sites with miniature or mural art in this region, sixty-nine of which are in the Les Eyzies district. These figures represent the highest concentration of such sites known anywhere and there are outliers to this group in Gironde as far north as Rouen, and a further group in Quercy. Périgord is undoubtedly the best studied area for Palaeolithic art and the number of caves and shelters known probably reflects the intensity of twentieth-century interest as much as it does a prehistoric predilection for this area; as much but not more. Certain areas in the Pyrenees and Cantabria have been intensively studied but do not rival Périgord in the number of decorated or of simple habitation sites. This is also the area in which all stages of this art are most equally represented. The Pyrenees show no intensive occupation before the middle and late Magdalenian and although there are early art stages in Cantabria, the total record here is not so complete. Périgord is thus every archaeologist's yardstick and conclusions drawn here are applied elsewhere, though this is not always of benefit. We owe the two principal studies of Palaeolithic art that we have to two Frenchmen, furthermore to two Paris-based Frenchmen

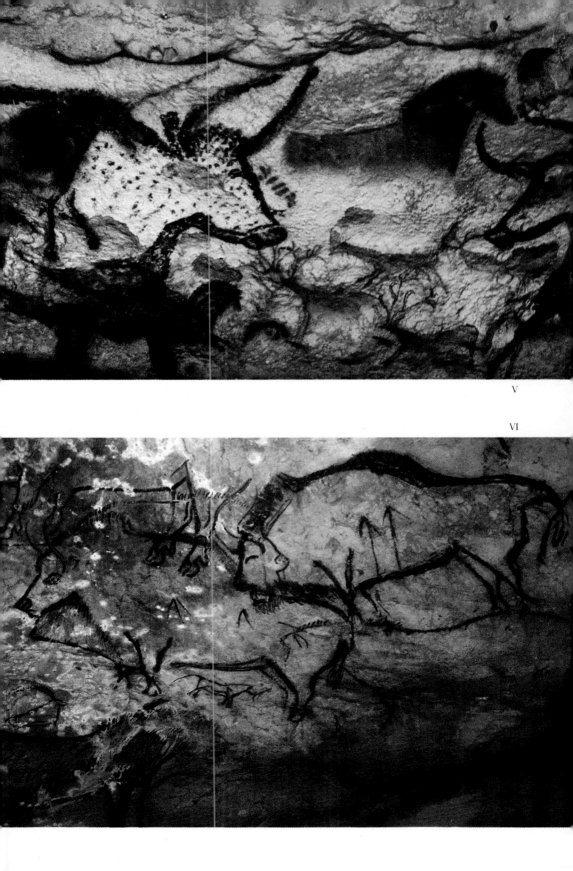

VII

VIII

and obviously Périgord is more accessible from Paris than are the Pyrenees or Cantabria. For many years of his life Breuil perhaps had no base more permanent than the Palaeolithic cave he was currently engaged in deciphering, but Leroi-Gourhan's suggestion that deep caves were abandoned in the latest stages of the Magdalenian is essentially a deduction drawn from the Perigordian evidence rather than, in this case, that of Cantabrian Spain.

Many authorities divide the geographical distribution of Palaeolithic art into more than three units, for while Cantabria and the Pyrenees each stand as single units, the group based upon Périgord is often subdivided and slightly differently grouped by different authors. Leroi-Gourhan (1968), for example, distinguishes a group in north and east France, a second comprising Charente and Périgord and a third for Quercy, while Lorblanchet (1974) follows the same general pattern but with more restricted boundaries. His first group centres on Vienne, his second on Périgord, his third on Quercy but he does not group the sites in north and east France at all; they are in fact very few. One of the characteristics of Palaeolithic art is that it shows surprisingly little regional variation; certainly there are regional characteristics but these are usually no more than modifications and Leroi-Gourhan himself points out that his divisions reflect the present state of documentary knowledge more than regional characteristics in the art. Slight differences tend to be overemphasized by defining small groups; for example, while it is geographically valid to differentiate Quercy as a separate region, stylistically it is much less so.

In fact mural art is found in other parts of south-west Europe besides the three major areas listed above, principally in the Rhône Valley, in the heel of Italy and in central and southern Spain. Again, there is divergence in the grouping of these sites. For Leroi-Gourhan each of the groups is a single unit, while Lorblanchet includes the most southerly Spanish examples with those from the Rhône and southern Italy in a Mediterranean group. There are arguments in support of either system but both neglect the connection between the sites in the Rhône valley and Périgord, or more accurately, Quercy. This is chronologically an early association apparently discontinued by the Magdalenian, but is nevertheless important. Altogether it is tempting to classify Palaeolithic mural art in groups, but the more groups are differentiated, the more are connections between areas ignored and if one considers the grouping of miniature art it is seen

VII Forequarters and head of a horse carved in low relief on the rock shelter wall at La Chaire à Calvin, Charente. The complete figure is 140 cm. in length. It is now badly corroded but the carving of the head may still be seen to be masterly

VIII Outline figure of a megaceros deer with a small cervid painted on its neck, a half figure of a man, stuck with spears, on its shoulder and an ibex on its flank, from Cougnac, Lot. The large deer is 150 cm. in length

not always to coincide with that proposed for mural art. In Magdalenian IV, for example, the miniature art of the Pyrenees and Dordogne is very closely connected. One might perhaps look for similar relationships between decorated caves in this period.

Périgord, however, whether as a single or multiple unit, is the classic area for Palaeolithic art and Les Eyzies, surrounded by decorated shelters, caves and low reliefs, has become known as the Capital of Prehistory. If you are energetic you may walk from here to Cap Blanc, Laussel or La Grèze; with a reasonable effort you may reach Font-de-Gaume and Combarelles, both deep caves, and with even the smallest exertion you may cross the river and consider the extraordinary abundance of Palaeolithic shelters along the banks of the Vézère. You may even sit in your hotel – one of many for this is a gastronomic as well as an archaeological centre – and look at the sites from your bedroom windows. Probably all were once decorated, for traces of paint, engraving and sculpture exist in many of them still.

It is a cliché in prehistoric archaeology that the Palaeolithic settlers in the Vézère sat in the sun outside shelters running along the cliff face above the present-day village and, from time to time, crossed the tributary valley of the Beune to create or use their sanctuaries at Font-de-Gaume or Combarelles. It is a happy conjecture, but no more, for we have no means of telling to which shelter or stage of occupation we may relate such caves, or how much they were used, or by how many people. We are subject to twentieth-century patterns of thought so that we presume that Cro-Magnon man would, if able, have chosen a site facing the sun, but a study of the orientation of Upper Palaeolithic sites such as has been done in the Pyrenees for example, does not support this idea, for there nearly all of them face north. We assume also that as we visit churches or shrines, so Upper Palaeolithic people visited their decorated caves, but we are perhaps as wide of the mark in this as in the matter of choosing the aspect of a living-site. We know virtually nothing about the use of deep caves, except that use hardly appears to have been made of them at all. There are no traces of big fires to light the galleries by, no blackening smoke or soot stains on the roof and almost no possessions left lying about. A few caves have footprints in sand or mud, but at Niaux, for example, in the Reseau René Clastres these belong to a few adults and children exploring on one occasion only, whereas one might have expected the floor to be trampled with hundreds of super-imposed footmarks. The footprints that exist are of bare feet and

it has been suggested (Lorblanchet *et al.* 1973) that these are found in places where people would normally take off their shoes. This poses further problems, for we have no idea whether these people habitually wore shoes or not. If Palaeolithic visitors to the caves came shod it would, of course, be much more difficult to identify trampled floors. In most caves such evidence was, in any case, lost long ago for the state of the floor was overlooked by early discoverers and twentieth-century man has himself since trampled the floors with shod feet. However, a few new caves have been studied in totality and some early discoverers, such as the Count Bégouën and his sons, did take care of the floor. The evidence we have in this context still suggests little use. When interpreters of Palaeolithic art talk of mime and dances enacted in front of the painted friezes they should consider how often they assume this to have happened over the millennia, how many torches were carried and how many people participated. In less than half a century of public visiting the walls of Font-de-Gaume have been changed from white to deep grey by the smoke of carbide lamps but although we think its period of use in the Palaeolithic covered many thousands of years it was not dirty when first rediscovered in the twentieth century; nor was Lascaux, nor Ekain in the Basque province of Guipuzcoa, both **IV** of which are caves that still have a beautiful white crystalline surface.

Equally, we do not altogether understand the chronology of cave decoration. There are caves that suggest a single-period use, in which all the paintings or engravings conform to a single style suggesting they were done over a period of days, weeks or perhaps at most a few years apart. This is comprehensible, but more difficult to understand are the caves with continued decoration. Although Breuil was incorrect in postulating two cycles of cave decoration he was right in claiming a certain amount of decoration as Aurignacian or Gravettian in date and it is not altogether confined to shallow daylit sites such as Pair-non-Pair. La Mouthe, for example, has a chamber ninety-four metres from the entrance decorated in unmistakably 'Primitive' style (Leroi-Gourhan's Style II), while other work in this cave, such as the famous drawing of a hut, belongs to a period many millennia later. Usually we have no means of dating cave painting or engraving except by stylistic comparisons, but such comparisons are clearly recognizable and valid. This Palaeolithic habit of adding an animal or two, or a new panel, at intervals hundreds, or even thousands, of years apart persuades

one towards Leroi-Gourhan's contention that caves were decorated to a known formula that was augmented from time to time, but always respected.

At present there are one hundred and twenty-seven caves known in Périgord itself with art of some form: in fact the majority of these (seventy) have miniature art pieces; of the remaining fifty-seven, seven are sculptured, twelve are painted and the remainder engraved. Amongst these fifty-seven sites with mural art perhaps fifteen are of major importance. A number of decorated shelters in daylit situations, such as Cap Blanc, Teyjat and Laussel are included in this figure; they comprise four of the fifteen, in fact, while the remaining eleven decorated sanctuaries are in deep caves. Outside this focal area, but here included in the same geographical group, there are twelve further important sites: this number includes the daylit sites described in the previous chapter. Seven of these twelve are in deep caves and the most important group is in Quercy. With the exception of Pech-Merle and Cougnac, two of the Quercy group, they are all attributable to Style IV, that is they are middle or late Magdalenian in date, but, as in Périgord proper, if you consider the daylit sites as well as those in deep caves, the bias towards the later period appears less great. Approximately half the sites of major importance in Périgord are attributable to Styles I, II and III, the other half to Style IV. This is a balance that is partly, though not wholly, determined by the numbers of daylit sites and it is not repeated in other regions where the majority of caves belong to Style IV. In west-central and north-eastern France eleven of the twenty-seven major sites are in daylit situations. This again is a proportion that is not known elsewhere, for it is only in this region that sculptured friezes occur. These figures are of necessity extremely arbitrary and are only intended to give a picture of the incidence of Palaeolithic art in this region.

The important sites, however, make up much less than half the total number known and it is of some interest to know what constitutes an inconsiderable, or minor, site. It may have a single engraving, or a group that is damaged, for instance. To give an idea of what has actually been found in a particular district we may look at the sites in the valley of the Petite Beune: this river joins the Grande Beune, on whose banks Cap Blanc, Laussel and La Grèze are situated, a kilometre or so above Les Eyzies, where they in turn join the Vézère. Eleven decorated shelters have been found in the valley of the Petite Beune, distributed

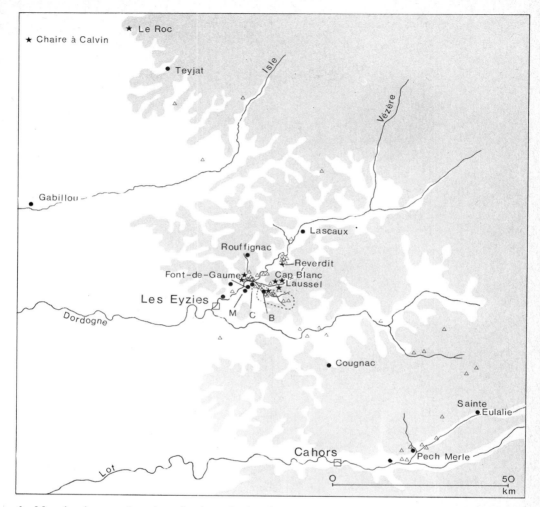

★ Chaire à Calvin

★ Le Roc

● Teyjat

Isle

Vézère

● Gabillou

● Lascaux

Rouffignac
★—Reverdit
Font-de-Gaume ★ Cap Blanc
★★ Laussel
Les Eyzies
M C B

Dordogne

● Cougnac

Sainte
● Eulalie

Cahors

● Pech Merle

Lot

O ⊢―――――――――――――― 5O
km

62 Map showing mural art sites of major and minor importance in central and western France. Rock shelters with low relief carving are marked by a star and the group of sites on the Petite Beune is enclosed by a dotted line. Other sites of major importance are marked by a dot, those of minor importance by a triangle. Contour: 200 m.

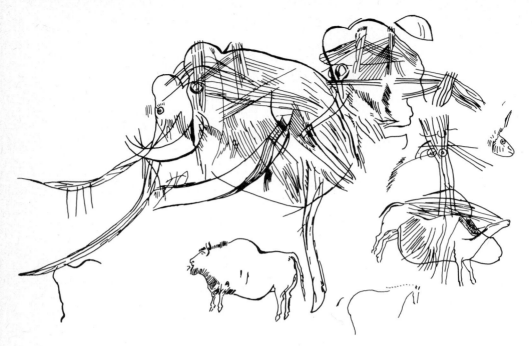

63 Engraved panel with mammoths and tectiforms from Bernifal, Dordogne. Length of panel 220 cm.

on either side of the river over a distance of about seven kilometres. Only one of these, Bernifal, is a cave of major importance and it is a deep cave while the majority of the lesser sites are daylit shelters. The shelters will here be described as they occur going upstream from the direction of Les Eyzies. Bernifal is, in fact, the third cave, but its importance allows it to be described first. This cave is about seventy metres deep and consists of three communicating 'rooms'; two side clefts open into the main gallery and it is decorated throughout. Painting in both black and red is found here as well as engraving and there is much utilization of natural shapes; the total result, however, is not spectacular for most of the figures are small. The first room has a mammoth, a bison's head in red and a group of negative hand prints, outlined in black. The second room has perhaps fifteen animals massed in a frieze but not all are identifiable; amongst these are a bison, a probable reindeer, a horse, four mammoths and five tectiforms, two of which, superimposed on an engraved mammoth, are very elaborate in design. One side cleft opening into this gallery has another comparable tectiform and a cleft on the other side has four more engraved mammoths. The main gallery continues with a bison, two horses, one mammoth and six further tectiforms and at the extreme end a possible bear and some black dots. Leroi-Gourhan attributes

a

b

64 *a* Engraved mammoth with triangular eye, similar to some figures from Bernifal and others from Rouffignac (Ill. 65). The mammoth is 57 cm. long. *b* Engraved tectiforms comparable to those from Bernifal (Ill. 63) the most complex tectiform here measures 26 cm. Both *a* and *b* are from Font-de-Gaume, Dordogne

this assemblage to his Style IV, both on grounds of style and inventory. He points out that the triangular eye of the engraved mammoths is a stylistic trick found elsewhere only among the later engravings in Font-de-Gaume and Rouffignac, a pleasing regional idiosyncrasy for the first of these caves is about two, and the second ten kilometres away from Bernifal.

The large shelter of La Calevie is (as stated above) a little downstream from Bernifal and thus strictly the first site in the series. Palaeolithic occupation debris was found at the entrance of the shelter and some engravings, comprising a panel of four horses and some other figures, may be seen by daylight on

65 Engraved frieze with horse and mammoths from Rouffignac, Dordogne. The right-hand mammoth, which has a triangle to mark its eye, measures 70 cm.

the back wall. The Grotte d'Archambeau is near La Calevie, but boasts nothing more than a negative hand in *red*: this is of interest, however, as it is one of only two such known in Périgord. The Nancy shelter (see Chapter 4) is across the river from these on the north bank; here in the first room there are two low relief sculptures, one very worn but one recognizable as a horse, and three engravings of ibex, bison and horse in the second room. Returning to the south bank, above Bernifal, there are the shelters of Bison and Sous Grand Lac. The Grotte de Bison, which owes its name to bone deposits found here, has traces of engravings and paintings, among them a negative hand in black, and the Grotte de Sous Grand Lac has two panels of very fine engraving, veiled with calcitic deposits. One panel shows an ithyphallic man surrounded by animals such as ibex, horse and bovids and the other a horse without a head; on this same bank is the shelter of Vieil Mouly II where it is claimed there are engravings on the wall, although this is badly decomposed by frost. All the remaining sites are on the north bank of the river, above Nancy. The first of these is the shelter of the Moulin de Beyssac with, again, very vague traces of engraving and painting, covered by calcite, amongst them a possible horse. The shelter of Beyssac itself comes next. This has the only other example, in Périgord, of a negative hand outlined in *red*. There are besides a few further traces of red ochre, but nothing more. The next decorated shelter (although it has entered the literature with a variety of names and locations) is the Grotte du Roc d'Allas, or du Mas, about a kilometre above the château of La Tour du Roch. The small engraving of a horse, described by Breuil has now been located by Roussot and others in the second hall of this cave and not in the cave beneath the château itself with which it has often been confused. Finally the shelter of Puymartin has some black painting, a possible engraved mammoth and some other curvilinear and criss-cross engravings, but all are difficult to decipher. This is not a very impressive catalogue, but in one respect it is very interesting because it contains all the known examples of negative hand prints in Périgord, with the exception of Combarelles, Labattut and Font-de-Gaume. Bernifal and the Grotte de Bison have negative hands in black; Archambeau and Beyssac the only two examples known in red. Combarelles and Font-de-Gaume are as near to Bernifal, Archambeau and the Grotte de Bison as is Beyssac and all are within a distance of five to six kilometres of each other; Labattut is outside this group, but only eight kilometres distant.

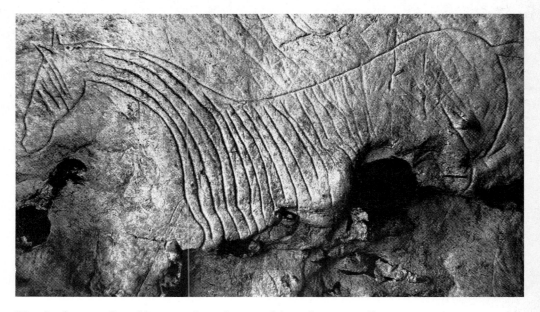

66 Engraved striped horse from Gouy, Seine Maritime. Approx. 40 cm. in length

Hand prints are found in a number of caves, although not usually in great quantity; Castillo in Cantabrian Spain with fifty examples and Gargas in the Pyrenees with more than one hundred and fifty are exceptional. The distribution of this motif is wide however; in addition to the Pyrenees and Cantabria, hand prints are found in caves in the Rhône Valley and in Quercy but, except for this group on the Grande and Petite Beune, they are rare in Périgord.

Since there are seventeen deep caves of major importance in Périgord and its surrounding regions it is obviously not feasible to undertake more than a selection here, and even amongst the selection mentioned only a few will be described. Most deep caves are relatively late and perhaps fairly confined in date also, so that the examples mentioned here range from the Solutrean to the late, or latest, stages of the Magdalenian, depending upon whose attributions you favour – Pech-Merle and Cougnac in Quercy are stylistically early in this sequence, Lascaux and Le Gabillou are central and Combarelles, Font-de-Gaume and Rouffignac are the most recent. Of the three caves farther north, Arcy-sur-Cure in the department of Yonne and Gouy near Rouen are probably the most recent (Magdalenian), and La Dérouine, in the department of Mayenne, the oldest, that is Solutrean. Breuil considered that some of the work in Pech-Merle was Aurignacian because there are hand prints and finger drawings here, both of which he classified as early features. In

fact it is not possible to rely upon either of these as chronological indicators and Pech-Merle is now more generally accepted as Solutrean. From the point of view of style it is interesting to look at the animals in this cave and in Lascaux, the suggested stage for which is Magdalenian II or III, and compare them with the low relief friezes: the distended bodies and small heads are very similar.

Pech-Merle is near Cabrerets, in Quercy; it is open to the public and it is a spectacular cave, worth visiting as much for its stalagmitic formations as for its paintings. Two periods of decoration have been recognized here, on stylistic grounds; both occur in the main gallery and in its side chambers but in the adjoining gallery of Le Combel only the earlier is represented. It is probable that the original entrance to the cave was through this second gallery for the alternative route, discovered by the Abbé Lemozi and André David in 1920, is long and extremely awkward. Also the route used in 1920 brings the visitor into the later-dated gallery before the earlier, which is in contradiction to the usual pattern of cave decoration. Nowadays one enters by way of a modern cutting, leading straight into the main hall and Le Combel is closed to the public. However, its decoration demands at least a brief description. Starting from the extremity of the gallery, where the Palaeolithic entrance is thought to have been, there are in succession a small chamber on the left with quadrangular signs formed by dots and then a small hall with stalactites, shaped like breasts, hanging from the roof. These have been daubed with black paint. In this same hall there is a line, or procession, of four ludicrously large-bodied animals with

67 Two spotted horses in black paint and a series of negative hands, outlined in the same colour, from Pech-Merle, Lot, each horse measures approx. 160 cm.

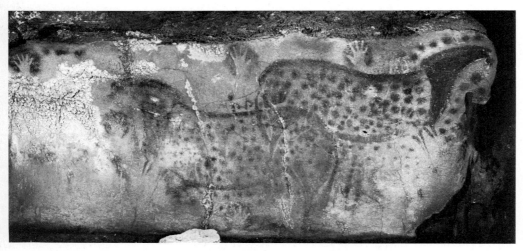

68 'Macaroni' drawings in the mud film covering the underside of a rock slab from Pech-Merle, Lot. Among many indecipherable lines is the figure of a woman, 55 cm. high, at the bottom of this picture

miniscule heads; one of these has a shoulder hump, another a corkscrew tail. A further small chamber on the left has two horses in a similar style, though less exaggerated, an unfinished bison, a feline and some rows of dots. There are also a number of hand prints in red in Le Combel, as there are in the main hall of Pech-Merle itself. Here they are found in a side chamber called the ossuary because, when discovered, it was filled with cave-bear bones. The engraving of a megaceros deer and other drawings in this same chamber, mostly unfinished outlines and meanders, are also considered early in style; so is the famous panel of dotted horses which is adjacent to the ossuary, but the remaining six or so decorated zones in this deeper part of the cave are of later date. The dotted horses echo the style of the 'procession' in Le Combel, being quite unrealistic with tiny heads attached to huge bodies, but also, like these others, they are executed in a very elegant manner. There are two horses in this panel, each about one hundred and sixty centimetres in

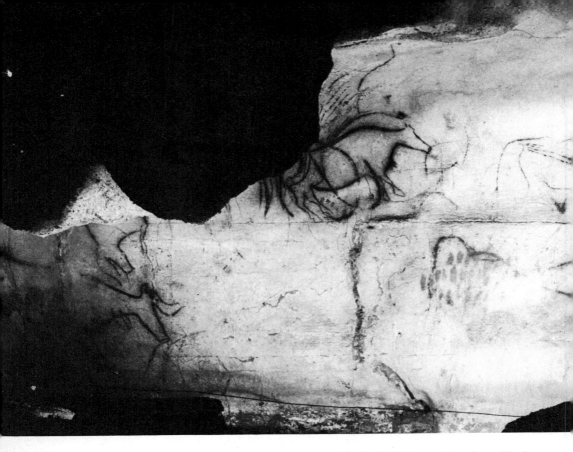

length, standing back to back and slightly overlapping. Their heads and necks are in solid colour, their bodies are filled in with fairly large dots which are scattered about beneath their bellies as well and, in the case of the right-hand animal, used as a decorative emphasis around its head and neck. Six stencilled negative hands in black are arranged round these two figures and a large fish, most probably a pike, is painted in red over the body of the right-hand horse. A little more painting in red exists also, not easily identifiable. Unrealistic animals are not without parallel in this region; Lascaux, Le Gabillou and Pergouset all have them but while composite animals are known in other regions, unreal animals are not.

This main hall at Pech-Merle is large, measuring approximately one hundred and forty metres by twenty-five and there are huge fallen slabs piled up in the centre which you walk around and, in some places, over. The undersides of some of these blocks coated, by nature, not man, with a thin film of mud are covered with a quantity of engravings, presumably done by hand or with a stick. These are mostly chaotic jumbles of lines but a few figures emerge, amongst them several mammoths and

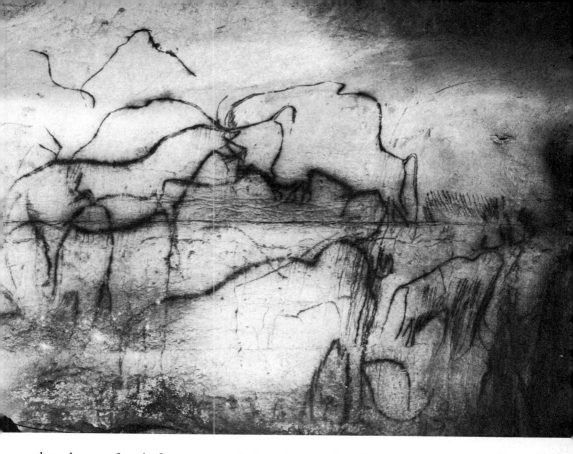

three human female figures, one of whom has pendant breasts that are reminiscent of the stalactites in Le Combel. Opinion is divided in dating these drawings but, from the occurrence of a typical Magdalenian radiating-line motif they may be considered as belonging to the later group.

The most considerable panel in the later assemblage at Pech-Merle is that designated as the 'Chapel of the Mammoths' which covers a wall space about three metres by seven on the side of the hall opposite to the dotted horses. This fresco, in black outline save for two figures and some dots in red, comprises ten mammoth, four or more bison, four oxen and three horses opposed and superimposed, some of which are drawn completely and others only indicated by a line or two. Although the style is freer and more naturalistic the linear quality of these figures has an affinity to the earlier outline drawings in this cave and exaggeration still appears. In this instance it is used in depicting the bison with huge overshadowing forelocks that fall over their faces in a quite unrealistic manner. Mammoth and bison appear juxtaposed five times in this panel and Leroi-Gourhan thinks that these species are here consciously paired and show the

69 Frieze of bison, oxen and mammoth in black outline in the 'Chapel of the Mammoths' from Pech-Merle, Lot. The small mammoth at the right-hand end of the frieze is 60 cm. long

fundamental opposition of male and female but it is, as always, difficult to decide conclusively on this question of paired animals. Other things about these figures are interesting, for example a number amongst them, one ox and one mammoth in particular, are marked by arrows or gashes and two animals are drawn vertically. The ox appears to be falling but the mammoth is a classic example of a quite common element in the formula of panel layout; that is an animal drawn as if in a horizontal position but placed vertically. In the middle of this black fresco, confused with heads of both horse and bison, is a tectiform of a very idiosyncratic type, usually described as 'brace-shaped'. Another of these occurs in the 'chamber of the wounded man' with other paintings in red, notably an ibex, a bull and the man himself. He has a rather prognathous profile and is drawn bent forward, or running, and lines protrude from him in all directions. These are generally described as spears and they appear to be stuck into him, but it is perhaps possible that he is carrying them.

This association of a 'wounded' man and brace-shaped signs is repeated at Cougnac, another very beautiful and more recently discovered cave in Lot, about thirty kilometres from Pech-Merle. At Cougnac, however, they do not form a part of the same panel; a group of brace-shaped signs is placed on an overhanging wall near the entrance, while three wounded men occur in the main painted frieze. Even an association of this degree is rare between caves and it gives an unusual confirmation that these two sanctuaries are contemporary. They are close in style also; that is, the style of the later period at Pech-Merle, for Cougnac is a one-period cave. The most notable figures at Cougnac, in the principal frieze, are three big megaceros deer whose small heads and humped shoulders recall the early-style procession in Le Combel, some ibex, rather solid and square in shape and the three spear-stuck men; one of these is in fact only the lower half of a body but the other two are complete. One is upside down, the other is bending forward and is painted in black within the outline of a red mammoth. There are three further human figures in Cougnac but of a simplifed 'ghost' type that is quite common elsewhere.

To return to Pech-Merle there is, in the main hall, one remaining panel of considerable controversial interest. This is the panel of women/bison, consisting of a group of twenty red dots, a mammoth and eight small silhouettes, also in red, painted under the overhang of a huge fallen block. The eight small figures are all highly schematic and range from bison silhouettes

44

VIII

VIII

III

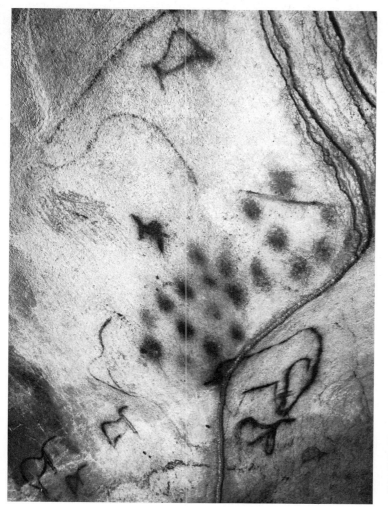

70 Panel of women/bison and dots, all painted in red. Pech–Merle, Lot. Each of the woman/bison figures measures approx. 10 cm.

to an outline that is very reminiscent of the woman with pendant breasts drawn on the ceiling nearby. The Abbé Lemozi, who made the first study of this cave, described these paintings as bison, as did Breuil (the raised tails being characteristic of the species, in his opinion), but Leroi-Gourhan sees in them an important association of bison with woman and a transition from one to the other. Though this may be so, it is possible that this sequence was not drawn deliberately but was an inspired doodle. It may have had great significance, or the significance we see in it may be quite accidental. It remains, however, a remarkable exercise in schematization, suited to a cave where naturalism is often abandoned in favour of exaggeration.

A variety of themes, species and styles is characteristic of Leroi-Gourhan's Style III in mural art. Pech-Merle falls happily into this category and Leroi-Gourhan considers that both stages of decoration here should be placed after the Gravettian and before Magdalenian III. Cougnac corresponds to the later part of this period, and Leroi-Gourhan suggests it is early Magdalenian in date, but it might equally be late Solutrean. The problem of the Solutrean/Magdalenian transition is the same here as it is in low relief work. Breuil thought little of the artistic ability of the 'Solutreans' and allowed them almost no painting, although he was forced to concede some excellent low relief work to them (Le Roc), but there is no reason to perpetuate this bias. In fact the nomenclature probably tends to personalize such groups too much. No characteristic tools were left in the painted galleries and we have no means of determining whether the people who painted these caves used a technical assortment of Solutrean tool types or Magdalenian, though Solutrean forms are most numerous in the locality. As people they probably differed little and, as we know from the art, one religious concept was universally accepted.

For Breuil the great importance of Pech-Merle, apart from its intrinsic interest, was that it represented the high point of his Cycle I (the Aurignacian Perigordian cycle). The abandonment of a two-cycle system and the revised dating of Pech-Merle does not really change its position; it still remains, with Lascaux, the most spectacular pre-Magdalenian IV cave in France. This is not the same as saying they are the most important caves in Leroi-Gourhan's Style III, in which he includes only the early cultural phases of the Magdalenian (I and II). Leroi-Gourhan includes Magdalenian III and IV in his classical art phase, Style IV, but many archaeologists, following Breuil, consider that a notable divide exists between Magdalenian III and IV rather than where Leroi-Gourhan puts it, between II and III. More than eighty per cent of miniature art pieces belong to the periods of Magdalenian IV, V and VI, less than twenty per cent to all the earlier periods together (Aurignacian, Gravettian, Solutrean and early Magdalenian) and, although the disparity is not so marked in cave painting, it does echo this pattern, for most deep caves belong to the period of Magdalenian IV or later. These classifications are perhaps more of a problem in the Pyrenees and Cantabria than in Périgord and will be discussed in a later chapter, but here it is relevant to say that Breuil's view of Palaeolithic art as following a steady, slow progress until a

9

sudden *floruit* occurred in Magdalenian IV remains substantially correct. It applies to miniature art throughout the Franco-Cantabrian area and in mural art it fits the Pyrenean evidence and probably the Cantabrian, although the elucidation of archaeological and art stages here is difficult. It is, however, less imperative in Périgord (and it is relevant that Leroi-Gourhan's work is based upon this region), where there are substantial sanctuaries of Solutrean and early Magdalenian (pre-Magdalenian IV) date: for example, Le Roc, Angles, Lascaux and Pech-Merle. Even here, however, the vast majority of deep caves cannot be dated to a period before Magdalenian IV. As we have seen, it is the occurrence of open-air sanctuaries, particularly those with low relief sculptures, that alters the situation in Périgord, giving an important emphasis to the earlier stages which they do not receive elsewhere.

Leroi-Gourhan would place Lascaux in Magdalenian II and thus within the confines of his Style III, a date which is supported by the radiocarbon dates obtained from charcoal found in the cave. However, a piece of charcoal found on the gallery floor is not actually a painting and the stylistic associations of Lascaux are at least as, if not more, important when attempting to define its chronological position. It has clear affiliations to the later phase of Pech-Merle and Cougnac, but is also evocative of Le Roc and Angles, having figures with voluminous bodies, a rocking-horse stance and diminutive heads and legs; while, on the other hand, the use of polychrome is found elsewhere only in caves of a date later than any of these. On these grounds one might equate Lascaux to any stage from the late Solutrean to, and including, Magdalenian III. To insist that a cave belongs to Style III or Style IV, or is Magdalenian II or III in date is obviously unrealistic, for caves have no obligation to fall into neat categories; rather, as one might expect, they seem to follow a continuous gradation in style and a very fine example in any one period may anticipate the general characteristics of the next.

Lascaux is probably the most famous of all Palaeolithic caves and has a claim to be the most beautiful also. Originally it may have had rivals but today its state of preservation makes it unique. It is near Montignac, in Dordogne: it was found by chance during the war, opened to the public in the late 1940s and closed, nearly twenty years ago, because the temperature and humidity changes caused by a great number of visitors threatened to ruin it. Extremely careful chemical treatment and

monitoring of its interior climate have saved the paintings, but there is no prospect that it will be opened again. It now belongs to the nation and its previous owners are considering building, or perhaps more appropriately digging, a replica for the public to visit. These details may seem irrelevant, but they are its modern history and are mentioned here in extenuation. In a book such as this it seems more appropriate to describe caves that may be visited, rather than those that may not, but it is essential to have at least a short description of Lascaux and it is quite comprehensively published.

Lascaux is a small cave, (hence the difficulty in ventilating it and controlling the temperature), consisting of a main hall that is approximately thirty metres long by ten wide with two further galleries beyond, and it is more densely decorated than any other known Palaeolithic sanctuary. Much of the wall surface has a natural coating of white crystalline calcite and this is covered with paintings in red, brown, black and yellow, or polychrome combinations of these, producing a marvellous effect. The abundance of decoration is one reason for this visual impact and the other is perhaps the impression of movement that the paintings give. This is rare in Palaeolithic sanctuaries; the figures at Niaux for example are typically static, even if one finds that their static quality has a suppressed vitality, whereas at Lascaux ponies trot, cows gallop, even leap, deer move in line and bison confront one another. The extreme difference in size of the animals in a panel adds to this effect. In fact, the state of preservation even here is not perfect: in one section, the passageway to the Nave, the paintings have been eroded by damp and in the main hall (the Rotunda) large sections of the wall and ceiling have fallen but the paintings that remain have kept all their colour and sharpness, in contrast, for example, to Altamira where the polychromes are all equally faded.

Lascaux is considered to be a typical one-period cave, and it is obvious that the decoration of the main hall, for instance, was conceived as a single unit, but this does not preclude superimpositions and the use of different styles. Style varies according to the animal depicted: for example, in the main hall the largest, and probably the first, figures are five bulls in black outline, reinforced with a little shading of the same colour, the most complete of which measures five and a half metres. Interspersed among these are some oxen, half their size, in solid red colour; some very delicate deer, much smaller again, in red or bicoloured shading, and some small ponies in a dense brownish

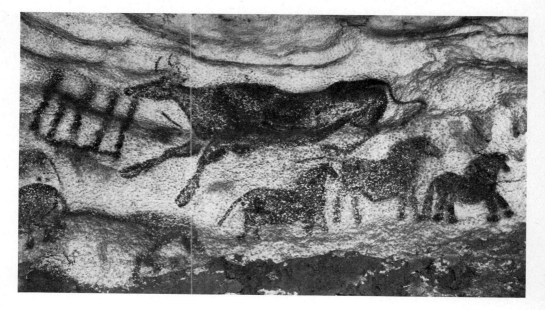

71 The leaping cow from
Lascaux, Dordogne. This
is painted in black and red
wash, the ponies below
predominantly in black.
The cow is 170 cm. in
length

black that have rounded bodies, blob feet and a rocking-horse stance that is quite different from that of any of the other animals. These last are painstakingly done and their execution has nothing in common with the large bulls which are inspired sketches. In fact the vitality of the drawing in Lascaux seems frequently to run away with its proportions. Artistically this is a gain rather than a loss for the exaggerations are all essentially those most applicable to the animal. For example, a cow with a long back, deep chest, a long swinging tail, delicate legs, neck and head, with long, forward-curving horns, is more, not less, cowlike. In some cases the audacity of the painter is considerable; the 'leaping' cow in the axial gallery, for instance, is drawn as if seen half from below with both hind legs drawn up towards its body in a position that one would think could only be caught by photography. It is not anatomically quite correct, but it is very effective.

The Abbé Glory said he could identify the hands of eight different artists in Lascaux. One would not disagree with this, the only problem is whether one is to consider them as successive decorators of the cave or as specialists working simultaneously. The unity of decoration in the cave suggests a short time span but the species represented cover a range of climate and habitat from temperate forest to extreme cold and could perhaps indicate a longer period of frequentation. Reindeer and musk-ox which are native to a sub-arctic tundra are here each represented

17

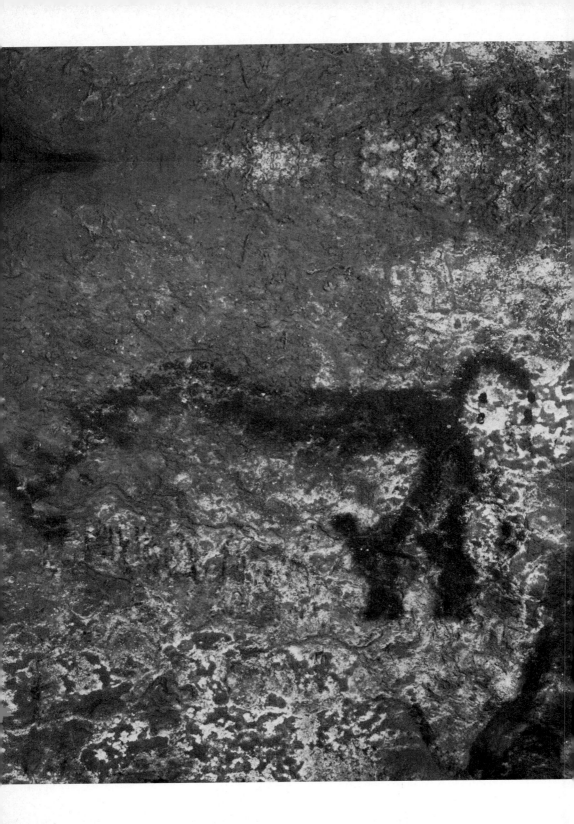

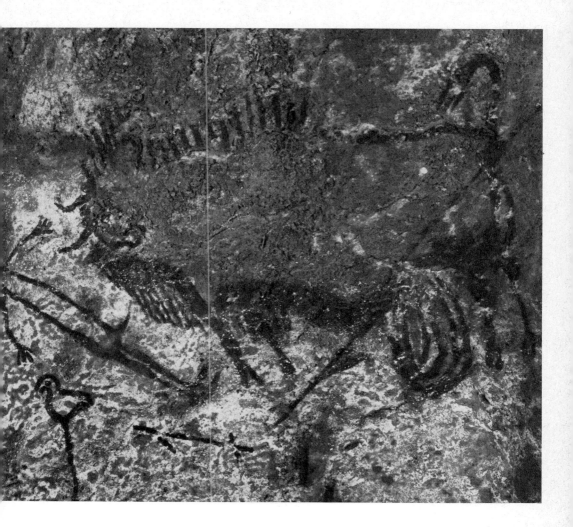

72 Figures painted in black outline from the pit at Lascaux, Dordogne. The prostrate man, the disembowelled bison and the rhinoceros are presumed to be part of a single scene, but the stylistic differences between rhinoceros and bison are considerable and there may be no anecdotal relationship between them at all. Width of panel 185 cm.

by a single engraving only, both among the latest made; the remainder of the fauna, horse, oxen, bison, deer, bear, felines and ibex, is either native to a cold/temperate environment, or else, like the ibex, relatively adaptable. If the identification of the rhinoceros as a warmth-loving species (*Rhinoceros merckii*) is correct, then this creates a more considerable problem. Its identification is not at all certain, however, and the most recognizable of the two examples in Lascaux is in any case removed from the rest of the cave as much by style as in location. This is one of the figures in the pit scene, the pit being a small gallery, reached from the floor of the apse by a vertical shaft about seven metres deep. Here, on the wall, drawn in black outline are a rhinoceros, a bird-headed man, lying prostrate, a partially disembowelled bison which is still standing, although wounded, and two devices, perhaps a bird token and a weapon. There are also several series of dots and the unfinished outline of a horse, but the panel defies any analysis except by imagination.

In addition to the paintings there are an enormous number of engravings in Lascaux; these are found interspersed with the paintings in the Nave (the right-hand gallery), in the passageway to this gallery and in the apse that opens off this where there is a tremendous confusion of superimposed engravings, as yet unpublished though the Abbé Glory deciphered fifteen hundred in his lifetime. Many of the engravings, particularly those of ponies and stags, are beautiful. As for signs, a quadrangular
39 form, like a chequerboard, is peculiar to Lascaux but is not the only type represented: there are other quadrangular and brace-shaped forms as well as strokes, dots, crosses and barbed shafts. Such a quantity of signs is more typical of Pyrenean or Cantabrian caves than of those in Périgord and it is interesting that Lascaux has, in addition, a group of claviform signs. These are sometimes claimed as the only examples known north of the Pyrenees, but in fact they occur at Ste-Eulalie also (see Chapter 4) which, perhaps significantly, is again a site with an exceptionally high proportion of signs, and also at Combarelles and Rouffignac.

A number of animals at Lascaux are marked with, or accompanied by, arrows or barbed signs: these may be painted, or subsequently engraved over a painted figure. There are also a falling and a headless animal, features that one comes to regard as almost compulsory in the layout of a painted sanctuary. It was from a study of Lascaux, which is clearly decorated as a unit, that Leroi-Gourhan and Annette Laming developed their theories of layout. In other caves one could easily fail to detect an organized

73 Engraved head of a stag with fine antlers, Lascaux, Dordogne. Height 50 cm.

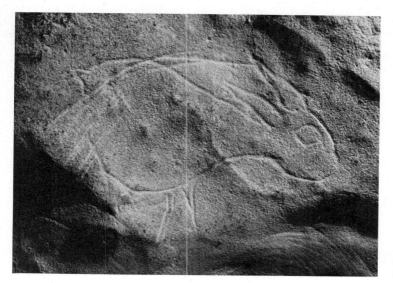

74 Engraved hare from Le Gabillou, Dordogne. 23 cm. in length

spatial plan, or deny that such existed, but in this cave it is inescapable and one may claim that the discovery of Lascaux prompted a reappraisal of Palaeolithic art.

As has been stated above, from the earliest stages to the latest, the content and layout of Palaeolithic art are remarkably uniform but this uniformity is not necessarily greater within any particular region or period than it is between differing ones. For example, one may compare Lascaux with Le Gabillou, near Sourzac (Dordogne) which on stylistic grounds, is considered to be contemporary. While Lascaux is essentially a painted cave with a clearly recognizable layout of large figures, Le Gabillou consists almost totally of small engravings and the layout is one of the least easy to reconcile with Leroi-Gourhan's concept of repeated panels. This cave consists of a single narrow gallery, about thirty metres in length, with a habitation deposit at the entrance and engraving throughout, although the figures nearest the entrance are now largely destroyed.

The inventory of animals in Le Gabillou, as is usual in Perigord caves, is quite large; there are horses, reindeer, bison, oxen, felines, cervids, ibex, some people (one resembling a woman in a garment like an anorak and one a masked man), some bears, two hares, a bird and five unreal animals, amongst them one with a giraffe's neck. There are more than two hundred engravings, few exceeding thirty centimetres in length: their preservation is good and they are lively in execution; as at Lascaux (but few other caves), the figures are full of movement

and they trot, leap and gallop from their position on the wall. The majority of the engravings are simple outline drawings of a certain originality: for example, one bison is drawn in profile with its head in full view, while another shows a variation of the same position, its horns at least being drawn frontally. Dr Gaussen, who studied the cave, thought that the numerous flint picks found in the gallery had been used to dress the wall surface before engraving; certainly the figures are distributed in every smooth zone and these may well have been partially prepared. Signs are numerous in this cave and both in quantity and type show a similarity to Lascaux; in particular Le Gabillou has a variant of the compartmented rectangle and there are brace-shaped signs, single-sided barbs, crosses, strokes and dots. Controversy exists, however, with regard to the layout of this cave. Leroi-Gourhan thinks that the basic theme of bison/horse may be seen to be repeated in zones throughout the cave, every large surface having an AB composition of animals (that is, horse and bovid) and every constriction in the gallery between these having passageway animals, such as ibex and related signs, but this is a subjective analysis for there are really no appreciable constrictions in Le Gabillou. One may accept Leroi-Gourhan's repetition of themes but in this case one must accept that it was applied arbitrarily and was not here determined by the topography of the cave.

Le Gabillou is a constricted, if beautiful, cave that is not open to the public but Font-de-Gaume and Les Combarelles near Les Eyzies may both be visited. The first of these caves is painted, the second engraved and both may be considered, on stylistic grounds, as a little more recent in date than Lascaux or Le Gabillou. Font-de-Gaume is a tall, narrow cave notable for a series of friezes of animals, principally bison, painted in polychrome. These are almost all outlined with a fine engraved line, reinforced by a heavier one of black paint and coloured in with red or a darker tone of mixed red and black. In style they may be said to be quintessentially 'Classical', static, formalized and beautiful. In addition there are black and red outline figures, earlier in date and, although this is predominantly a painted cave, a few engravings, such as the mammoths with a triangular eye, related to figures at Bernifal and Rouffignac, which are found cut upon the polychrome bison.

In all there are just over two hundred figures in Font-de-Gaume, comprising both animals and signs, which is a relatively modest number for a major cave. Some of these have been

IX Small horse with conventionalized coat markings shown by hatched shading from the Salon Noir in Niaux, Ariège. Length 30 cm.

64

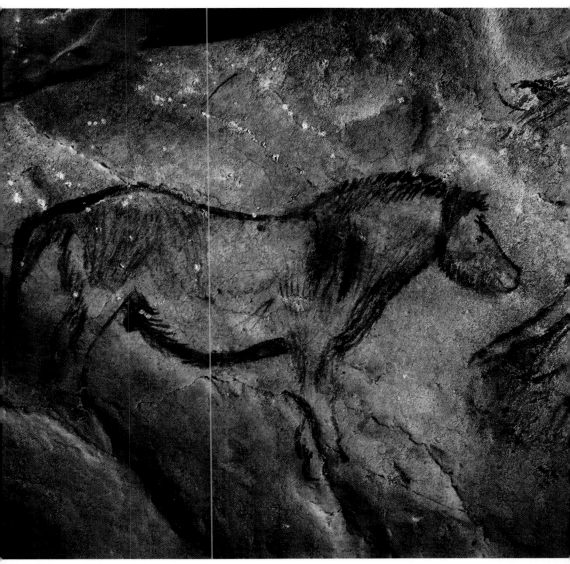

IX

X

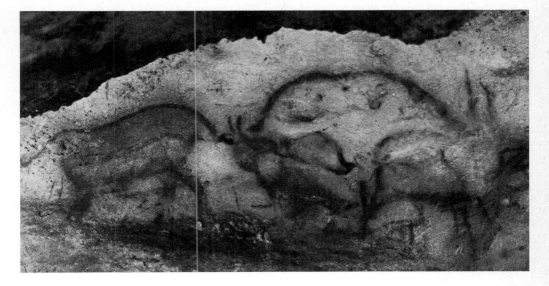

obscured by calcite and all are a little faded, although not yet ruinously so. A frieze of bison at the back of the cave has recently been cleaned by having a skin of mud removed and they are much more vivid than, for example, the famous pair of reindeer, one of which is kneeling, in the main gallery, although these are painted in the same manner and are presumably of similar date. At the beginning of the principal right-hand gallery there is a group of reindeer with fine antlers partly hidden by calcite and, further on among other figures, two ponies that are constructed upon the shape of stalagmitic formations. Conversely in the 'chamber of small bison', at the extremity of the main gallery, one bison has been shaped around the depression formed by a hole in the rock. In fact many of the bison in the main gallery frieze also utilize the shape of dips, in contrast to Altamira, for example, where positive relief gives them their form. Font-de-Gaume is considered to be a cave with a long history of decoration showing figures of successive periods from Style III to late Style IV; for example, the 'chamber of small bison', filled with black outline drawings on a red ground, is early, while the polychrome friezes are late. Certain superimpositions may be clearly seen, in particular on the left wall of the main gallery where the polychrome bison are painted over early deep engravings of bison and reindeer and themselves form the ground for later engravings of mammoth. Bison, horse, mammoth, reindeer, felines, oxen, a few rudimentary humans, a rhinoceros, a stag, a wolf and a bear are represented here; there

75 Reindeer, which now lacks a head, facing a bison painted in black, Font-de-Gaume, Dordogne. Length of reindeer, 100 cm.

X Sketch of the grand panel in Tito Bustillo, Asturias. At the top there is a horse's head, below this one engraved horse facing left and four painted horses facing right, all with carefully shaded coats and one with striped legs. Below these again there are, at the left of the picture, a number of tectiforms and two reindeer facing each other, with a third reindeer further to the right. Finally there are two deer facing each other at the bottom right hand limit of the panel

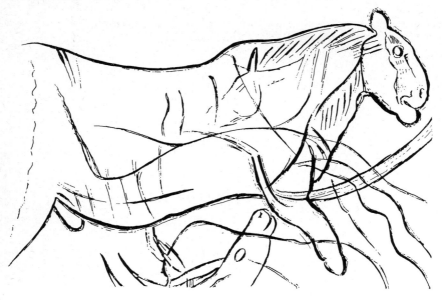

76 Engraved lion and heads of other animals from Combarelles, Dordogne. The complete figure of the lion measures 68 cm.

are also negative hand prints in black and quadrangular and numerous tectiform signs, these last being very like those at Bernifal.

Font-de-Gaume is a high, if not very wide, cave. Combarelles however (like Le Gabillou) is extremely constricted; it is narrow, low, lengthy and cold, or rather humid, which makes one feel cold. There is no reason, though, to think that the humidity may have ruined paintings once made here, for there are two tectiforms in red and two animals and a negative hand print in black, showing that the dominance of engraving is due to choice, not accidental preservation. Because engravings are difficult for the unaccustomed eye to appreciate, the visual impact of Combarelles is far less than that of Font-de-Gaume or Pech-Merle, although the engravings themselves are often beautiful, in particular those of the horses. A lion and a reindeer found here are much photographed, or reproduced from Breuil's copies, which are in fact extremely faithful, but these animals are in a minority. Ibex, bison, cervids, mammoth, a rhinoceros, bears and a number of human figures are also drawn but it is really a horse-dominated cave: a hundred and twenty of the two hundred and fifty decipherable figures depict horses.

The figures in Combarelles are found sporadically from a point seventy metres from the entrance and in greater numbers from about a hundred and sixty metres to the back of the cave, where it becomes waterlogged at two hundred and thirty-seven metres. The gallery has sharp bends and a narrow tunnel in the

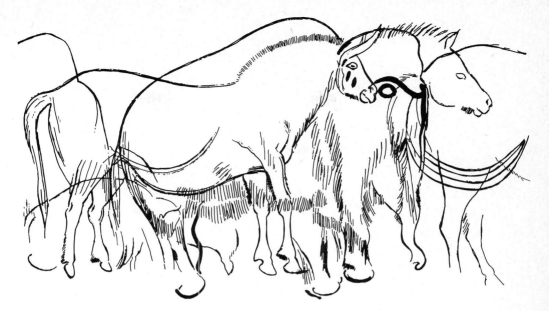

77 Engravings of mammoth and horses superimposed, Combarelles, Dordogne. Length of panel 130 cm.

middle, dividing the 'outer' from the 'inner' section. Both a deep cut and a delicate line of engraving are employed here, presumably having a chronological difference, but it cannot be very great for stylistically all the figures fall into Leroi-Gourhan's Style IV. More specifically, since Leroi-Gourhan includes the earlier stage of Magdalenian III in his Style IV, they may be ascribed to the stages of Magdalenian IV and perhaps V. There are a great many series of simple engraved lines that add up to nothing comprehensible, usually found below or between the panels of recognizable animals, which are often superimposed, and there are signs including tectiforms, lattice and quadrangular shapes and a motif unique to Combarelles, an oval with a line through the centre. A group of three feminine figures in profile is in style very like certain figures of late Magdalenian date found in miniature art, engraved on plaquettes.

Leroi-Gourhan considers Combarelles as a classic example of repeated figure groupings determined topographically. The basic combination is bison/horse, with mammoth and reindeer in a secondary affiliation. This combination is basic to Font-de-Gaume also and, without the reindeer, to Bernifal, La Mouthe, Rouffignac and Pech-Merle. At Combarelles Leroi-Gourhan finds it repeated fourteen times, with an ox/horse combination repeated twice. Constrictions and sharp bends in the gallery demarcate the zones, and animals such as bears occur in the passageways between. As at Le Gabillou it can be said that the zones are more subjective than self-evident but, although you

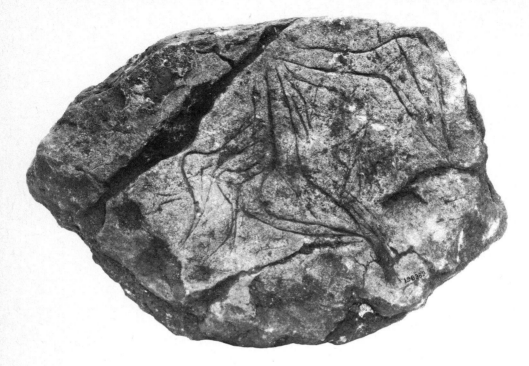

78 Stone block with schem-
atized female figures
engraved on it. La Roche,
Lalinde, Dordogne.
Length of block 37 cm.
Field Museum, Chicago

may disagree with the zonal demarcations, you cannot altogether dismiss the repetition of themes.

The paintings and engravings in Rouffignac (the Grotte de Cro de Granville) near Fleurac are a comparatively recent discovery, although the cave has been known to local visitors and speleologists for centuries. It contains ten kilometres of galleries and you may travel around some of the decorated sections that occur about three hundred to eight hundred metres from the entrance on a miniature railway. Drawings of mammoth are very numerous in this cave and friezes of these animals, painted and engraved, are arranged in line; also a frieze of rhinoceros in black outline, but the principal concentration of paintings is found on a ceiling in the left-hand gallery. There are thirty-seven figures there including bison, horse, mammoth, ibex and rhinoceros and all but the last species are represented by one particularly large drawing amongst other smaller ones, a characteristic not confined to Rouffignac but comparatively rare. In general this cave has very few signs and a great many zones decorated with meanders; the signs however are definitive, for both tectiform and claviform occur. The engraved bison at Rouffignac are like those at Font-de-Gaume and Combarelles,

65, 48

47
2

the mammoth again are like those at Font-de-Gaume and 65, 64
Bernifal (those with the triangular eye) so that, in spite of a
certain individuality in the proportional content of species
shown, it is relatively easy to date Rouffignac, for it must belong
to the same period as Font-de-Gaume and Combralles, that is
Magdalenian IV – V. In style, however, it seems to owe more
than these do to the low relief tradition in Périgord. It is not
unique in this; for example, the large-bodied cows at Lascaux are
evocative of the carvings at Bourdeilles, while at Rouffignac one
can see a reappearance of the squat, heavy figures of Le Roc de
Sers. This is more apparent in the depiction of some species than
others; it is particularly clear, for example, in the ibex. Those at
Rouffignac are very like those at Cougnac, also constructed on a 79, VIII
square block, and one may conjecture that both derive their shape
from low relief examples. Disproportionately large distended 16
bodies are, it is true, an early feature everywhere but seem to be
perpetuated, in certain sites at least, for longer in Périgord than
elsewhere. As we know, although the majority of rock-cut friezes
were sculptured in the late Solutrean and early Magdalenian, the
sites they are associated with were often occupied in later

79 Two ibex and part of a
mammoth on the ceiling
at Rouffignac, Dordogne.
The lower ibex measures
approx. 50 cm.

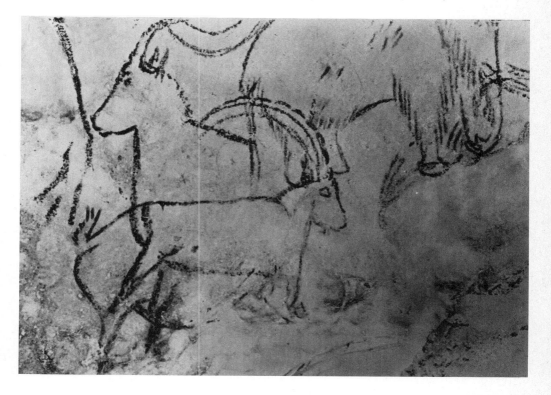

periods. Their image was still present and was, it seems, still influential upon mural artists of later periods. Animals with disproportionate bodies are not found in Magdalenian IV sanctuaries in the Pyrenees or Cantabria and when they occur at Rouffignac, for example, at this stage, one may regard them as a local tradition.

If the question of layout appears to have been neglected in this chapter, and any detailed discussion of Leroi-Gourhan's fan-shaped spatial design omitted, it is deliberate. One can prove, or contest, this theory with the heterogeneous caves of Périgord but it is much better demonstrated in the 'classical' Magdalenian caves of the Pyrenees and Spanish Cantabria; these form the material of the next chapters. However, the best source for his theories are obviously his own works. (*Préhistoire de l'art occidental* is published in English under the title 'The Art of Prehistoric Man in Western Europe'; other more recent articles are available only in French.)

6
The Pyrenees and Cantabria: 1
The Central Pyrenees

Having, in the previous chapter, discussed the unity or divisibility of the Périgord art group, we may now examine the Pyrenees and Cantabria. These are generally classified as two separate areas; the French sites in the central and west Pyrenees forming one group and the Spanish sites, whether Basque or Cantabrian, another. The line of division coincides with the frontier. However, at present, the only real gap in distribution is between the west and central Pyrenees. The sites in the Basque provinces on either side of the border form a unified group and it is difficult to justify attaching some of them to the French central Pyrenean group and others to the Spanish Cantabrian. Three groups could be distinguished but the division between the Basque and Cantabric regions would be quite arbitrary and it is preferable, since all three groups have more in common with each other than with Périgord, to count them as one. This may be subdivided for convenience, or with regard to date, for minor groupings that are apparent in one period sometimes differ from those in another. The closing of the gap between Spanish and French Basque sites is due largely to recent discoveries for in the past decade more than a dozen sites have been found in districts previously considered empty. Distribution maps compiled in the nineteen-sixties, for example, show no sites between Isturitz, near Hasparren, and Santimamiñe, near Guernica, a distance of a little over a hundred kilometres, but latterly both decorated caves and sites with miniature art have been found in this region at Cestona and Aya, near San Sebastian and near Urdax, on the frontier.

In spite of the gap between them, which is a gap more marked in mural than miniature art, the caves in the central Pyrenees are closely connected to those at the Atlantic end of the range. This is a fact of some interest if one considers the topography of the intervening country for here the Pyrenees are high and conform to the classic fish backbone pattern; that is, a central spine with

83

80, 83, 115

133

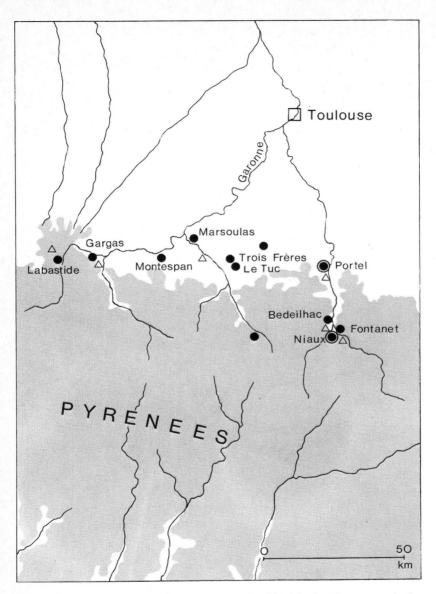

80 Map showing the location of mural art sites of major and minor importance in the central Pyrenees. Sites of major importance are marked by a dot, those of minor importance by a triangle and sites belonging to the 'black outline' group are encircled. Contour: 500 m

long parallel ridges running out from it both north and south. This means that east-west travel on either side is extremely difficult, but more particularly on the French, north-facing gradient, where the ridges are more extensive. Under glacial conditions, such as prevailed here in the late Palaeolithic, such communication must have been virtually impossible. The only open routes would have been along the glacially eroded valley bottoms in a north-south direction, that is from the Pyrenean chain towards the Basin of Aquitaine, or back again. The affiliations of art sites, however, show little concession to this pattern. It might have been expected that sites bordering on the River Garonne, for example, would show a regional style, whether in the decoration of caves, or in the manufacture of miniature pieces, and that styles found here might be different from those in the Pays Basque, an area networked by rivers that join the Adour to flow into the Atlantic at Bayonne. The Garonne, although it rises in the central Pyrenees, takes an eastward and then northward course and does not finally reach the sea until Bordeaux. However the distribution of art styles is not like this. In miniature art a particular and distinctive motif is as often repeated in a site hundreds of kilometres to the west or east as it is in a neighbouring one. There are one or two examples of local groupings in style or subject matter, but they are so few as to confirm the rule that it is the lack of local distribution that is significant, rather than the existence of it. The situation is the same in mural art. A more exact parallel to, for example, a horse in the cave of Niaux in Ariège may be found two hundred and twenty-five kilometres away in Sinhikole-Ko-Karbia in the Basque provinces, than in any other cave in Ariège. One can only explain this by suggesting that the people of the later Magdalenian (the period to which most art in the Pyrenees belongs) had a mobile economy, following a seasonal pattern. In the summer, perhaps, they travelled south, following migratory herds into the Pyrenean valleys, and in the autumn or winter they made their way back again on to the plains of Aquitaine. Individuals probably moved from one group to another so that ideas in art were interchanged and styles developed in one region transferred to another. Social groupings must have been flexible and contact frequent for the similarity of miniature art pieces from Dordogne, the Pays Basque and Ariège, for example, is very striking. As has been said above, but may be repeated here, nearly all present-day hunter-gatherers who for most of the year operate as small family groups, collect together on a tribal basis,

11
10

annually. On the evidence of their art we can assume the same commitments applied in the late Upper Palaeolithic.

It is quite probable that the gaps in distribution of decorated caves along the Pyrenees do not represent interruptions in the original pattern but are due to lack of modern investigation. It is possible that there may be more decorated caves in the Arudy region where one isolated painting is known to date, but where there are several rich miniature art sites. It is generally considered, also, that the scarcity of Magdalenian sites of any type in the eastern Pyrenees is due to a lack, until recently, of modern interest in this area.

The uniformity of art in the Pyrenees and Cantabria is a characteristic of the last three stages of the Magdalenian for it is not until Magdalenian IV that the proliferation of sites in the Pays Basque provides, or is perhaps the result of, a link formed between the two areas. There is only a little earlier occupation in the central Pyrenees for, until the end of the Solutrean period, moraines and glacial conditions kept people out of these valleys. In contrast, though, to the periods that precede it the late Magdalenian is a period of mountain occupation, as may be seen in Switzerland (Sonneville-Bordes 1966), in Haut Quercy (Lorblanchet 1969), or in the Pyrenees. By the last stages of the Würm the glaciers were in steady retreat and later Magdalenian settlers penetrated the mountains by way of the liberated valleys. In the Pyrenees their habitation sites are seldom above the 650 metre line, however, and few open-air settlements are known, though more may exist than have yet been found. To our present knowledge, the Magdalenians here lived in caves and often deep inside these, regardless of the lack of daylight, but presumably well sheltered.

As in the Pyrenees, the earliest stages of the Magdalenian (I and II) are lacking in the Pays Basque and in Cantabria; these two stages are apparently a local development confined to Périgord but Magdalenian III is represented in the Landes and is plentiful in Spain. The stages of IV, V and VI are rich in the central and western Pyrenees but IV is poorly represented in Spanish Cantabria; in fact, it is sometimes claimed that it does not exist here at all. The stages of the Magdalenian that are well represented in northern Spain are III, V and VI, more usually described as early (III) and late (V and VI). These are the most usually recognized industries and Magdalenian IV, or even a middle Magdalenian of a more generalized character, is rare. It does exist, however: Aitzbitarte IV and Ermittia in Guipuzcoa

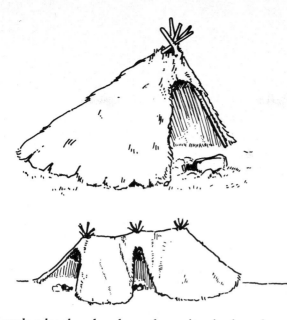

81 Suggested reconstructions for tents at the Late Magdalenian site of Pincevent, Seine-et-Marne. One has a single hearth and the other, two

have such a level and so have three sites in Asturias; these are Cueto de la Mina, Balmori and Paloma which has not only a recognizable industrial assemblage but also a characteristic collection of plaquettes engraved in palimpsest. The presence or absence of Magdalenian IV would be a matter of minor importance if the evidence of the art did not make it very difficult to accept its absence. It is unreasonable to ascribe a different chronological stage to certain cave paintings in Cantabria that are exactly parallel in style to a series in the Pyrenees dated, with as much security as one may ever achieve, to the period of Magdalenian IV. One may ask whether the lack of Magdalenian IV living-sites in this part of Spain is not due simply to looking in the wrong places.

The end of Magdalenian III is marked in Cantabria by a period of heavy rockfalls. This geological activity, which was possibly tectonic in origin as well as climatic, choked the mouths of many caves: if they were not actually filled with fallen rock such situations must, at least for some period of time, have been dangerous to live in. Under these conditions one should not expect to find Magdalenian IV deposits overlying Magdalenian III in cave mouths or shelters; we might, however, look for their living-sites elsewhere. They could have lived in open-air sites; if the caves were uninhabitable some perishable structures were probably made instead, such as tents of hide and timber. Evidence that these existed in the Upper Palaeolithic is well documented in northern France and Germany where conditions

of preservation in the loess are exceptionally good. In this context it is relevant that whereas in Périgord and the Pyrenees the number of habitation sites with miniature art is considerably greater than that of decorated caves, in Spain it is the reverse. Here almost twice as many sites with mural art have been recorded, which suggests that a considerable number of habitation sites have so far escaped detection and, until more work is done, one may at least consider it a possibility that the living-sites of Magdalenian IV have not yet been found in Cantabria. It is known that the region around Posada in Asturias, for example, had an advantageous micro-climate during the Würm, which it is suggested allowed a high density of population (Gomez Tabanera 1975); it might also have made it possible for people to live in the open air without too much hardship.

The alternative to insisting that a Magdalenian IV stage must exist in Cantabria is to accommodate the decoration of caves to the local archaeological record, an equally difficult proposition but one that many authorities try to enforce. Jordá Cerdá thinks that since the Solutrean and early Magdalenian are the periods showing the greatest density of sites, and thus population, they must also represent the period of greatest artistic activity. This scheme assumes that the cultural record for Cantabria is complete which, as suggested above, is questionable and it pays no attention to the stylistic associations that certain Cantabrian caves have outside this region. Leroi-Gourhan absorbs the difficulty by defining his Classical phase (Style IV) as covering Magdalenian III and IV but while this may ease some of the difficulties of Spanish chronology it makes for extreme confusion in the central Pyrenees. Niaux, in Ariège, for example, is in an area where the stages of Magdalenian IV, V and VI are plentiful, but where Magdalenian III is represented at a few sites only, and those not at a high altitude. In fact the Vicdessos valley was probably inaccessible to settlers until the end of this period when the climate shows some amelioration. For most of the period coincident with Magdalenian III the Pyrenean region was very cold and dry (Clottes 1974). Niaux is the epitome of the 'Classical' Magdalenian style, characterized by static black outline figures, a pronounced bias for the theme of bison and horse, the presence of claviforms and a particular style of formalized drawing with certain stereotyped methods of shading. This is an artistic formula that occurs in the Pays Basque and Spain as well as the Pyrenees and of all Palaeolithic

33

IX, 96

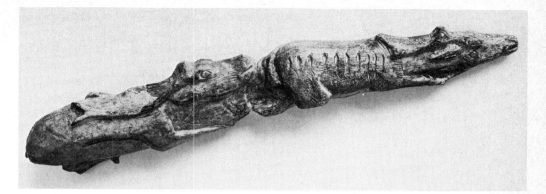

art stages it is the most conformist and recognizable. One must accept that Niaux and El Pindal in Asturias, for example, or La Cullalvera near Santander, or Ekain in Guipuzcoa belong to the same short-term artistic stage and, since it is unrealistic to ascribe Niaux to Magdalenian III, one must consider the Basque and Cantabric sites as possibly related to Magdalenian IV.

As stated above (Chapter 5), many authorities do not agree with Leroi-Gourhan's division of the Magdalenian art styles between the cultural stages of II and III. Breuil stressed the difference between the stages of III and IV and it is hard to see why Leroi-Gourhan chose to include III with IV in his Classical phase, Style IV, except in an endeavour to accommodate the Spanish evidence. He himself says that when decoration on *exterior* walls disappears, decorated objects increase in number and variety. We know that the increase of such objects coincides with the phase of Magdalenian IV and the implication of this observation is that deep sanctuaries also belong to the period of Magdalenian IV. The evidence of Périgord and the Pyrenees does not justify the grouping of Magdalenian III with IV and the Spanish chronology might be better explained some other way also; it must be stressed however that this is a personal viewpoint based on a preference for the internal evidence of the art, which is demonstrable, rather than the archaeological record which, in this case, appears incomplete. At present the evidence is contradictory: in the high-altitude sites of the central Pyrenees there are no Magdalenian III industries; in Spain very little trace of Magdalenian IV. However, a number of paintings in these two regions are identical in style and are, again by style, related to the miniature art of Magdalenian IV in the Pyrenees and Périgord. The period we are considering is very distant and the number of sites we know in any region, whether inhabited or decorated, is

82 Two reindeer sculptured on a piece of mammoth ivory 21 cm. in length, from the Abri Montastruc, Bruniquel, Tarn-et-Garonne. The leading animal has its coat markings engraved. British Museum, London

probably only an unrepresentative sample of the original total. Moreover preservation gives a great bias to cave sites, for open-air settlements are easily destroyed and difficult to locate. If there are gaps in the distributional and chronological reconstructions that we make, it is not surprising; it is not necessary, however, to draw too many positive conclusions from what is, after all, only a lack of evidence.

To produce some comparative figures of the incidence of decorated caves in the Pyrenees and Cantabria the sites in the Spanish Basque provinces of Navarre, Guipuzcoa and Vizcaya have here been added to the French Basque group to make a third unit. At the western limit this is a quite arbitrary division but at its eastern extent it places Ekain, near Cestona, within the same group as the caves in the Forêt des Arbailles with which it is closely connected. The Cantabrian region has, according to a 1971 census (Beltran 1971) forty-nine sites with art, thirty-five of which have mural art and seventeen miniature. Four of the thirty-five mural art sites have sizeable collections of miniature art also. The Basque region, to date, has twenty-nine sites, eleven of which are decorated caves and eighteen of which are sites with miniature art only: two of the eleven mural art sites have miniature art as well. The central Pyrenees has approximately twenty-five sites, seventeen with mural art and eight with miniature, but the number of miniature art sites is increased by the fact that eleven of the seventeen decorated caves have rich habitation deposits with miniature art, making the total of sites in this group nineteen. This marked overlap in mural and miniature art is not a feature unique to the Pyrenees, a number of decorated caves in Périgord having occupation deposits at the entrance (though not necessarily of the same period as the decorations in the cave), but it is particularly pronounced here and very much in contrast to the Basque and Cantabrian groups. The central Pyrenees differs from Périgord, the Pays Basque and Cantabria in other respects also; of the seventeen decorated caves perhaps only five are of minor importance, the other twelve either still are, or must originally have been, major sanctuaries, while only three of the decorated caves in the Basque provinces are of equal importance and perhaps a dozen of the thirty-five in Spanish Cantabria. Numbers in this context are invidious and are used here only to give an indication of proportions. The central Pyrenean group is also that with the shortest history. Gargas and Tibiran, near Aventigan, have some Gravettian work, so perhaps does one gallery in Les Trois Frères

115

80

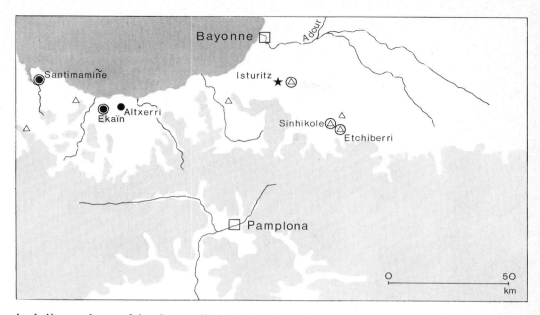

in Ariège and one of the three galleries in Le Portel is thought to be Solutrean in date. Apart from these, the decorated caves in this group date from the later stages of the Magdalenian and the majority may be ascribed to Magdalenian IV.

As the caves and shelters in Périgord form the most heterogeneous group of Palaeolithic art sites, so those in the Pyrenees form the most homogeneous, for which reason it seems inappropriate to single out and describe certain caves, more particularly as many of the important caves in this region are not open to the public. It may be better, perhaps, to make a survey according to style or technique used, or with regard to location or subject. The most famous paintings in the Pyrenees are the black outline figures, best represented at Niaux and Le Portel but found at Bédeilhac, for example, or Marsoulas and other sites as well. These are the epitome of Magdalenian IV style but because as a group they have such widespread connections outside this area they will be discussed last and other, more local, facets of Pyrenean art will be described before them.

There is no low relief mural sculpture in stone in the Pyrenees; in its place three-dimensional figures are modelled in mud, a technique which is unique to this region. Such figures are very vulnerable to changes in humidity and temperature in caves and there may originally have been many more of them; today they are known from four sites only, all in Ariège, and in only one of these is their state of preservation perfect. Labouiche has a

83 Map showing the distribution of mural art sites of major and minor importance in the French and Spanish Basque provinces. Sites of major importance are marked by a dot, those of minor importance by a triangle and sites belonging to the 'black outline' group are encircled. A star indicates a site with low relief sculpture. Contour: 500 m.

85, 86

single small bison and Bédeilhac has four of the same animals in low relief but one has been obliterated, two much damaged and even the fourth is not above suspicion of re-shaping. Montespan has, firstly, a series of horses cut on the clay-covered wall which, in technique, range from deep engraving to low relief; secondly, the remains of three statues in high relief which appear originally to have been propped against the wall and, lastly, one statue in full relief. This is the famous 'headless bear' which Breuil thought was a dummy over which a bear's skin had been thrown and stabbed symbolically. There are more than thirty deep incisions in this model and Norbert Casteret, who discovered the gallery, is reputed to have picked up fragments of a bear's skull nearby. Such an interpretation gave great support to the then current theories of hunting magic, but nowadays opinion is more reserved; in fact, no detailed report has ever been made of this much damaged cave, which has been an all too happy hunting ground for speleologists. When, in 1922, Casteret reached the entrance to the gallery with the headless bear, it was blocked by a siphon through which he dived, in the dark, with a candle and some matches tucked into his rubber helmet, 'an action that a modern speleologist would consider reckless', according to a modern guide to subterranean France and one that one cannot suppose was necessary in the Upper Palaeolithic when the gallery was presumably much drier.

The two finest examples of low relief modelling are in Le Tuc d'Audoubert, one of two outstanding sanctuaries in the abandoned subterranean courses of the River Volp which were found by Count Bégouën and his three sons in the second decade of this century. The second cave is appropriately called Les Trois Frères. There were originally four models of bison in Le Tuc, two large and two small, but one of the small figures was sold to the St-Germain museum at the time of the discovery and for many years the group was represented by three figures only. It is not possible for a national museum to part with gifts or purchases but in 1976 a replica was made of the fourth bison and placed in its original position. The two principal figures in this group are a female followed by a male, the sex of which, as often in Palaeolithic art, is differentiated by general physiognomy rather than specific attributes; the bull bison for example is more robust, larger and heavier in the chest than the female. They are respectively sixty-one and sixty-three centimetres long and are modelled in a form of three-quarter relief; that is they are not disengaged, three-dimensional statues, (although the head of the

I

84 (*opposite*) Head-on view of clay bison, showing the slightly flattened form of relief used to model them. Le Tuc d'Audoubert, Ariège.

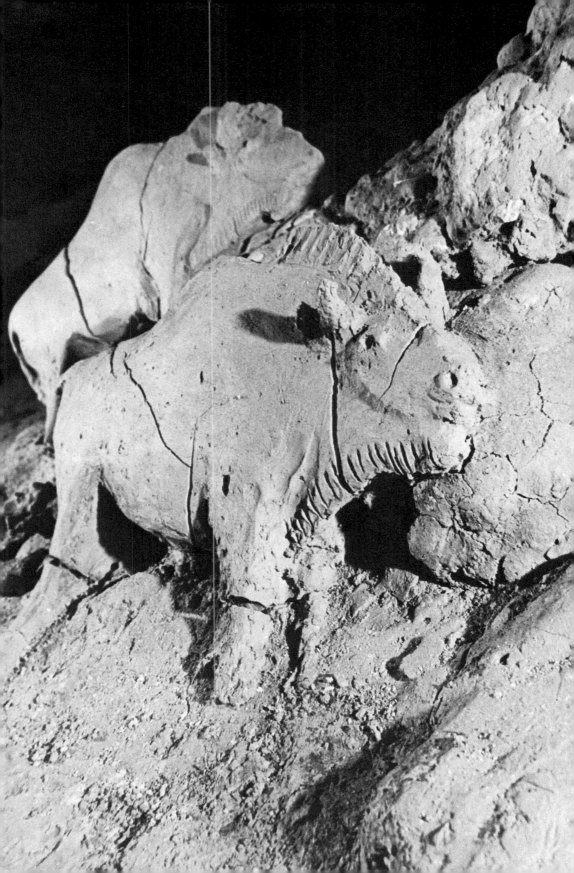

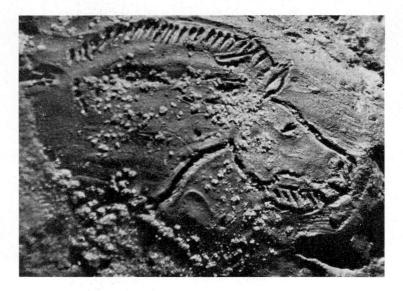

85 Horse head incised on a mud-coated wall. Montespan, Ariège. Length 15 cm.

female almost approximates to this), but slightly flattened figures leaning against and attached to a rock support behind. This three-quarter technique is a characteristic of Magdalenian IV miniature relief work also, as is the formalized rendering of the animals' manes. Blobs of clay lying near the finished figures suggest further ones were intended and there are hollows in the mud deposits at the side of the gallery where the raw material was scooped up and taken to the centre of the chamber. The modelled bison are seven hundred metres from the entrance of

86 A complete horse incised (as in Ill. 85) on the mud-coated wall of a gallery in Montespan, Ariège. This figure, which is 30 cm. in length, is part of the 'Fresque de la Chasse', so named because of the holes stabbed in the figures

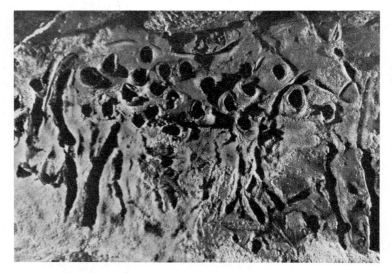

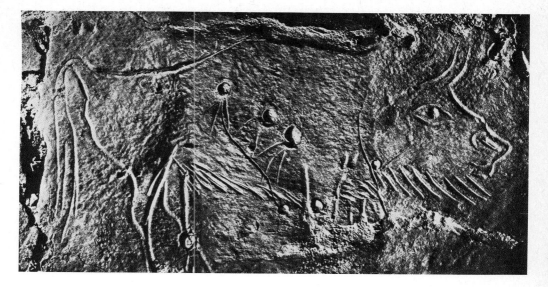

the main gallery in Le Tuc and were only discovered after breaking two stalactite columns that blocked the continuation of the passage. These columns must have formed in the fourteen thousand years or so between the creation and the rediscovery of the bison and are a very convincing guarantee of their age.

In utilizing clay or mud it is obviously a small jump from modelling to deep engraving. At Montespan in the 'Fresque de la Chasse', there is a particularly beautiful horse's head incised on the mud-covered wall with a continuing frieze of horses beyond, similarly cut or modelled. These are covered with stab marks in the mud and the deep-cut lines that surround them have suggested a palisade; hence the name given to the gallery. Ganties-Montespan is, like the Volp caverns, a very extensive underground river complex; here the Hountaou river enters the hill at Ganties and emerges, nearly two kilometres distant, at Montespan. In addition to the Casteret-Godin gallery with the clay statues and the Trombe Dubuc gallery with the 'hunt' fresco there are many engravings throughout the cave, expectedly of bison, horse, cervids, ibex and bovids and, more unusually, one of a bird with a fish in its mouth.

Mud engravings are found in other caves also, but they are few, probably because, like clay models, they are so vulnerable. Niaux had a famous trout and still has a number of other figures, amongst them horses, ibex and bison. One of these last is drawn around three small natural hollows made by dripping water which have, by the addition of arrow markings, been made

87 Bison incised on the clay floor in Niaux, Ariège. Pre-existing small hollows made by dripping water have been used for the animal's eye and to indicate three wound marks on its flank. Length 58 cm.

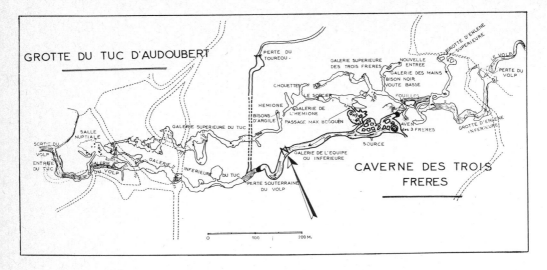

88 Plan of Les Trois Frères and Le Tuc d'Audoubert, two separate, and now abandoned, subterranean galleries of the Volp river

to appear as wounds on its flank. Bédeilhac, which is a very interesting cave, not so much for the quantity as for the variety of its decoration, also has engravings on the mud floor, in this case a bison, a possible horse and a pony's head that resembles that from Montespan. Here there is also a painting of a small horse done in mud, a technique known elsewhere in Franco-Cantabria only from two sites in the Pays Basque.

There is no decorated cave in the Pyrenees without engravings, whether on the mud floor or the limestone wall, although in Le Portel and Niaux, for example, they are of minor importance compared to the paintings. As there are caves that are predominantly painted so, conversely, there are caves where the engravings are of greatest importance such, for example, as Les Trois Frères. This is one of the six caves that Breuil distinguished as his giants (the others being Lascaux, Font-de-Gaume, Combarelles, Niaux and Altamira) and is the second of the great caverns of the Volp found by the Bégouën family. The two sanctuaries do not now connect and apparently were not connected in the Palaeolithic epoch either: the chamber in Le Tuc with the clay bison is actually above the gallery of Les Trois Frères, but independent of it. The entrance to the latter is now made from the far side of the hill but originally was probably much nearer the small chamber called the Sanctuary which contains the famous figure of 'the Sorcerer' and a great quantity of animal engravings. Evidence for the original entrance is partly archaeological, partly conjectural. 'Many bones, flint implements and objects bearing man's handiwork' (MacCurdy 1915)

91
6

were found on the floor of Les Trois Frères near the Sanctuary when it was first discovered, suggesting an entrance nearby. There is also a huge heap of fallen earth containing the articulated bones of a complete bison in this part of the cave, which indicates a substantial fall-in. Secondly, for Leroi-Gourhan, the layout of the cave is comprehensible only if one rejects the present entrance because the typical back-cave animals and entrance figures are reversed by the present approach. Lastly, no very elaborately decorated gallery or chamber is ever very inaccessible, even in the period of deep-cave use. Niaux is a possible exception to this rule but although the Salon Noir is a long way inside the mountain the route is not very difficult and, furthermore, the technique of painting used at Niaux is fairly rapid. The same cannot be said for the Sanctuary at Les Trois Frères; it is covered with extremely detailed, superimposed engravings that must have taken a great deal of time to complete, for which reason it seems probable that the original entrance was somewhere near and is now perhaps choked by the earth fall.

89 Superimposed engravings in the Sanctuary at Les Trois Frères, Ariège. The whole, or part, of at least fifteen animals may be deciphered here; among them are two large bison heads, one in profile and one full face, at the top of this illustration. The overall height of this panel is 150 cm.

6

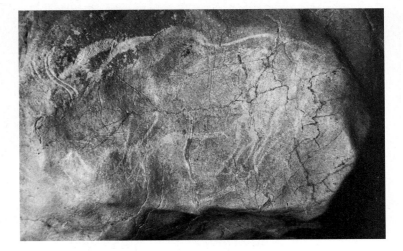

90 Carefully engraved bison in the Sanctuary at Les Trois Frères, Ariège. Length 67 cm.

91 'The Sorcerer' in the Sanctuary at Les Trois Frères, Ariège. This figure is 75 cm. high and both painted and engraved

Many of the engravings in the Sanctuary in Les Trois Frères are exquisite; a natural film of yellow mud and the white weathered surface on the black rock below were used to create a cameo effect and shading was used to indicate the coat markings or the shape of the animals' bodies. The figures are, however, exceedingly difficult to decipher, for the Sanctuary is an awkward, small, low room and the engravings are tucked under the slope of the wall and superimposed almost to the point of obliteration. Breuil copied them with great care and it is a great deal easier to understand the figures in reproduction than it is to identify them amongst a quite astonishing number of unrelated lines on the rock wall. In this sanctuary there is a little recess leading up to a higher-level niche which is where the figure of the Sorcerer is placed. It is the only figure in this complex that is painted as well as engraved and is one of the most naturalistic human figures in mural art. Apart from the Venuses of Angles and Penne which relate to a long-lived cult associated with living-sites, most human figures in mural art are a sort of ridiculous contradiction of all that characterizes the animal drawing, being ill-drawn, anatomically incorrect and sketchy. Sometimes they are given animal attributes, as are the Sorcerer and the man playing a musical bow in the Sanctuary, both of whom have horns, a tail and hooves or paws for arms, but most often they are incomplete half figures, a penis and two legs perhaps, a prognathous profile that is hard to distinguish as human or a bunface with rudimentary eyes and mouth. Such

III

anthropomorphs, or 'ghosts', are quite numerous, indeed most caves have their complement, often in peripheral positions and

usually fugitive in appearance, in contrast to the Sorcerer at Les Trois Frères who stands in a position of dominance. As has been stated above (Chapter 2), it would be incorrect to dismiss these figures as unimportant because they are so poorly executed, but they remain highly problematic.

It is interesting that the other category of representations in Palaeolithic mural art that are badly drawn are birds: of fifteen examples known only seven can be identified (Lorblanchet 1974) and, curiously, it is not always easy to distinguish between these poorly drawn birds and poorly drawn humans. Owl and human faces are very similar. In fact the only convincing owls are in Ariège, for example a pair drawn face to face in Les Trois Frères itself. Of the bird species recognizable in Palaeolithic art, most are of waterfowl, while the occupational debris shows that of many birds eaten these are the least common. This is simply evidence confirmatory to that of the reindeer which, while little drawn in Magdalenian IV, provided nearly all the bone and antler for tools and decorated objects and a high proportion of the meat supply.

92 A reindeer, a deer/ bison and a man playing a musical bow, all perhaps part of the same scene, Les Trois Frères, Ariège. This drawing is a detail of Ill. 6 and the man is 30 cm. high

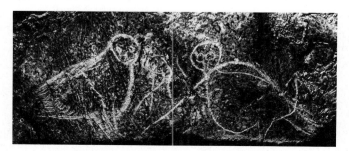

93 Two snow owls with a chick between them, Les Trois Frères, Ariège. Length of panel 87 cm.

There is a gallery in Les Trois Frères with engraving of an earlier style than that in the Sanctuary: Breuil classified it as Aurignacian although it is probably not so old, but the majority of the engravings in the cave may be attributed to Magdalenian IV on grounds of style. Breuil considered some work in the Sanctuary to be later, and certainly the zigzag line drawn on a reindeer's flank is a stylistic convention found on miniature art pieces of Magdalenian V date. Composite figures, such as the 'man' playing the musical bow, are also characteristic of late Magdalenian miniature art, as are processional scenes, such as that in which this figure is involved. Claviforms occur in the cave and there is a recognizable, though incomplete example of a radiating line design, that is a pattern of lines drawn from a central point, encircled by a double line at the perimeter, which, although very rare in mural art, is one of the most characteristic known in miniature. It is found as a decoration on discs of bone or stone and both the objects and the design, although known in other periods in central Europe and Russia are, in Franco-Cantabria, confined to the period of Magdalenian IV. We may therefore equate most of the gallery engravings in Les Trois Frères to this stage, both by reason of their style and the occurrence of this motif.

92

True polychrome painting is rare in the Pyrenees: it is known only from Marsoulas (Haute Garonne), Labastide (Hautes Pyrénées) and Fontanet (Ariège). Breuil regarded some of the figures in the Galerie Vidal in Bédeilhac as polychromes, and this may be so, but the series is so faded that one cannot confirm his description. Marsoulas has two very large polychrome figures, a bison and a horse, each over two metres in length and in style clearly Magdalenian IV or later, as are the two smaller bison whose bodies are filled in with spots. Spots call to mind the horses in Pech-Merle but neither the effect nor the technique at Marsoulas are similar and, to date, no counterparts to these bison have been found. Labastide is potentially one of the most interesting caves in the Pyrenees but it has not been fully studied or published. Like Mas d'Azil it is a still active underground river course and while exploring here in 1933, Casteret found a large polychrome painting of a horse in a dry gallery now abandoned by the river. There are also three series of animal engravings in Labastide, mostly depicting horses but including a bison, some reindeer, ibex, a wild boar and a very fine head of a feline. There is in addition one complete human figure, said to be dancing, one face and the head and neck of a goose. These are

67

XI 'Bison de la découverte', so called because it was the first painting recognized by Jeannel in 1906. Le Portel, Ariège, length 63 cm.

XII Delicately painted horse, with characteristic conventionalized coat markings from Ekain, Guipuzcoa. Length approx. 90 cm.

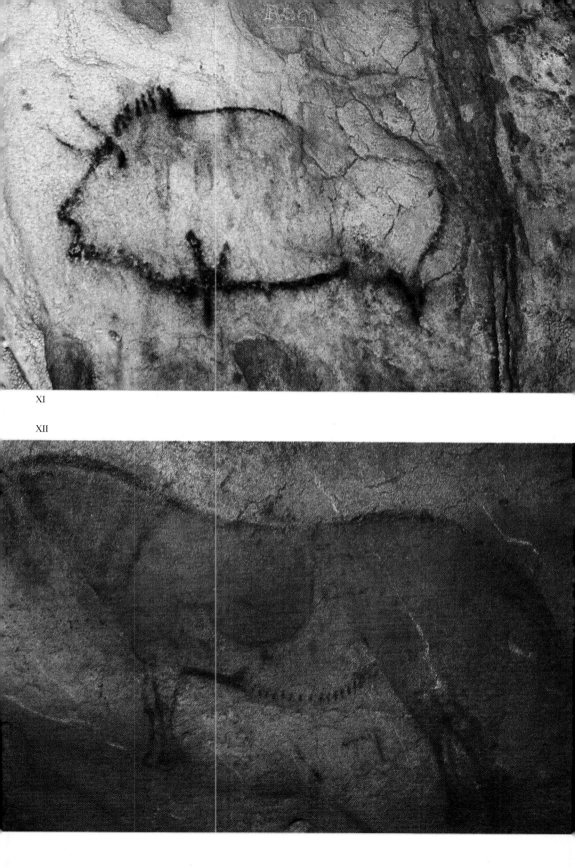

XI

XII

XIII

XIV

94 Part of the engraved wall in the 'Sanctuary of engravings' at Gargas, Hautes Pyrénées. The length of this section of the decoration with animals and meandering macaroni designs is 240 cm.

interesting in themselves, but more particularly because a very great many engraved plaquettes were found in this cave, some in the occupation debris on the floor and some, according to Casteret's account, set up in a circle on the ground. There are said to be nearly a thousand fragments in all (Clot 1973) but very few have yet been published: amongst other figures on the known pieces are two further birds, several salmon and a human figure. Here is a cave that apparently contained both a mural and a plaquette sanctuary of unprecedented size but from which, because of its situation, we have very little usable evidence. In fact, the task of preserving engraving, painting or objects in a cave of this size is almost impossible. A door can be set into a small gallery but a river mouth can hardly be closed in this manner, so that from the moment that decorations or objects are found in such a situation they are at risk: engravings on the walls cannot be saved from defacement and plaquettes cannot be left on the ground for fear of theft.

Like Labastide, Gargas, also in Hautes Pyrénées, is a cave with unique features. Most of the mural decoration here is early: by analogy with the engraved plaquettes found in the habitation levels at the entrance to the cave, it appears to be Gravettian and it consists of deep-cut, superimposed engravings and finger tracings in mud. Mammoth occurs among the animals drawn

XIII A hole in the rock, suggesting a vulva, outlined with red paint and lines of dots, Chufin, Santander. Length, approx. 145 cm.

XIV View over the river from the mouth of the Baume Latrone cave, Gard

here, with horse, bison and cervids, but it is the series of negative
hand prints in red and black that is most famous. There are more
than one hundred and fifty in the cave, which is a number far in
excess of any other known site. Breuil considered that hand
prints were early in date but, although this may be the case at
Gargas, it is not always so. The hands in Font-de-Gaume and
Combarelles, for example, cannot in their context be early and
one may consider that this motif had a long history. The Gargas
hands have caused much speculation about ritual mutilation or
the ravages of disease, such as leprosy, for many prints show
hands with shortened fingers. However, this is not the only detail
in which they are unrealistic; even among the small series shown
to the public one hand has thumb and fingers at the same level
and another a very deep V cleft between first finger and thumb.
Until a more careful anatomical study is made of them, perhaps
accompanied by experiments, one cannot even be sure that
actual hands were placed upon the wall.

Real imprints, more often of feet than hands, are known from a
number of Pyrenean caves, though in many cases they have been
spoilt by cave explorers crawling or trampling over them. They
still exist in Niaux and Le Tuc, however, and a good series has
been discovered lately in Fontanet. This includes the hand print
of a child who slipped and fell on the mud while chasing a fox,
whose footprints are also recorded here.

Fontanet, like Bédeilhac, is a cave with a numerically small
but very comprehensive inventory. It has one polychrome bison,
some red outline painting of deer, black paintings, very fine
infilled engravings, human faces, a figure resembling the
'Sorcerer' of Les Trois Frères, a female figure of unique form, a
vertical falling bison, claviforms and punctuation patterns made
by sticking fingers into the mud coating on the cave wall. It also
has a rich habitation deposit with bones, charcoal and a complete
salmon skeleton, stored on a ledge, but this has not yet been
excavated and the cave is not open to the public at present.
Bédeilhac can produce an example of every technique known in
Palaeolithic art, except perhaps for polychrome, although even
this Breuil thought was represented here. The low reliefs are in
mud and there are engravings in the mud on the floor as well as a
painting, using mud as a medium, on the wall. Rock formations
are much used here as a base for figures; in one case a stalagmite
forms a man, another a phallus, which face each other in a small
side gallery. There are conventional engravings, figures
combining engraving and painting and paintings in a pointillist

95 Bison heavily outlined with black paint and an engraved line from Fontanet, Ariège. Length approx. 75 cm. The 'Sorcerer' can be seen behind the bison

7

technique, in outline, in flat wash and in bichrome. Some of the best figures are in tiny side galleries with extremely narrow entrance passages, for example a headless horse and a bison painted in a manner so close to that of the Niaux figures that in this instance one can well believe it was done by the same artist. Niaux, in fact, is only seven kilometres away. Bédeilhac has a number of obvious sexual symbols, such as phalli and vulvae, and the headless and falling animals that are a consistent feature of most Magdalenian caves; in addition, to complete the inventory, there is one claviform. It is also, as a cave, an outstanding example of the idiosyncratic use that Palaeolithic man made of space. It is an enormous cave, large enough to have housed an aircraft factory in the last war but almost all its paintings and engraving are tucked away under overhangs or in narrow side galleries with constricted entrances.

A great variety of techniques is usually explained as the result of long use, but this explanation seems to be inapplicable to either Fontanet or Bédeilhac. They have a great variety but on grounds of style as well as climatic and habitation evidence, they appear to be relatively short-term sanctuaries, used in Magdalenian IV and perhaps in later periods of the same culture. Here

variety is perhaps not the result of chronological accumulation but a characteristic of their period. There are many miniature art sites in the Pyrenees that have a comparable scope with free-standing sculptures in stone and bone, bone cut-outs, engraved plaques and decorated tools and ornaments. In miniature art this variety is more characteristic of Magdalenian IV than of other periods and even if one cannot date decorated caves so firmly, the complexity of Bédeilhac and Fontanet suggests they could be ascribed to the same period.

In contrast to these are the 'Classic' caves of Niaux and Le Portel: their animal inventory is limited, their style uniform and their adherence to a formula very tight. They are famous for black outline paintings of bison and horse, arranged character-istically in panels. At Niaux in the Rotunda, which is a small apse formed of overhung niches at the back of the Salon Noir, the bison and horse compositions are accompanied by a single ibex or, in one case, a stag. Leroi-Gourhan identifies six panels here and the topography of the wall supports such a division. Elsewhere in the main cave, in addition to bison and horse, there are representations of oxen, a very doubtful rhinoceros, a possible feline and three fish; signs are represented by dots,

VI, 33

96 Two bison and a very small ibex from the Salon Noir at Niaux, Ariège. Black paint is used to shade the lower part of the animals and each animal is nearly 200 cm. long

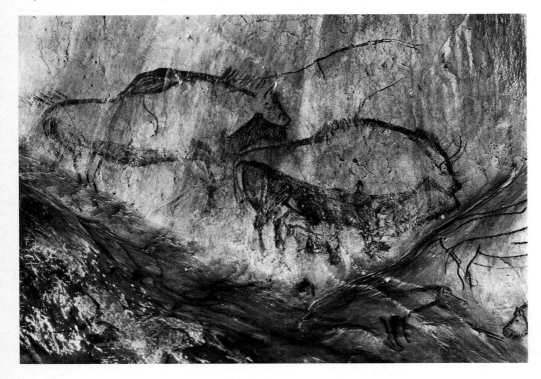

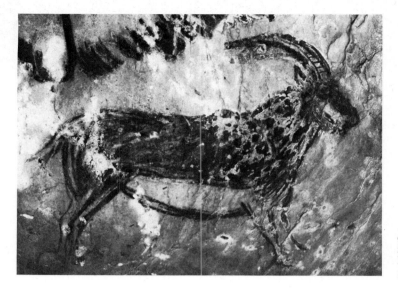

97 Ibex with coat markings shaded in black paint, Niaux, Ariège. Length 52 cm.

bunches of lines and numerous claviforms. There are two bison painted vertically, an ibex without a head and some small paintings in red as well as a number of engravings. Nothing however approaches, in quality or quantity, the panels of horse and bison in the Salon Noir. These are drawn in complete outline with a strong line; a few long strokes are used for back or leg and neat vertical or parallel lines for mane or beard or stomach, anywhere, in fact, where hair springs or falls from the body line. A number of animals have only minimal interior marking, such as a cheek line on a horse or a usually double line on a bison underlining its mane, but many are carefully shaded. This is done by short parallel lines; in horses it is employed to give shape to shoulder and rump and also to indicate the wavy line of its heavy top coat on rump, flank and shoulder; in bison it is employed in an almost opposite manner but to the same effect, to give relief and demarcate its coat. On a bison, shading is used on hind legs and in a diagonal direction from its tail to the top of its front leg, but the shading is on the lower part of the animal, not the upper as with the horses. Ibex, like horses, have their heavy back coat shaded in solidly. A double, single, or triple line is used to mark a horse's shoulder irrespective of other shading, a characteristic which, like the wavy ventral line of its coat is diagnostic of this species in this style. These same tricks of style, the double underlining of the bison's mane, for example, and the shoulder marking on a horse, as well as the general use of neat hatched lines for shading, are found in engravings on bone and

VI, 33

45

IX

11

98 Rapidly drawn, black outline bison from the newly discovered gallery the Reseau René Clastres, in Niaux, Ariège. 114 cm. long

antler objects in habitation sites of the period of Magdalenian IV. The style is very recognizable and one can without hesitation identify it in either mural or miniature art. Leroi-Gourhan would derive the black outline style of Niaux from earlier caves in Quercy and it does, of course, occur at Lascaux also. In fact, the relationship of Périgord to the Pyrenees is difficult to determine, for the quantity and richness of sites in the Pyrenees in the last three stages of the Magdalenian suggests that this region became the centre of artistic development. However, while sites in Périgord such as Laugerie Basse and La Madeleine have rich collections of miniature art that are almost identical with collections from Pyrenean sites, the mural art in these two regions is not so similar. Some fashions appear in Périgord that are perhaps Pyrenean in origin, such as black outline painting at Rouffignac, but indigenous traits persist also and the evidence is not really sufficient to permit one to draw general conclusions.

In 1970 a new gallery was explored in Niaux and named the Reseau René Clastres. In addition to a marvellous series of footprints, left on the sandbanks of the once existing under-ground stream, five paintings were found here, done in a rapid style with a charcoal crayon. One bison, a stone-marten and a horse are virtually complete, two further bison are simply

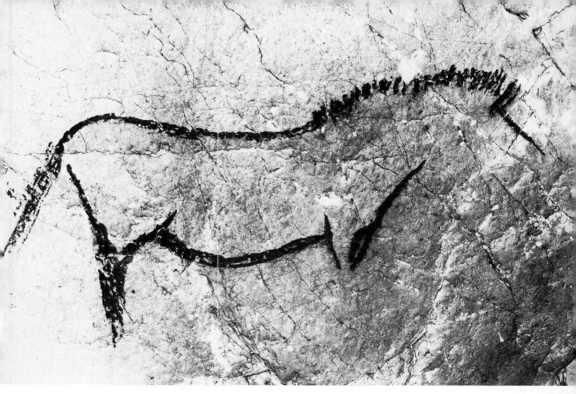

99 Horse in black outline from the Reseau René Clastres, Niaux, Ariège.
Approx. 100 cm. long

100 Stone-marten from the Reseau René Clastres in Niaux, Ariège. 46 cm. high

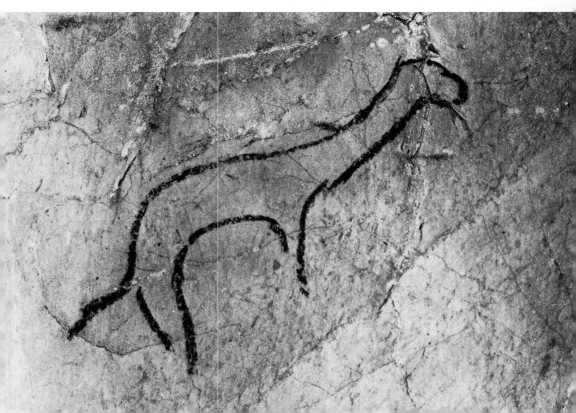

sketched in; all are in black outline and it is possible to see that the stone-marten, for example, was created with ten strokes only. The rapidity of the drawing is probably a concomitant of their position, deep inside the cave, but the style is consistent with that of the Salon Noir: the proportions of the figures, the treatment of the manes and the black outlines are all evocative of the 'Classical' Magdalenian IV style, though interestingly the figures in the Reseau René Clastres are actually closer in appearance to the drawings in Le Portel than to those in Niaux. This does not affect their date, however, for Le Portel belongs to the same period. It is simply that a number of figures in Le Portel are sketches, lacking feet or with unfinished heads, as are the figures in the Reseau René Clastres. Some of the bison and horses at Le Portel have the same rapidity and springiness of line also, and they share with the Reseau René Clastres a spontaneity that is lacking in some of the carefully completed and shaded animals in the Salon Noir, who stand upon four carefully drawn feet. Not all the figures in Le Portel are in plain outline, although the majority belong to this group; some bison have a very thick outline, emphasizing their manes and the triangulation of their coat markings, one horse is in solid wash, another has head, neck and forelegs only in solid colour, the rest of its body in outline and some have a very little shading, a shoulder and ventral coat marking on the horses, for example, or beard and mane on a bison. The paintings in Le Portel are simple but some amongst them are exquisite because of a lightness and surety of line and shape. As in Bédeilhac the best figures are in the most awkward places and, as at Niaux, the inventory of animals is very limited. Again like Niaux, the decorated galleries are some way from the cave entrance although in neither case is the route a very difficult one.

Difficulty of access is a characteristic of sanctuaries of the later Magdalenian. By no means all the sanctuaries in deep caves accord with the Niaux/Le Portel formula, but it is often found in such locations. This group, which comes within Leroi-Gourhan's Style IV, Ancien (covering Magdalenian III and IV) but which for reasons discussed above may more simply be ascribed to Magdalenian IV, is the most consistent and recognizable of all Palaeolithic mural associations. Leroi-Gourhan does not use the word 'formula', but it can well be applied here for these are the caves in which a basic pattern of content and layout is most striking. As in Niaux, horse and bison are always the basic theme; to these may be added a few but not

XI

101, central figure

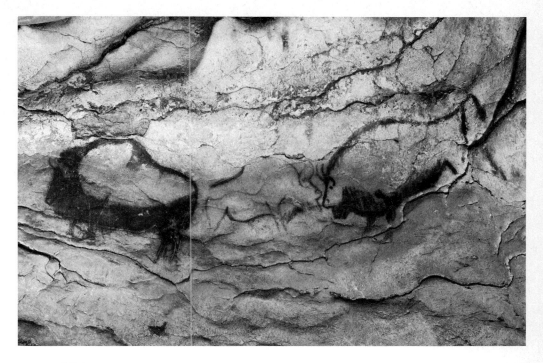

many additional species, deer or ibex most usually, but they may be omitted altogether. Many caves of this pattern have an unusual animal, such as the stone-marten in the Reseau René Clastres, for example, the tunny at El Pindal or the bears at Ekain. Amongst the animals there is usually at least one drawn vertically and one without a head; in the category of human representations one or more phantom figures or faces: as for the signs, they are limited in variety also. There are dots and claviforms. Claviforms, which are rare in Périgord, are numerous in the Pyrenees and Cantabria, where they have a fairly restricted horizon in time, being most characteristic of Magdalenian IV. The style of drawing in these 'formula' caves is very consistent also; the figures are static and most often black outline is used with certain stereotyped methods of shading and detail. For example, the horses frequently have, as described above, a single or double line on the shoulder and a wavy ventral line on the flank to indicate their coats while bison may have a double line under the mane and shading on the hind leg and lower part of the body. Taken together these characteristics constitute a very recognizable pattern but caves that conform to this formula seldom exhibit all the basic traits. They show a different or varying proportion of these. For example, one cave

101 Three bison, each depicted differently, from Le Portel, Ariège. The animal on the right measures 55 cm.

112, 104

IX

96

may have many falling animals, instead of the expected single example, another no claviforms or headless animal. Even at this most conformist period no Palaeolithic cave is an exact replica of another.

In the central Pyrenees, Niaux and Le Portel are the most striking examples of this unified group: Sinhikole-Ko-Karbia and Etchiberri-Ko-Karbia on the French side of the frontier in the Pays Basque belong to it and so does Ekain on the Spanish side. It continues along the Cantabrian coast with Santimamiñe in Vizcaya, La Cullalvera in the province of Santander and El Pindal in eastern Asturias. There are other caves where most elements of this formula are repeated, for example certain galleries in Castillo and La Pasiega, near Santander, and there are related caves where a smaller selection of the basic traits occurs. There is no cave of this type in Périgord, though Font-de-Gaume, Combarelles, Bernifal or Rouffignac are all of a period comparable to Niaux. Their basic theme is bison and horses also but in Périgord the characteristic sign is a tectiform, not a claviform and the style of the painting is more diverse. Rouffignac, which has some of the few claviforms in this region and where the paintings are in black outline, is the only possible aspirant to the Pyrenean group. In those regions where the fashion for these 'formula' caves does occur it is not, in any case, long lived. That is they are all short-term sanctuaries; many of them are placed deep in caves and they seem to have been very little frequented. However, the thing that is most interesting about them is their more than usually strict adherence to a basic formula. In these caves there is a consistent choice, both in content and association and of execution and layout. Content and association are defined by the presence of bison and horse in great predominance over other species, associated with unusual animals, few signs other than claviforms and phantom human representations. A uniformity of execution and layout are attested by a widespread use of black outline painting, very formalized methods of shading, the presence of animals that are headless or placed vertically and the placing of sanctuaries very deep in caves, where the decoration is arranged in clearly defined panels. An observable pattern such as this is what Leroi-Gourhan postulates as the underlying structure of Palaeolithic sanctuaries and it is shown very strikingly in this 'black outline' group. If you accept that there is a repeated pattern here, and it is very hard to deny it, then you are committed to its existence in other periods and regions, for all Palaeolithic mural art is related.

10

XII
109
111

114

2, 79

Inventory and positioning show variations in different periods but they do not change radically, presumably because, as Leroi-Gourhan suggests, all Palaeolithic art from its genesis adheres to the same basic structure. It is not possible to suggest where this strict formula of Magdalenian IV originated. In describing Niaux and Le Portel first no explicit implication of originality is intended, they are simply clear examples of the type. A description of others of this group may be used as a stepping stone to Cantabria and for simplicity the sites in the Pays Basque will be included with the Spanish examples in the next chapter.

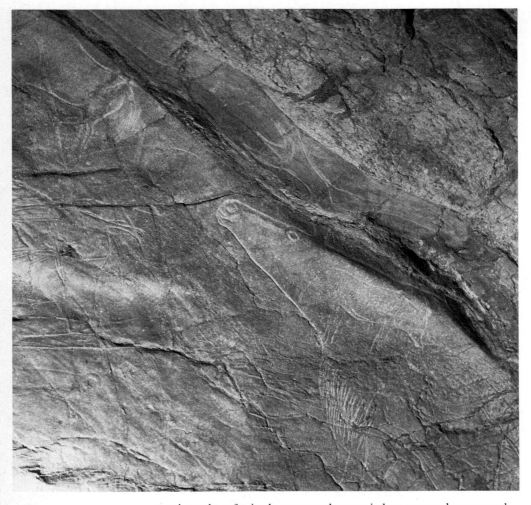

102 A number of animals, amongst them a reindeer, engraved on a smooth piece of wall, Altxerri, Guipuzcoa. A wolf, approximately 26 cm. in length, is lightly engraved on the lower neck and shoulder of the reindeer

7
The Pyrenees and Cantabria: 2 The Basque Provinces and Spanish Cantabria

Nearly all the decorated sanctuaries in the Pays Basque conform to the strict formula group of the Niaux and Le Portel type which is distinguished by black outline paintings and a restricted inventory of animals and signs. The only important cave in this region which does not is Altxerri and although the assemblage here is not typical of the group it is clearly related to it. Altxerri, near Aya in Guipuzcoa, is a newly discovered cave that has not yet been fully explored. To date about a hundred figures have been identified, of which two thirds are engravings and one third paintings, principally in black. The animal most numerously represented is the bison, but there are cervids, bovids, caprids, horses, fish, a fox, two anthropomorphs and some very fine engraved reindeer. Reindeer are very rare in Cantabrian art, the only other indisputable examples being those from Monedas, near Santander, and Tito Bustillo in Asturias, both of which on stylistic grounds are considered to be late in the Cantabrian sequence. It is difficult to date Altxerri; the presence of black

113
X

103 Engraved bison from Altxerri, Guipuzcoa, approx. 30 cm. long

outline painting, vertical and headless animals and the scarcity of signs align it with other Basque caves, but the range of species shown is not typical of these caves and the presence of the reindeer suggests that a date rather later than these is most probable. Of the remaining five caves near the border of the French and Spanish Basque provinces only Ekain near Cestona is of major importance but the remainder of the group is of interest because it is closely related within itself and has very clear associations with the central Pyrenees. For example Sinhikole-Ko-Karbia, one of a group of sites in the Massif des Arbailles, has the horse which, in form, provides the closest parallel known to one from Niaux. In form, but not in colouring for, unlike Niaux, where both outline and shading are in black, this is in two colours, black outline and red wash. In this respect it is like Ekain and the treatment of its eye, left as an uncoloured dot, is found at Ekain also, both on a bison and a horse. Etchiberri-Ko-Karbia, near Sinhikole, has a frieze of black outline horses that again may be closely matched at Ekain. Sinhikole has horse, bison and a human phantom head, Etchiberri has horse, bison, ibex and dots in red and black paint and two large horses, an ibex and a bison drawn in mud. Mud is used as a pigment in Jaisiloaga also, the third site in this group, but otherwise, within the Franco-Cantabrian region it occurs only at Bédeilhac, in Ariège. The paintings in Etchiberri are difficult to reach but the decoration in the two neighbouring caves is not far from the entrance and at Ekain access is easy. Perhaps for this reason it was decorated with more than usual care.

Ekain, like Lascaux, is one of the Palaeolithic caves that may be described as beautiful; many are more honestly described as interesting but here the quality of the drawing, the state of preservation and the natural white crystalline coating on the walls, which sparkle, allow the epithet of beautiful. The paintings are found from approximately forty to a hundred metres inside the cave, in four main groups. The last of these is in a small hall but most of the figures are crowded in a narrow passage in the centre of the cave. They are exclusively of animals with both headless and vertical beasts represented; there are no human representations and no claviforms, although there are lines and dots that may be accepted as signs. Ekain abandons the basic formula in one further respect also; its figures, though mainly in black outline are upon occasion in red, or have quite extensive areas of red wash. Both Niaux and Le Portel do, in fact,

have red outline figures, but at Ekain this colour is used to produce bichromes that are technically different. Engraving is used with painting but except for some bunches of lines it is not here used independently. There are only fifty-three figures in Ekain but this relatively small number is compensated for by the fact that most of them are complete. Thirty-three of these are horses; the remainder comprise ten bison, two deer, four ibex, two bears and two fish. In size they range, with a few smaller and larger examples, from forty to seventy centimetres in length. This is consistent with Le Portel, for example, but smaller in scale than Niaux where many figures are over a metre in length. However, it is the style of painting, of the horses in particular, that allies Ekain to the Pyrenean caves. The closest parallel to the horse with schematic coat markings from Le Portel is to be found at Ekain and many more such examples might be cited, for the Ekain horses with double shoulder line and wavy ventral coat markings are very typical of the Niaux/Le Portel style. The horizontal stripes on the leg that some of them show, is not, however, a Pyrenean trait; the only parallel known to this is from Tito Bustillo in Asturias. It may be explained as a more than usually observant record of the animal's coat marking for Darwin recorded such stripes on an Isabelle (dun) pony from Devonshire (Rousseau 1973). They also occur very occasionally, on Przewalski's horse, usually on one of the same colouring as Darwin's pony, that is a pale Isabelle. Darwin's pony showed the shoulder-line markings as well as stripes on the leg but although

104 Two bears, one headless, in heavy black outline, the paint now rather blurred, from Ekain, Guipuzcoa. Together they measure 120 cm.

X

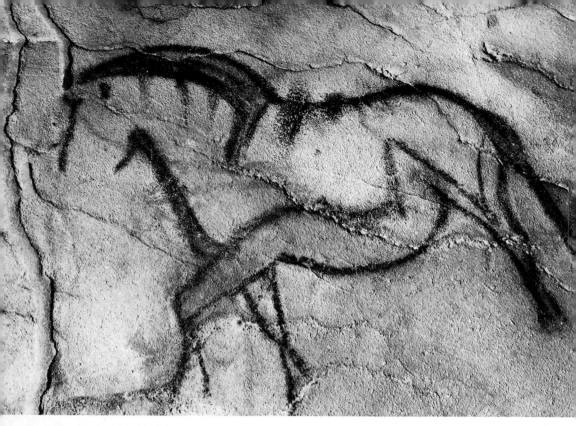

105 Horse painted in black in a very schematic manner from Le Portel, Ariège. 45 cm. long

106 One of a number of schematically painted horses from Ekain, Guipuzcoa that compare with the horse from Le Portel, Ill. 105. Length of this figure approx. 90 cm.

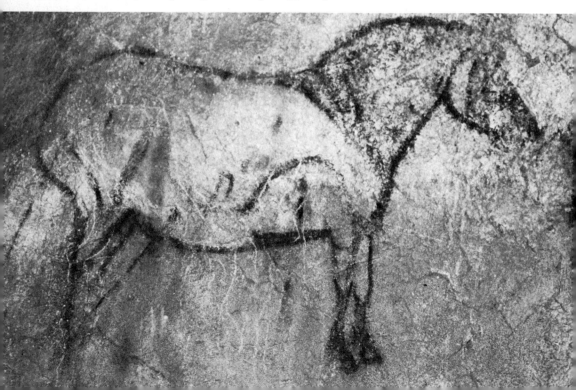

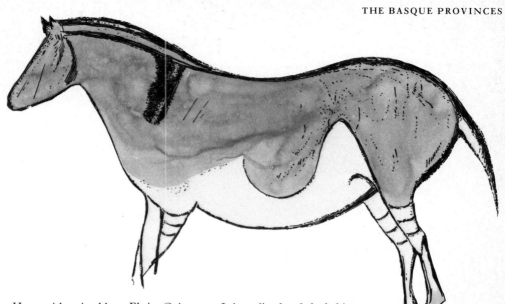

107 Horse with striped legs, Ekain, Guipuzcoa. It is outlined and shaded in black and measures 75 cm.

108 Dun Devonshire pony with shoulder and leg stripes, illustrated by Darwin

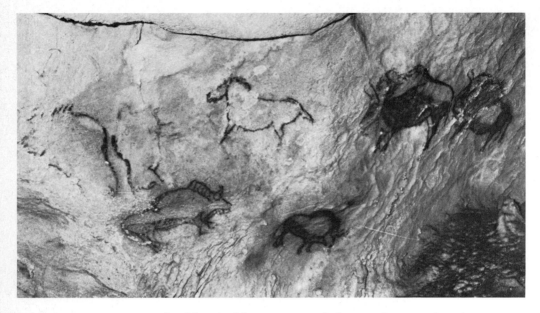

109 Panel of black outline paintings of bison and horse from Santimamiñe, Vizcaya. Two bison are drawn back against back on the left of this panel and the horse in the centre measures 45 cm.

shoulder markings are recorded on modern species, they are not now found in conjunction with leg stripes.

Ekain was as yet undiscovered when Leroi-Gourhan published his major study of Palaeolithic art in 1965. He therefore did not discuss it, but it might well stand as a prototype for his ideas on layout. The paintings are clearly grouped in panels, each showing the central association of bison and horse; a deer, clearly in a peripheral position, an ibex, less conclusively so, and a fish are adjuncts to the main panel; the other two interior groups have horse, bison and such signs as exist in the cave. The bears are in a 'diverticule' deep in the cave, consistent with their status as peripheral or end figures, and the first group encountered, nearest the entrance, consists of some odd lines, one horse's head, two ibex, a stag and a fish, predominantly marginal or entrance figures. One could consider the stag and ibex peripheral to the horse in this group, or all these figures as representative of an entrance group; the stag, for example, has a more than random chance of being found in entrance or rear situations. Here is the essential distribution that Leroi-Gourhan takes as a basis for his fan-shaped layout scheme. As one may see amongst the caves belonging to the black outline group, in which no single cave adheres exactly to the total basic formula but in each of which is found a recognizable selection of the basic traits, so cave layout may equally be regarded as a selection of possibilities taken from a basic master plan and adapted to the individual

topography of a particular cave. Whether you accept either of these theories will probably depend upon whether you think enough basic traits are present to constitute a recognizable pattern. The question is not really whether there are exceptions to the rule, but whether the rule is itself demonstrable. As has been stated above, it is difficult to consider Niaux, Le Portel and Ekain together without seeing a coherence in style and content and the same coherence may be claimed for the layout of caves. In all aspects Palaeolithic art plays variations on a theme, rather than repeating one basic pattern; we have, for example, almost no copied pieces in miniature art and the situation is the same in caves. They are not replicated but are constructed as the re-expression of a continuing basic concept.

Geographically Ekain is the central example of the black outline formula caves; further to the east, but still within the Basque region there is Santimamiñe, near Vizcaya, and still more distant are La Cullalvera and El Pindal. The drawings in Santimamiñe, as in Ekain, are almost totally of animals, but bison is more numerous here than horse. Other species such as ox, stag and ibex tend to be represented by heads alone, but the exception to this is a very fine painted bear. Apart from two central bison the figures are small and the majority are painted in black, but a few engravings exist in the first of the two halls that form this cave; the paintings are in the second. Some authorities consider the differences in depiction here between simple outline and strongly shaded figures indicate a difference in style and age, but it is more probably only a difference in elaboration. Some are finished drawings and others, perhaps like the incomplete animals so often found in caves, are just additional figures. The shaded bison are very reminiscent of those at Niaux, both in the use of the diagonal emphasis with line stroke shading on the hind leg and stomach of the beast, and in the alternative heavy, near-solid shading for mane and body outline. They express the same static belligerence too but are much more coarsely drawn. While some elements of the black outline formula are omitted at Santimamiñe another is overemphasized: it has vertical animals in quantity. There are three vertical bison, two drawn facing each other on a column of stalagmite and two more back to back as well as two further animals that are upside down. For a cave with a small number of figures, about fifty in all, this is a very high proportion.

The question of close similarity between drawings from different caves is of interest. If they are very alike there are

110 Bison placed vertically, although in a normal upright stance, from Santimamiñe, Vizcaya. The total length of these figures is 80 cm.

96

18

109

perhaps three possible explanations. The first is that the same artist drew both, the second that whoever drew the second had at some time seen the first, and the third that both were copied from a prototype, perhaps a small object carried about in the hand. Considering the distances involved – Ekain is approximately two hundred and fifty kilometres from Niaux and Santimamiñe nearly three hundred and fifty – the last might seem the most reasonable explanation. However, in consideration of what we know of miniature art it is not at all satisfactory. There is for example no miniature art piece drawn in the manner of the Santimamiñe and Niaux bison; in miniature art the details chosen and the manner of shading this animal are quite different. In the case of horses the differences are not so extreme; a few miniature art pieces, such as the ivory horse from Lourdes, have the double shoulder line and wavy ventral marking but this is shown with hatching and hatching does not obviously translate into the flat wash pattern that is used on the horses from Sinhikole and Ekain. Furthermore no miniature art pieces show the same schematization that is found in the Le Portel and Ekain horses where the figures have almost been reduced to a pattern. Possible prototypes may have been painted, and the paint now lost, but paint even when fresh is apt to rub off and an engraved design (which we might have expected to find) would probably have suffered less from carrying. The most probable explanation

109, 96

19

10, XIII, 107

105, 106

111 Horse in black outline from La Cullalvera, Santander, 50 cm. long

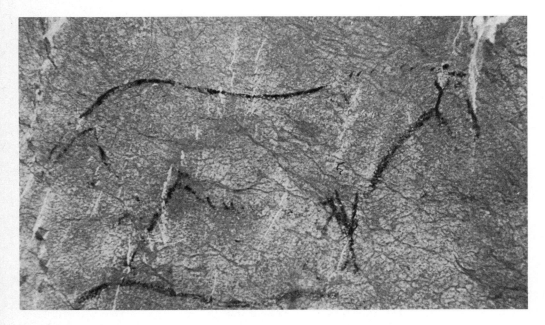

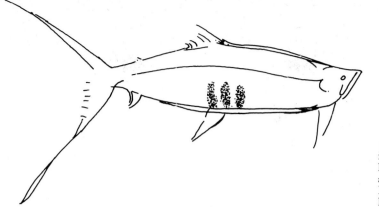

112 Engraved fish, which is perhaps a tunny, but has some characteristics of a salmon also, from El Pindal, Asturias. 43 cm. long

is that the bison in Santimamiñe were painted by someone who had seen Niaux, or if not Niaux itself, some cave now lost to us, painted in that same style; perhaps having lived with a group in Ariège, he then joined a group who hunted and gathered along the coast of the Pays Basque and, while there, painted a sanctuary according to his recollections of the original cave.

The decoration of Santimamiñe, which consists entirely of animals without accompanying signs, is not typical of Cantabrian sanctuaries. While the claviform is characteristic of both regions, in the Pyrenees there is only a small variety of other signs but in Spain they can be enormously varied and important. In some caves, such as Castillo, a whole gallery or diverticule may be filled with abstract designs and La Cullalvera, while belonging to the black outline group, reflects this regional bias. The signs it has are claviforms and dots, in keeping with its allegiance to the Niaux/Le Portel formula, but the proportional quantity in which they occur is excessive for this group. La Cullalvera is a very big cave but in one thousand metres only the most elemental decoration was attempted. It consists of two horses, perfectly comparable to those in the Basque sites, with numerous claviforms, dots and lines in series painted in both black and red. El Pindal is similar, being another magnificent cave with a careful selection of decorative elements. Its inventory is less restricted, though, comprising bison and horses, one of which is vertical, deer, a fish which is part tunny, part salmon, and a celebrated drawing of an elephant, which is probably more correctly identified as a mammoth. This figure has a red dot, traditionally described as its heart, placed in the centre of its flank. There are rows of dots and claviforms here also, though not in quite such abundance as at La Cullalvera. The style of the

5

43

bison, which is the most numerous species drawn in El Pindal, is entirely consistent with Niaux but at Pindal the majority of the figures are in red.

It is, to a certain degree, arbitrary to complete this very distinctive group of decorated sanctuaries with Pindal. Monedas in the Monte Castillo, near Santander, has many similarities for it has black outline figures of bison and horses, headless and vertical figures and a possible, though atypical, claviform. However, it has other signs as well as the claviform; it also has reindeer, which in Cantabria occur at a late decorative stage and the style of drawing in different. Black outline is still used and certain characteristic details such as the shoulder line on the horse still occur but the drawing is more delicate and fluid, in contrast to that at El Pindal, for example, or Santimamiñe. It has an almost graceful naturalness in place of the synthesized formality of the static figures, typified by Niaux or Le Portel. Stylistically it is clearly a later cave than these and for this reason is not included in the black outline formula group which consists of one-period, short-term sanctuaries which were, in all probability, contemporary. Every element in this formula group occurs in other caves; for example in the Pyrenees, Le Tuc and Les Trois Frères have bison and horse associations, claviforms, ghost figures and vertical animals, while Bédeilhac or Fontanet have virtually all the basic traits, but their inventory is not limited to these. Bédeilhac, for example has drawings in mud, engravings, models, sexual symbols, both masculine and feminine, while Fontanet has numerous fine engravings, a polychrome, a sorcerer and a female figure in addition to the ghosts. Such a variety of decoration is a barrier to their being included in the black outline group which is as much defined by the omission of certain traits as by the existence of others. The situation is the same in Spain; Monedas is later but certain galleries, or panels in Pasiega or Castillo are clearly related to the Niaux/Portel group. It is probable that at this period many caves were refurbished with this formula or that, in some caves where this decoration was initial, other figures and motifs were added later. In either case they do not qualify as one-period caves. The definition of a black outline group of Niaux and Le Portel type is in any case not intended as a rigid classification; it is simply put forward here to show that in Palaeolithic art a formula may be recognized and seen to be repeated.

In Cantabria, as in Périgord, the decoration of sanctuaries extends over a long period of time. There are caves with early

113 Black outline painting of a reindeer, placed in a vertical position on the wall of Las Monedas, Santander. Approx. 70 cm. long

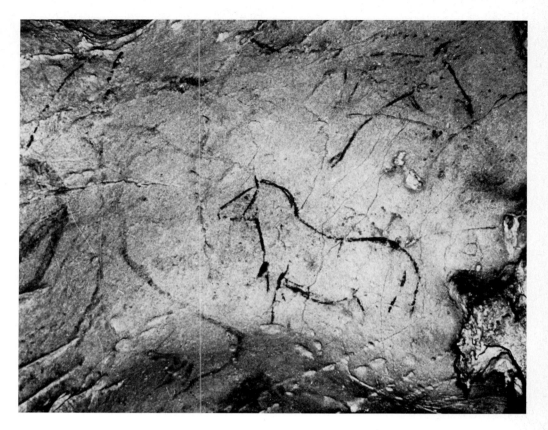

decoration, at least Archaic in style, that is they are Solutrean and early Magdalenian in date, and there are caves decorated in the characteristic style of the late Magdalenian. Covalanas, near Ramales, is an example of the first and La Loja, near Santander, with a frieze of cows that is evocative of Teyjat, an example of the second: as we have seen, the question of the middle Magdalenian, more particularly Magdalenian IV, is controversial. In addition to single-period caves of various date there are sanctuaries of long use such as Altamira, Pasiega and Castillo, all in the Santander region, where subsequent figures have been superimposed, or deeper galleries utilized in successive periods.

Cantabrian Spain, at the extreme western limit of the Franco-Cantabrian art province, might be expected to show some regional variation but here, as in the other two major regions of Palaeolithic art, it is easier to define and recognize a chronological style that is common to all regions, than to find a regional one. In Spain perhaps certain techniques have a particular vogue that they do not have elsewhere, figures of a certain style may be

114 Two horses and a hind placed in a niche in La Pasiega, Santander. The central horse is black, the hind below it red, and the horse measures 47.5 cm.

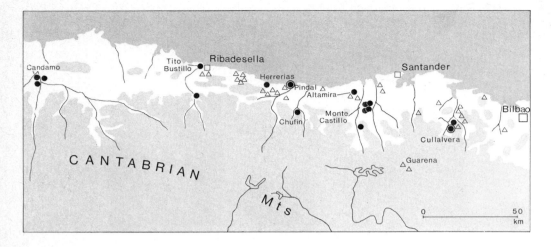

Candamo

Tito
Bustillo

Ribadesella

Herrerias

Pindal
Altamira

Chufin

Monte
Castillo

Santander

Cullalvera

Guarena

Bilbao

C A N T A B R I A N

M t s

0 50
km

115 Map showing the location of mural art sites of major and minor importance in the Cantabrian region. Sites of major importance are marked by a dot, those of minor importance by a triangle and sites belonging to the 'black outline' group are encircled. Contour: 500 m.

missing and a category such as signs may be more than usually important. These are really no more than proportional differences, but they are perhaps worth enumerating. An example of the vogue for a particular technique is the use of a dotted line to outline the figures, such as is known from Covalanas. The majority of animals represented in this small cave are deer, of which there are sixteen, but there is one horse and a possible bovid. They are painted in red with a distinctive pointillist dabbed line and, although the style of drawing is very simple, the figures are elegant and lively, particularly the string of deer on the right-hand wall, some with their heads raised and one with its head turned. Covalanas is in an upland valley, described by Breuil as an amphitheatre in the hills, and there are other decorated caves here. One of these, La Haza, has figures in the same technique; so has Atapuerca, which is farther inland to the east of Burgos, but is geographically accessible from Covalanas. If it were not that this same style occurs in Pasiega, near Santander, and at La Peña da Candamo, two hundred kilometres distant in Asturias, one might have recognized it as a regional group. As it is, it forms a chronological one, being stylistically early and shows a fashion in Cantabria, at this time, for dotted outlines in red.

8

An example of a missing style are the figures with very voluminous bodies and tiny legs and heads. Isolated examples exist but no whole sanctuary exhibits this trait as do those in Périgord.

Lastly, there is the importance given to signs. The early quadrangular forms that are found in Périgord do not occur in

Spain where the proliferation of signs seems to be a relatively late feature but brace-shaped and claviform types, comparable to those in the Pyrenees, do exist. Not only do we find variants on these and multiplications of them, but also a quantity of quite different forms. They still tend to be based on dots and enclosing lines but are bigger and, on occasion, form a decoration in their own right. The tectiform gallery in Castillo, for example, has no 5 animal or human figures. A number of these signs are related to vulvae, as at Chufin, about forty kilometres from Castillo, where XIII a suitably shaped hole in the rock is bordered by lines of red dots, while the brace- and shield-shaped signs of Pasiega and 40 Castillo are both quite convincing derivatives of this female 42 sexual symbol. Whether this schematization may be carried further to include all quadrangular and oval shapes, whether filled with patterns and dots, or not, is a matter of opinion. Breuil thought these abstractions were representations of huts, traps or even boats; his colleague Obermaier described them as spirit houses, while claviforms were most usually designated as clubs. Leroi-Gourhan traces all tectiforms back through a gradual process of schematization to a simple triangular or oval vulva, or 23 even to a divided square representing a vulva; by contrast in his scheme the claviforms derive from the complete female form which, with time, is reduced to an essential shape. This claviform progression is paralleled in miniature art where the naturalistic early Venuses are succeeded by increasingly

116 File of deer painted in red dotted outline, from Covalanas, Santander. The complete figure in the centre measures 60 cm.

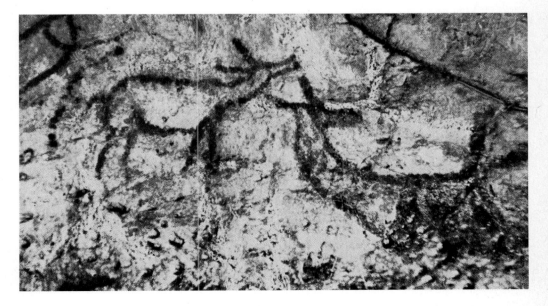

117 Signs painted in red on a gallery ceiling in Las Herrerias, Asturias. The complete composition measures about 300 cm.

schematized shapes; at first these have both breasts and buttocks but from this point they develop in alternative ways. In Russia, a rod figure may have two breasts, while in western Europe most 78 often only her rump is indicated. The claviform may be seen as a derivation of this shape.

Signs show a certain degree of both regional and chronological grouping. Quadrangular signs of the chequer-board type, such 39 as occur at Lascaux, are peculiar to Périgord and are also early in context. Brace-shaped signs everywhere are found in sanctuaries of late Solutrean and early Magdalenian date, Leroi-Gourhan's late Style III, and claviforms with his Style IV, more particularly with Magdalenian IV. Few signs are so consistent as the claviforms; Niaux, Le Tuc d'Audoubert, Marsoulas, El Pindal 43 and La Cullalvera all have the same type of claviform but much more usually each cave will have its own variant of a particular type and usually the presence of one type precludes the presence of others. If a variety of signs occurs in a cave it suggests that the decoration was made in more than one period. The meaning of these schematic signs is a question that still remains unresolved. Leroi-Gourhan thinks that all of them may be divided into masculine and feminine groups which reinforce his postulated masculine/feminine dualism among the animals but while the

feminine group of signs is demonstrable none of the other three propositions, that is the masculine group of signs and the masculinity or feminity of animals, is nearly so convincing. Leroi-Gourhan himself says that he can find no consistency in the pairing of signs, which suggests there is no uniformity among dots, lines and barbs such as there is among signs based upon female sexual symbols. Even in the female group some of the abstractions are so remote from the prototype that one might consider them to have become independent of it. Furthermore, although signs are nearly always associated with animal figures in caves one cannot tell how much importance there is in the association since in Spain, where signs have a particular importance, they also achieve a certain independence. At first they constitute the complete decoration of a particular panel or 'diverticule' in a cave but finally, on occasion, they may furnish the decoration of the entire cave as at Las Herrerias, in Asturias. Here there are twenty-three signs, mainly of a quadrangular grid pattern, a motif that although not exactly like those known from other caves, is as similar as many such associations usually are. Tentatively, this cave is ascribed to a late Magdalenian or early Azilian context, Azilian being the name given to the industries of late or post-Palaeolithic character that follow the last stages of the Magdalenian in both northern Spain and the Pyrenees. Azilian art, consisting (as it does) almost entirely of pebbles painted with dots and linear divisions, is often pointed out as a contrast to the naturalistic tradition of the Palaeolithic but if one considers the alternative Palaeolithic tradition, that of schematic signs, Azilian art appears less as a contrast than as a continuation. Some decorated Azilian pebbles are quite similar to the quadrangular signs of Altamira or Castillo, for example, and the colours used are the same, black and red. In the Azilian, signs have either come to embody all that was significant in Palaeolithic art, whether naturalistic or schematic, or the significance of the schematic element has superseded that of the naturalistic; what is left appears almost as a form of abbreviation.

To return to the earlier stages of the Upper Palaeolithic and having described a number of caves that show a short period of use, some description is needed of caves as famous as Castillo, Pasiega and Altamira, where the decoration has been accumulated over a long period of time. The caves in the Monte Castillo, near the village of Puente Viesgo in the province of Santander, form the largest complex of decorated sanctuaries known anywhere and if you wished to see Palaeolithic art in a day you

118 Pebbles painted with red ochre, Azilian in date and from Mas d'Azil, Ariège. Approx. 5 cm. in length

41

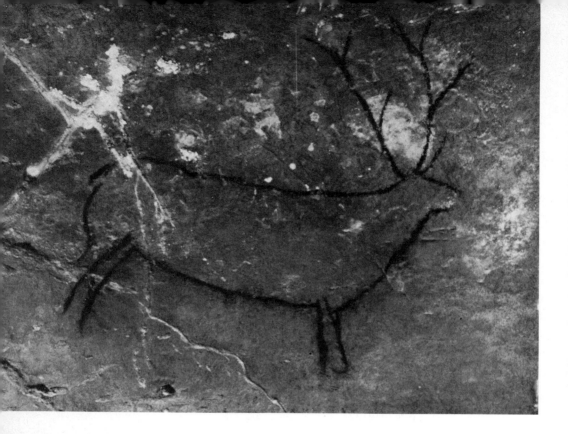

119 Simple black outline stag, typical of Leroi-Gourhan's Style III, from Las Chimeneas, Santander. About 40 cm. in length

could well spend it here. At present four groups of galleries with decoration have been found in this hill. Castillo was the first to be discovered; La Pasiega on the southern face of the mountain the second and Las Chimeneas and Las Monedas, near Pasiega, the most recent. They are not, like the Volp caverns, all of a similar period but between them cover practically the whole span of Cantabrian art; Chimeneas and Monedas are single-period caves, the first early, the second late, and Pasiega and Castillo are multiple-period sanctuaries. Las Chimeneas is decorated with engravings made in the soft clay film on the entrance wall and with black outline paintings of stags, hinds, horses, oxen, ibex and signs of a simple quadrangular type further inside the sanctuary. The simplicity of the drawings and the stiff legs of the stags correlate these figures to Leroi-Gourhan's Style III. Almost the same stage is represented in La Pasiega and Castillo, clearly separated from other stages in La Pasiega but superimposed with later figures in Castillo. La Pasiega (the Passage) is a complex in itself consisting of a gallery running parallel to the side of the hill with at least four entrances and several sanctuaries behind. Two of these galleries, A and C, contain a notable series of Style III paintings; Gallery A contains, as does Las

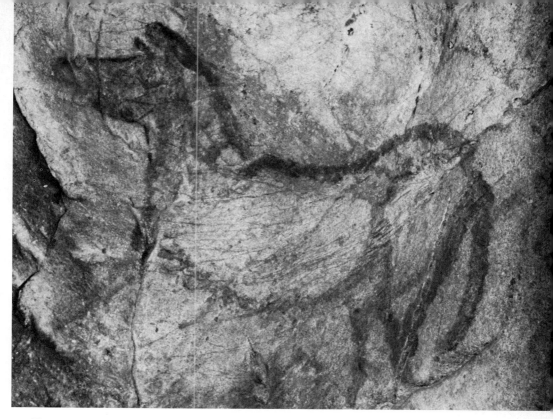

120 Horse in heavy red outline, 77.5 cm. in length, from La Pasiega, Santander

121 Bison painted in brown and black outline, later in style than the horse of Ill. 120, La Pasiega, Santander. Length 66 cm.

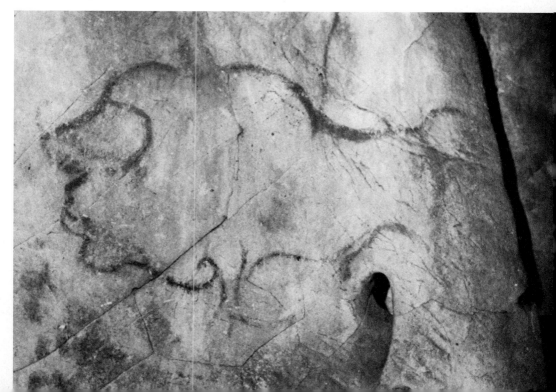

Chimeneas, oxen, horses, stags, hinds and one ibex, but in this instance in red paint and with brace-shaped signs in quantity rather than quadrangular forms.

'Brace-shaped' is a name given to those signs with a centrally placed protuberance at one side, suggesting the shape of a coat-hanger. Leroi-Gourhan considers that they are allied to the claviform group but in Pasiega the signs classified as brace-shaped have clear affiliations to the quandrangular group. Chimeneas has basic quadrangles, Pasiega has oblongs with rounded corners, occasionally with a protuberance at the side, and Castillo has the same oblong to ovoid form without protuberances. Although the tectiforms of Pasiega are called brace-shaped and those of Castillo are not, they are very similar and, as at Castillo, they are concentrated in a recess at the back of Gallery A. This gallery has a great many painted figures; some are close to Chimeneas in style, a few are even reminiscent of Covalanas with a daubed line, but the majority, although still simple outline drawings, are more advanced in form and must be considered to represent a very late stage of Style III. The assemblage in Gallery C in La Pasiega is similar to that in Gallery A but has in addition a group that is later in style, consisting of bison, horse and ibex associated with two claviforms, which is located deep inside the gallery. Galleries B and D have less coherent compositions than A and C but B contains, in addition to three further claviforms, the famous 'inscription'. This is a group of signs that in Leroi-Gourhan's opinion are variants on the quadrangular and brace-shaped forms, arranged in alignment, but which for Breuil and others have represented a boat, or a house without a roof, and two footprints.

Although the cave of Castillo itself shows four possible periods of decoration, none represents the claviform stage of La Pasiega. Castillo is a very big cave that had an unrivalled sequence of deposits at the mouth; these were dug early in this century and never fully published but if this material is inaccessible to archaeology the figures on the walls remain, available for each and every successive interpreter to study. The topography of the cave is complicated by huge falls of rock that choke the big hall, making access to the lateral galleries very circuitous, so that successive panels of decoration here are not found in increasingly deeper situations but must be elucidated by style. Breuil recognized two principal periods of use in Castillo and Leroi-Gourhan endorses this. The most important early sequences are to be seen on the right-hand side wall of the

122 A group of signs, usually described as the 'inscription', from La Pasiega, Santander. Total length, 56 cm.

main entrance chamber, where they are overlaid by later figures. Amongst those classified as early are a great many hands in negative, often associated with dots, a number of bison, hinds and horses and some elaborate tectiforms, the majority of which are grouped by themselves on the low ceiling of a small recess. Other drawings in Style III are found at what was originally the back of the main chamber and on the right-hand wall of one lateral gallery. Figures of Style IV are found in the same zones, with the exception of the group in the lateral gallery which has no later superimpositions. At the back of the main hall there are bison, horse, ibex and stags with a vertical bison based upon the natural relief of a stalagmite column and nearer the entrance three polychrome figures are superimposed on some earlier works. In fact they appear to utilize the earlier paintings; the red paint surrounding the hand prints provides the body shape of the bison and details are added with touches of black. There are numerous further animal figures in Castillo distributed throughout the cave; these are both painted and engraved and are principally of horses but also of ibex and stags. In particular, among the engraved figures, there are the famous hind and stag heads with striated shading that echo the engravings on shoulder blades recovered in the Magdalenian deposits at the mouth of the cave. This correlation, which is repeated at Altamira, formed one of Breuil's key links in dating Palaeolithic mural art (Chapter 2).

Las Monedas has already been mentioned because of its relationship with the black outline group of sanctuaries that are found from the central Pyrenees to Asturias. Its style, though, and the presence of reindeer, suggest it is later than these. It has no typical claviforms and is usually considered as one of the latest of all Spanish sanctuaries. However, it represents a different tradition from that of Las Herrerias for although it has a variety of

5

21

20

113

atypical signs these have not here superseded the animal figures in importance. In each of the first three of these four caves in the Monte Castillo there are certain figures that are similar to those in another, but no two groups are identical, although they are in such close proximity. Including Monedas, they appear to cover a continuous time span from the late Solutrean to the late Magdalenian, suggesting that this hillside was frequented and decorated over a period of about six thousand years, that is from approximately nineteen to thirteen or twelve thousand years ago.

There remains Altamira, which is perhaps the most famous of all Palaeolithic caves and certainly the most famous in Spain. It owes its notoriety to the romantic story of its discovery, to its possession of the largest group of polychrome paintings known in Palaeolithic art and to the quality of these. Polychrome is a misleading term for, with very rare exceptions, only two pigments are used in these paintings although a third basic colour is given by the wall surface and a further variety of tones achieved by scraping the surface or overlaying one pigment with another. To distinguish such polychromes from bichromes is, to a certain extent, arbitrary, for the only real difference is that in bichrome the wall colour is not exploited for colour and shading as it is in polychromes. However, the term is widely used and it would only be confusing to reject it. There are two caves with polychromes in Périgord, that is Lascaux and Font-de-Gaume, three in the Pyrenees, Fontanet, Labastide and Marsoulas and four examples in Spain, that is Altamira, Castillo, the Cueva Oscura d'Ania and Tito Bustillo. Castillo and Altamira are geographically close to each other and their polychromes are very similar in style: the Cueva Oscura d'Ania has a single bison in the Altamira style but is one hundred and sixty kilometres distant in Asturias while Tito Bustillo, also in Asturias, has a rather different series. Lascaux, Altamira and Tito Bustillo have the most important assemblages of these paintings and those at Lascaux are accepted as the earliest, however you may date the remainder.

The dating of the Spanish polychromes, as with other painting in Spain, is problematic. Breuil considered those at Altamira and Castillo to be among the last decorations made in the caves and placed them in Magdalenian V, as he did the examples in Font-de-Gaume. Leroi-Gourhan, however, places the Altamira sequence in his Style III. Of these two attributions Breuil's seems the more satisfactory for, while the Altamira ceiling precedes Monedas or Tito Bustillo stylistically and

II

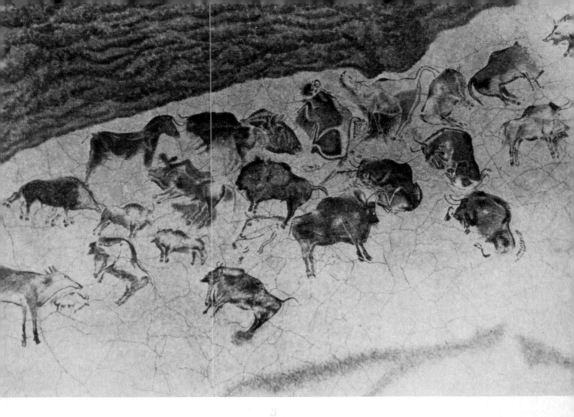

cannot therefore be later than Magdalenian V, it is clearly not prior to Niaux and therefore can hardly be placed in Style III.

The painted ceiling with polychrome figures at Altamira is in a small room approximately eighteen metres by nine to the left of the present entrance and not far inside the cave. According to Breuil its twenty-five figures include fifteen bison, one of which is headless, three hinds, three wild boar, two horses, a wolf and a number of claviforms. Leroi-Gourhan assesses the numbers and species somewhat differently, including a possible human figure and an ibex but omitting the wolf. One may account for the different opinions by the fact that a number of figures, particularly those nearest the entrance, are now badly faded. The polychrome group is superimposed on earlier painted sequences in black and red and, as at Castillo, the earlier red-wash figures are on occasion incorporated for use as a colour base in a polychrome. The sloping back wall of the hall has further early paintings, hand prints and numerous engravings and there are small engravings on the main ceiling also, including some of human figures. Many of the polychromes are very large, some being more than two metres in length, and most of the animals are coloured in red and brown wash with details of mane, head, feet and tail emphasized by strong, usually discontinuous, black

123 Reconstruction of the ceiling with polychromes at Altamira, Santander. This (from hind to wild boar) measures approx. 1800 × 900 cm.

II
140
lines and by over-engraving. The perspective of one leg in front of another is achieved by scraping off the pigment between the two, a technique already known at Lascaux and repeated at Font-de-Gaume and elsewhere. The most striking aspect of the Altamira figures, however, is their utilization of the natural
30
contours of the ceiling. This has a series of low rounded bosses, evocative of low relief carvings, and these have been used to give three dimensions to the polychrome figures. Bison stand or are curled in a sleeping position on each boss, the individual shape of which no doubt suggested the attitude of its figure. The effect is very sophisticated, as is the drawing of the animals themselves. This is rigid and formal but beautifully detailed and decorative. Pigments were used not only to colour the animal naturally but to build contours as well and indicate muscles. The formalized, synthesized way of treating an animal figure, particularly characteristic of the bison, is reminiscent of painting ascribed to Magdalenian IV elsewhere; the animals of the ceiling at Altamira are technically rather than stylistically advanced, that is they are most expertly painted but in a manner more archaic than at Monedas, for example, where the figures are in proportion, more realistic and freer in movement.

Support for assigning the polychromes at Altamira a date near to Niaux, which their style suggests, is given by the composition of the ceiling group itself. One of the characteristics of the decoration of the main ceiling at Rouffignac (Chapter 5) is the occurrence of a single large figure, or head in the case of the bison, of each species amongst a number of smaller drawings of the same animal. This is not a common feature; it was observed
89
X
by Breuil to exist in the Sanctuary in Les Trois Frères and it may be seen at Tito Bustillo also. Rouffignac and Les Trois Frères could be placed in late Magdalenian IV or possibly in early Magdalenian V and the decoration at Tito Bustillo also probably covers a period equivalent to late Magdalenian IV and V of Périgord and the Pyrenees. When the same feature occurs at Altamira, in this case a very large bison's head placed between
123
two complete polychrome figures, one may consider it an indication of contemporaneity with other like groups. Most of the arguments for dating the polychrome ceiling at Altamira to Style III are based upon expediency. It is felt that some continuity with Lascaux and with low relief friezes must be looked for and there is the problem of the rockfalls that closed the entrance of the cave. Present opinion in Spain is that the entrance of Altamira was closed in Magdalenian III but Breuil,

who knew and worked with a number of the original excavators, did not hold this view. 'The excavations, which induced several more falls of stone, revealed that there had been five successive collapses. The last two, which definitely sealed up the cave, date from the end of the Magdalenian age' (*Four hundred centuries of Cave Art*, p.67). We now have no conclusive proof of when this entrance was closed; in any case caves may have more than one entrance and the possible closure of the most obvious need not dictate the dating of the polychrome ceiling. As for the continuity with Lascaux and low relief work, the only similarity between Lascaux and Altamira is the use of polychrome and this is not a similarity in style but only a convergence in technique. Most low relief work is Solutrean or early Magdalenian and the use of the bosses on the Altamira ceiling argues an appreciation of relief, but no conclusive judgement may be drawn from this; not all low relief work ends with the early Magdalenian, Cap Blanc being, in all probability, later, as is Le Tuc and a preoccupation with suggested shapes is always present in Palaeolithic art and has no chronological significance.

The polychrome ceiling, however, is but a part of the decoration in Altamira. This cave, like Castillo, was decorated in many periods. Beneath the polychromes themselves are a black and a red series and the black recurs throughout the cave; it comprises oxen, bison and horses executed in outline with little modelling and Leroi-Gourhan considers that the quadrangular and ladder-like signs, in both black and red, are associated with these figures. Between the entrance and the back of the cave there are approximately sixty groups of signs in black, mostly simple dots and strokes but, as at Pasiega and Castillo, there is a diverticule entirely devoted to more complex forms. At Altamira this is virtually the last group of paintings in the cave; only two masks, or ghosts, exist beyond it and it consists of a series of black quadrangular tectiforms with two less usual porcupine-shaped designs amongst them. In general when it is said that no two 41 signs are alike, the meaning is that they are not identical; they are often like others, but never replicas of them. This is the case at Altamira: the black quadrangles are clearly related to the red group in Castillo, although the porcupine shapes are more 5 original.

Tito Bustillo, one hundred and nineteen kilometres west of Santander has not yet been fully studied or published but is open to the public. As stated above (Chapter 4) it was perhaps originally a daylit habitation site although the frieze is now, like

X

all the surviving polychrome groups, in protective darkness. There are more than twenty animals in the grand panel above the habitation area; they are of varying size but some are very large, in particular two beautifully drawn horses and a reindeer with a striped neck that is over two metres in length. There are further figures in the recesses of the cave wall beyond this panel and some now rather faded figures on the wall opposite to it. Violet occurs as a colour here, as it does for some hands and signs in Castillo, but whether this was chosen or is due to chemical change in a different pigment is not verifiable. There are some early red paintings in other parts of the Tito Bustillo cave and it is possible that the red ground of the main panel is obtained from such a series but more careful study is needed to determine this. To date, the paintings have been ascribed to Magdalenian III, IV, V and VI but all one may confidently assert is that the shoulder-line markings on the horses and the striped legs of one of these suggest Magdalenian IV and an association with Ekain, while the presence of a number of reindeer, as at Monedas, suggests a date later than this for some at least of the paintings.

The caves described here do not form a complete inventory for Cantabrian Spain. Candamo, in Asturias, with very fine black paintings, Buxu, also in Asturias, with quadrangular signs recalling those at Tito Bustillo and Hornos de la Peña, near Santander, with a series of beautiful engravings, are all caves of major importance, but there is not enough space here to describe more than a selection of caves in any region. In summary, what is perhaps most remarkable about the caves on the Atlantic coast of Spain is their lack of a regional style. In relation to the central Pyrenees and Périgord they are comparatively isolated but, except in the proliferation of signs, they seem not to have pursued an individual line of development. As elsewhere, a chronological style is more easily recognized than a regional one and Cantabrian Spain appears to have belonged, as much as Périgord, to the mainstream of Palaeolithic art.

8

Palaeolithic Art outside the Franco-Cantabrian Region

If a consistency of style is characteristic of the Franco-Cantabrian art group formed by Périgord, the Pyrenees and Cantabrian Spain, the same is true of regions outside this area. Central and southern Spain, Italy and the Rhône Valley form a Mediterranean province that has a characteristic style of its own, related to, but distinct from, that of Franco-Cantabria. While there are caves of a clearly 'Cantabrian' type in central and southern Spain there are also Palaeolithic caves here with a Mediterranean bias; in addition, there are decorated rock shelters in eastern Spain which, though different in style and date, owe their derivation to one or both of these earlier traditions. Since this book is based upon regional divisions it seems consistent to follow the Franco-Cantabrian group with a description of the remaining caves in Spain although the group in the Rhône Valley, for example, precedes these in date.

Firstly there are the caves that are clearly outliers to the typical Franco-Cantabrian complex; these form two principal groups, one in central Spain, near Madrid, and the other in the South, principally in the province of Malaga. Los Casares is the best known of the group near Madrid. There are also La Hoz, El Reguerillo and a newly found cave near Albacete, La Cueva del Niño, which may perhaps be included in this group although it is farther to the south-east. The figures of deer and stags in the Cueva del Niño are evocative of Chimeneas or Covalanas and it is relevant to recall that there are two Palaeolithic caves in the hills above Covalanas, on the route leading to Burgos; they are Penches and Atapuerca, which form a possible link between Cantabria and central Spain. In Casares large heavily cut outline figures are superimposed on smaller, more delicate engravings; horses, bulls, red deer, ibex, a wolf, two bears, a glutton, a bird and a number of disguised human figures are depicted; an inventory, in fact, typical of sanctuaries farther north and the style of the horses, in particular, shows a similarity to the

8

119, 116

124 Engraved horse heads from Las Casares, Guadalajara. Approx. 15 cm. in length

Cantabrian. La Pileta and Los Ardales are the most famous caves in the southern group; Nerja, La Cala and Las Palomas have only a few figures each and the most that can be said for them is that they are very unlike those of the local Neolithic. Ardales has a panel of superimposed deer heads in yellow and red ochre that is again evocative of the Covalanas style and a number of simple outline engravings of deer and horses that are less so. Like La Pileta it has a certain ambiguity of style, showing both Cantabrian and Mediterranean traits. La Pileta is a huge cavern with a complex of galleries that even now have not been fully explored and it has been decorated in all periods. The sequence of Palaeolithic painting appears to be yellow, red and lastly, black. Amongst the earliest drawings are serpentine macaronis made with the fingers and there is a great variety of signs, usually in red, including quadrangles of the Buxu type, fringed circles or ovals, like the porcupine signs at Altamira (but here described as tortoises), and varieties of claviforms as well as many other more individual forms. The largest group of black animal figures includes seventeen ibex, fourteen horses, eight stags, seven oxen, six fish and many incomplete figures in addition. Signs rival the animal drawings in quantity and importance and either to date or ascribe the style of La Pileta is difficult. The round bodies and large heads of some of the outline figures are traits that are more Cantabrian than Mediterranean in appearance and many of the abstract motifs have parallels in the north but some animals and humans are schematic in appearance, tending towards the Mediterranean style. Breuil thought Pileta, Casares and Ardales

41

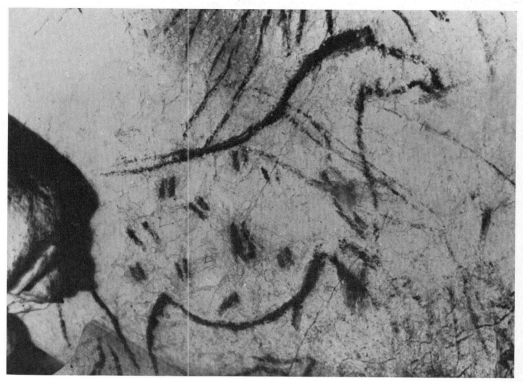

125 Horse painted in black, with markings of double dashes from La Pileta, Malaga. 55 cm. in length

126 Very large fish, painted in black, from La Pileta, Malaga. 150 cm. in length

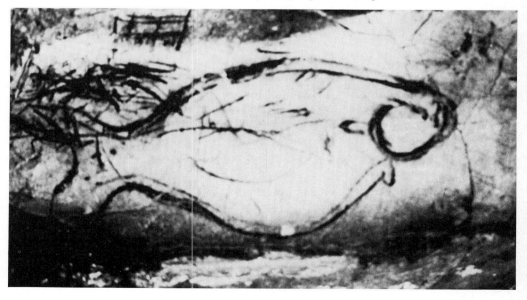

127 Engravings on stone plaques from the Magdalenian levesl of Parpalló, Valencia. The fragment at the top with a serpentine design measures 16.5 cm., that at the bottom with a similar design, 9.5 cm. The bovid, second from top, measures 5.5 cm. and the criss-cross pattern, 6 cm.

were relatively archaic in appearance and since Magdalenian industries are lacking in central and southern Spain these caves are usually attributed to the local Solutrean or Epi-Gravettian stages. Beyond confirming that they are Upper Palaeolithic, however, this gives them no firm date.

In contrast the sequence at Parpalló, in Alicante, is firmly dated. Plaques, both engraved and painted, were found in quantity throughout the sequence here and, although not mural art, they form a type series for the Mediterranean style in Spain. The earliest plaques in Parpalló are found in the Aurignacian levels, they continue in the Lower Solutrean, become very numerous in the Upper Solutrean, numbering more than two thousand, are less rich in the early Magdalenian but numerous again in Magdalenian III, which has more than one thousand such. There is a gradual tendency throughout towards schematization and the use of geometric motifs. The definition of a Mediterranean style comprising both mural and miniature art was made by Graziosi and based upon a study of Italian sites; the definition holds, however, for Spain also and for a number of sites in the Rhône Valley. Stylized, geometric or abstract art, as shown at Parpalló, develops alongside and has equal importance to the naturalistic element, though they are not always found in equal proportion; in extreme cases one site may have no naturalistic element and another nothing but. The recognizable characteristics of the naturalistic drawings are the use of a simple outline with no interior detail, except an eye or nostril; a disregard for feet; sometimes a single foot may be shown but most often the animal's legs end in a point, and the horns of bovids are drawn pointing forward with the line of the horn often cutting across the profile of the animal's head. The schematic element is formed of zigzags, parallel lines and ribbons. There is, of course, a schematic as well as a naturalistic element in Franco-Cantabrian art, whether on the walls of caves or on portable objects but the Mediterranean group is differentiated on the grounds that here the schematic element has a greater proportional importance. However, the differences are not always clear cut; Graziosi for example, claims La Pileta and Los Ardales (but not Los Casares) as Mediterranean in style, but does acknowledge the Cantabrian influence here. Whether you consider them primarily Cantabrian or Mediterranean is probably, to a large extent, subjective and one can suggest that the two styles are here in contact.

In eastern Spain few further sites have been found and, save

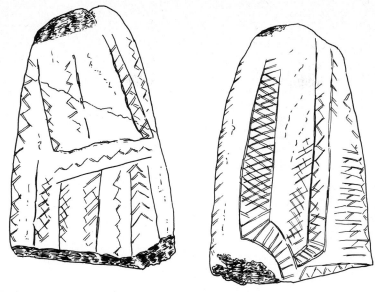

128 Pebble with engraved geometric decoration from the cave of Barma Grande, Grimaldi. 5.5 cm. in length. Musée de Saint-Germain-en-Laye

for Parpalló, the dating of all Mediterranean Palaeolithic art is problematic; it does, however, seem to have survived into the post- or epi-Palaeolithic. Two caves, newly discovered at Ojo Guarena, near Burgos, are in this style and appear to be relatively late. These are the Cueva Palomera, with deer in outline and multiple lines, either straight or in zigzags, and La Cueva de Kaite. Here there are outline animals, again deer, that are very schematic with over-long legs and groups of wavy lines in pairs, zigzags, criss-crosses and meanders mixed up with the animals. There is also one panel in the Levantine (East Spanish) style here but it has no similarity to the rest of the engravings in this cave. Breuil maintained that Spanish Levantine rock-shelter art was derived from the Franco-Cantabrian and was Palaeolithic in age, but this claim has little support nowadays and the whole group is generally considered to be post-Palaeolithic. However, although its style is distinct, it probably did derive from Mediterranean or Franco-Cantabrian art for it shares many elements with one or the other of these. Pericot, who excavated Parpalló, has emphasized that climatically the Quaternary and post-Quaternary periods were little different in the Spanish Levant, where hunters pursued the same way of life in both epochs and he sees a steady evolution in the art also: at first it is primarily concerned with animals, then the human figure is introduced, progressively group scenes are shown and finally it is combined with schematic art. It is plentiful and fascinating but since it is post-Palaeolithic it is outside the scope of this book.

129 Engraved deer from the Cueva de Kaite, Ojo Guarena, Burgos. This panel is 77 cm. high

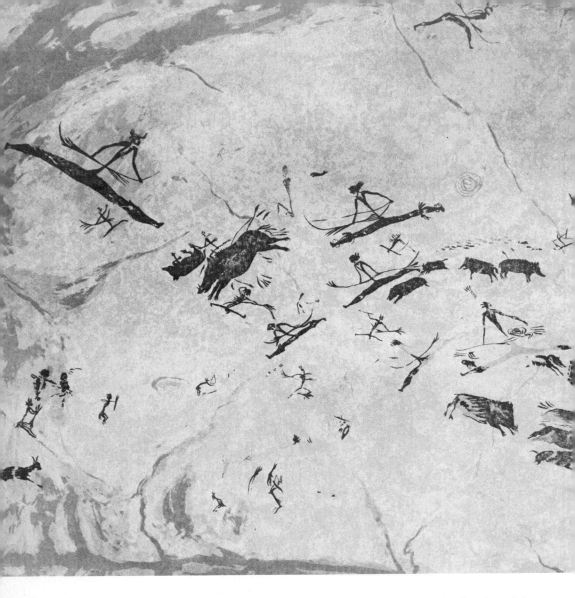

The emphasis on the human figure which is developed in Spanish Levantine art is probably an element derived from the Mediterranean art province, as is also the depiction of scenes. For example, at Addaura in the Monte Pellegrino in Sicily, there is a whole panel of human engraved figures, undoubtedly composed as a scene which, by analogy with a comparable site on the Isle of Levanzo, not far distant, is late in date. A naturalistic engraving found in the habitation deposit at Levanzo which is similar to the paintings on the cave walls has a radiocarbon date of $9,694 \pm 910$ BP suggesting a very late or post-Palaeolithic age for the figures here, which perhaps endorses the stylistic

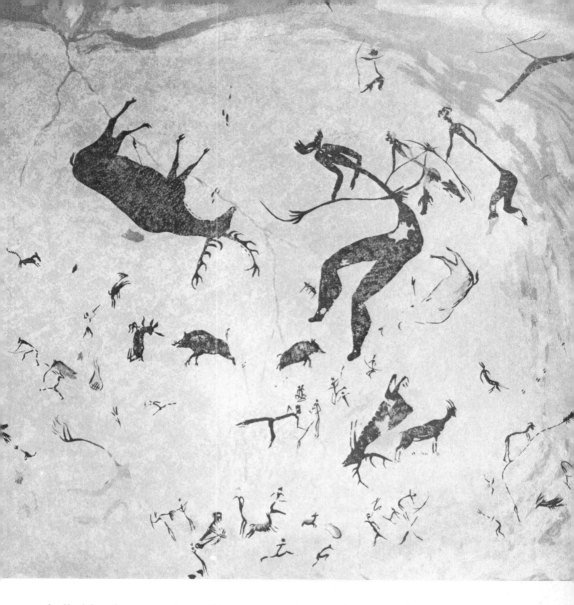

similarities between the Addaura engravings and those of
Spanish Levantine art.

There are three principal sites with mural art in southern Italy
and Sicily, claimed as Palaeolithic, but none in the rest of the
Peninsula. They are, firstly Romanelli, near Otranto in the heel
of Italy, where the naturalistic figure of an ox in outline is
associated with a schematic design, vulvae and shuttle-shaped
engraved motifs that are probably highly stylized female figures.
Secondly there are the sites in Sicily and on the now separate
island of Levanzo. The decoration at Levanzo is found in a dark
gallery behind the daylit, occupied shelter; it consists of more

130 Scenes painted in
black and ochre on the
rock shelter wall at Ga-
sulla, Castellon (Spanish
Levant). On the left seven
bowmen converge on a
herd of wild boar and on
the right there is a large
deer painted upside down,
presumably to show that it
is dead. The complete
frieze is approx. 200 cm.
wide

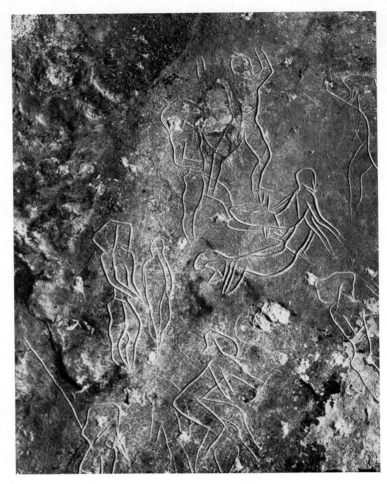

131 Central part of an
engraved panel at the
Grotta dell'Addaura, Pa-
lermo, showing to 'ath-
letes' or initiates among a
group of other figures.
The figure at the top of
this composition, with
raised arms, is 24 cm. high

than thirty figures, complete and incomplete, including twelve
horses, ten oxen, six deer, one possible carnivore and four
humans. The engravings are in outline only but the variety of the
poses, one ox full-face, two deer turning their heads and an ox
with its tongue protruding, following a cow, preclude their being
very early. The human figures show no affiliation to Franco-
Cantabrian forms, or indeed to the usual Mediterranean; the
central figure with a fan-shaped head, decorated with hatching
on the edges, has closer parallels in central Europe than
anywhere else. There are two decorated caves in the Monte
Pellegrino near Palermo (in Sicily), Addaura and Niscemi, the
second having three bulls and two horses in a style comparable to
Levanzo. Addaura is unique in Palaeolithic art in that the human
figures here are better drawn and more numerous than the
animals. There are approximately seventeen humans and fifteen
animals and they form two groups: the first, rather diffidently

132 (*opposite*) Engraving
of a young deer, with its
head turned backwards,
from Levanzo, Egadi.
20 cm. in length

engraved, is mainly of animals and the second, deeply incised, is principally of humans, but there seems to be little chronological difference between the two. Addaura is a small cave and all the engravings are lit by daylight. The animal engravings of oxen, deer and horses are like Levanzo in style but the human figures are very different. They have certain characteristics often found in Palaeolithic art, such as beak-shaped faces and a certain schematization but they lack the tentative, fugitive air that characterizes many Palaeolithic drawings of humans; they are in a variety of well executed postures and they form an interrelated group. The central panel comprises perhaps a dozen figures, spectators or participators grouped around two central males; the spectators appear predominantly masculine, but on the edge of the group there is a woman carrying a pack, back to back with a man carrying a spear and a large fallow deer. The posture of the central figures has aroused much speculation; they have been variously described as acrobats, initiates or victims of torture. Each is lying on his stomach with his legs bent sharply backwards at the knee and with his feet apparently tied by a string to his neck. One has free hands, the other hands clasped around the back of his neck. Their sex is clearly indicated but, as Graziosi has pointed out, the emphasized penis may be the representation of a sheath, for it is drawn like the bird-beak disguise of some of the spectators. Two of these spectators have their arms raised but whether to cheer or to castigate one cannot tell: the scene remains a mystery.

131

The sites of the Mediterranean art province are relatively few and scattered: there are no caves in this style between southern Italy and the Rhône Valley, although there is a characteristic collection of miniature art pieces from the Grotta Polesini, near Tivoli in central Italy and a less characteristic engraving of a horse from the Grotte du Cavillon at Grimaldi. However, the last group of caves that may be included in the Mediterranean province is also the richest. This is the group on the west bank of the Rhône, north of Nîmes in the departments of Gard, Ardèche, Hérault and Aude; there are more than a dozen sanctuaries here, quite closely grouped in spite of their different departmental attributions. La Baume Latrone on the River Gardon and Aldène in Hérault have the most archaic appearance, while Colombier and Ebbou in Ardèche and Sallèles Cabardès in Aude have the most recent figures: in so far as can be determined from analogy with other sites and evidence from often old excavations the earliest sanctuaries were decorated in, or before, the early

XIV

Solutrean and the latest decorations added in the Magdalenian. The majority of the caves are considered to be Upper Solutrean in date, corresponding to a stage well represented in the archaeological record here, but, although many of these caves are daylit and were inhabited, the attribution of their mural decorations is largely conjectural. Engraving and painting are both employed in these Rhône caves; the painting is most often in red and there is no modelling or use of bichrome; simple outline figures with small heads and pointed or crossed feet are the rule. At La Baume Latrone macaroni designs and animal outlines are drawn with fingers dipped in the clay of the floor, or in paint, producing a multiple outline for an otherwise very elementary figure. A presumably later, single-line style is also used here, in some cases superimposed on the macaroni designs. La Baume Latrone is a deep cave, as are Aldène and Bayol, and mammoth is the species most numerously represented in it. Aldène is generally regarded as early, but the style of the engravings is not conclusive; some felines and a rhinoceros remain here, but the cave has been much disturbed by phosphate mining and probably many other engravings have disappeared.

133 Mammoth outlined with multiple finger tracings in mud, from La Baume Latrone, Gard. 150 cm. in length

134 Outline engravings of mammoth, mostly incomplete, on the ceiling of the Grotte Chabot, Ardèche

Mammoth are important in the decoration of Chabot also; some are engraved with other animals on the right-hand wall of the cave, more form a palimpsest frieze on the left and they occur with unfinished outlines on the ceiling as well. Chabot, Le Figuier, the outer cave at Oullens and the smaller caves of Sombre and Huchard, all in Ardèche, are daylit sanctuaries that share a uniformity of style, typified by deep-cut profile engravings. The fact that they are daylit perhaps confirms the Solutrean date suggested for them. The figures in the outer cave at Oullens have been much destroyed by frost but amongst the animals that remain are a mammoth and two bison, a species otherwise represented in this region only from Ebbou. There is a further cave at Oullens, behind the daylit hall, the entrance to which was reputedly blocked with deposits of proto-Solutrean date. It is decorated very schematically with a few unfinished outlines of mammoth and ibex and with numerous signs, mostly of a triangular form, all in red paint. Such schematization occurs in the Bayol cave also, where again it is classified as early, but there is no conclusive evidence for this date and extreme schematization might well be a late phenomenon.

Ebbou, also in Ardèche, is the richest sanctuary in the Rhône Valley, with more than fifty engraved figures. These are placed deep inside the cave, one hundred and forty metres from the entrance, and are cut on a soft calcareous film that covers the gallery walls. There is only one mammoth here, the majority of the figures being deer, oxen, horses and ibex, associated with a number of signs. The animals represent a synthesis of the Mediterranean style, having small heads, unfinished legs on occasion drawn as crossed lines, horns often in full-face profile and, although they are simple, many are very elegant. It is suggested that they are later in date than the Chabot group, though not so late as those Rhône caves with a distinctly Magdalenian aspect, that is Colombier and Sallèles Cabardès. In Ebbou there are two engraved bison heads, characteristically late Magdalenian in the treatment of the hair, which are quite different in style from the rest of the cave. These two heads, perhaps together with the ibex of Sallèles Cabardès and the masked faces and other figures of Colombier, may be ascribed to Magdalenian influence; the Magdalenian is represented in the archaeological record here by a local facies stratified above the 'late Mediterranean type' industries which, in their turn, overlie the Solutrean in this region. There are further examples of a typically Magdalenian type of art infiltrating the Mediterranean province from time to time. For example, the engraved bison at

135 Ibex engraved in the typical Mediterranean style with crossed legs and small head. Ebbou, Ardèche. Length 25 cm.

136 A bovid, 30 cm. long, engraved over the horns of another much larger figure, Ebbou, Ardèche

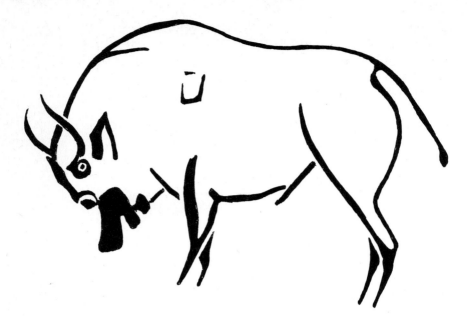

137 Small, but deeply incised engraving of a bison from Ségriès, Bassin du Verdon, Basses-Alpes. Length 16.5 cm.

Ségriès in the valley of the Verdon, which is the only example of mural art on the east side of the Rhône, is not Mediterranean but Magdalenian in style and both the wall paintings and the miniature art pieces from Paglicci in Apulia are Franco-Cantabrian in appearance also. The late Magdalenian, in particular, was a period of energetic expansion. This took the form of high-altitude colonization, as in the Pyrenees and Switzerland, or of long-distance penetration. There is miniature art of late Magdalenian date and type from Pekarna in Moravia and from Poland, while a single cave, decorated with mammoth, horses, rhinoceros and schematic signs, has been found on a tributary of the River Belaia in the Urals. The date of this cave, which is known in the literature either as Kapovaia or Choulgan Tache, is conjectural; all one can say is that the use of flat red wash without engraving and the static quality of the figures suggest comparisons with, for example, Font-de-Gaume in Périgord.

If it is difficult to date the Rhône cave group, it is perhaps less difficult to suggest its derivation. Graziosi has described it as a northerly offshoot of the Mediterranean province and there is some basis for this. The style of the animal figures is characteristic of the Mediterranean group, but it also has affinities to the Solutrean sanctuaries in Quercy, such as Pech-Merle, or Cougnac. The rarity of human figures in the Rhône

group, in contrast to Italy for example, and the paucity of miniature art of all types, but of schematic in particular, also suggest the Rhône caves owe as much allegiance to France as to the Mediterranean. In fact this is not a contradiction in terms; if the Rhône group was established early, perhaps in a period of climatic amelioration, and became independent when the Solutrean industries consolidated their position on the west bank of the Rhône, this does not conflict with the idea of a Mediterranean province. in Graziosi's definition the Mediterranean group is differentiated from the Franco-Cantabrian, not in its initial form, but by its perpetuation of early traits. Generally this is a result of isolation from Magdalenian influence. Southern and central Spain, Italy and, until the final stages of this culture, the Rhône, had no Magdalenian. The industries that took its place were developed forms of earlier generalized Upper Palaeolithic types, such as the Epi-Gravettian in Spain, the Romanellian or Grimaldian in Italy and the derivatives of the Pavlovian and other cultures in central Europe. If one wished to find an origin for the Mediterranean art group one might consider its similarity to the art of central

138 Horse in red wash from the cave of Kapovaia (Choulgan Tache), southern Urals. The figures in the frieze vary between 44 and 112 cm.

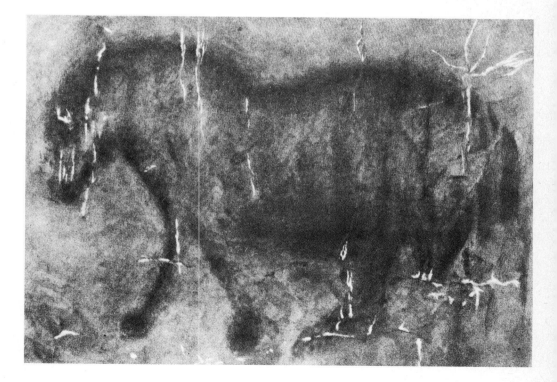

Europe, where miniature art is of paramount importance, where
the human figure is often represented and treated naturalistically
and where much of the decorative design is schematic. It is not,
in fact, the Mediterranean art province that differs from the
Franco-Cantabrian but the Franco-Cantabrian that is different
from the basic forms of Palaeolithic art found in central Europe,
the Mediterranean and western Europe at a date before the
Solutrean. The episode of naturalistic animal art that occurs in
Franco-Cantabria had its genesis before the Magdalenian but its
development, the apex of its achievement and its demise coincide
with this culture, as does its distribution.

To discuss the derivation of the Mediterranean art province
begs the question of the origin of all Palaeolithic art. Although it
appears as an Upper Palaeolithic phenomenon it seems probable
that sculpture and two-dimensional drawing developed before
this period. The earliest dated Upper Palaeolithic art objects
come from the Aurignacian levels of the Vogelherd cave in
Wurttemberg, with a probable age of more than thirty thousand
years. They are highly accomplished three-dimensional carvings
of mammoth, horse, cervid, lion and bear and neither they, nor
the other near-contemporary pieces from central or western
Europe look in any way elementary. In central Europe
schematic design appears as early as naturalistic representations
and the only observation one may make is that animals appear as
amulets before they are depicted in two dimensions on cave
walls. A bone, perhaps engraved by man, was found at Peche de

139 Statuette of a horse,
carved in mammoth ivory,
from the Aurignacian
levels of the Vogelherd
cave, Wurttemberg.
4.8 cm. in length

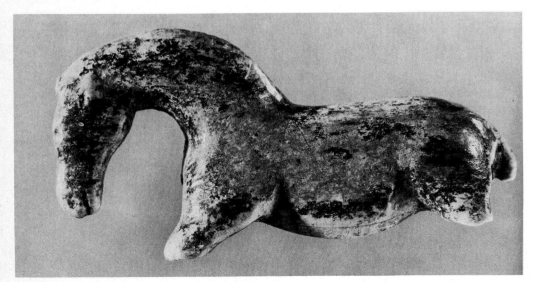

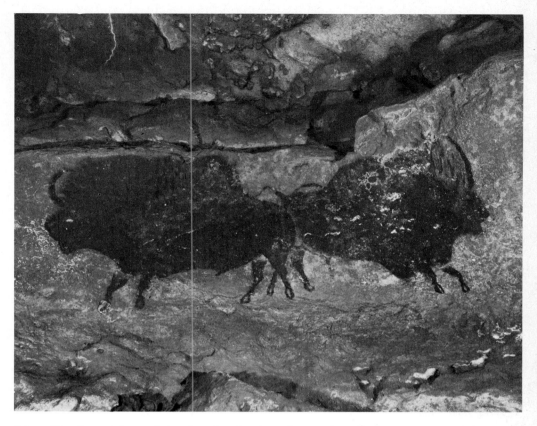

l'Aze (Dordogne) in an Acheulean level, where it was deposited more than two hundred and fifty thousand years ago and the quantities of ochre found in Mousterian habitation sites and burials are suggestive. Ochre may have been used only for tanning, or have been scattered on a burial to simulate blood, but one cannot reject the possibility that Mousterian people used it, as did their successors, for painting. Presumably, before the Upper Palaeolithic, sculpture and engraving were more often done on perishable substances such as wood, than on bone and stone. One has to postulate a similar gap in the record when looking at paintings or engravings in caves. To create a drawing on the wall it is necessary not only to know the subject well, but to know how to draw it. A drawing of a bison, for example, is not a recollection of the animal but a carefully practised re-creation in another dimension. No hunter, however carefully he had hunted his quarry, could draw it without learning this discipline also and the uniformity of style in cave paintings and engravings shows that this discipline was very well learnt. Whether exterior

140 Two bison, back to back, painted in the 'nave' at Lascaux, Dordogne. Note how the regression of limbs and figures is achieved by light coloured areas. Total length 240 cm.

rock-shelter walls, or flat patches of sand were used to learn and practise on, we do not know, but the few paintings that remain in caves testify to a great quantity lost outside. For this and other reasons, such as the apparently infrequent visits made to difficult caves and the erratic chances of preservation, one can assume that what is left of Palaeolithic wall art is only a fraction of the original total. That any stylistic pattern can be detected in what remains is remarkable.

The evidence of style in Palaeolithic art produces surprising results. For example, a chronological is always more apparent than a regional style. One might have expected that over a large geographical area, with a low density of population, local variations would repeatedly spring up, but this almost never happens. The reason for such uniformity must be social. In caves we are looking at sites that were frequented, rather than inhabited, but the homogeneity of the art suggests that social groups were large-scale and widespread and that contact between people in different regions was frequent. Tribal, or smaller, groups must have been flexible and people, either individually or in family units, must have travelled considerable distances. Uniformity is one remarkable aspect of Palaeolithic art; its duration is another. Again, a social explanation must be found for this, here a social sanction of some strength, for nothing of less importance than a religion would be likely to have been respected and practised for so long. Other factors must have contributed to this phenomenon, however: one can assume from the continuity of the art that during this time there were no great social upheavals, such as conquests or invasions, but that life was maintained in a state of relative equilibrium. From the beginning of the Upper Palaeolithic until the end of the Glacial period there is no evidence for major social change and, apparently, no necessity for such. This is in contrast to the post-Palaeolithic where habitat, subsistence and art all alter, not, one can suppose, due simply to climatic change, for this must have occurred repeatedly before, but triggered perhaps by an expansion in population, such as we know to have occurred in the late Magdalenian.

There is no sharp break in the industrial tradition between the late Palaeolithic and the post-Palaeolithic and in some cases the same locations were inhabited; the river bank at Mas d'Azil, for example, has a continuous sequence, but many groups went to the sea shores in search of food. Big game hunting appears to have declined and middens of shells were left by gatherers on the

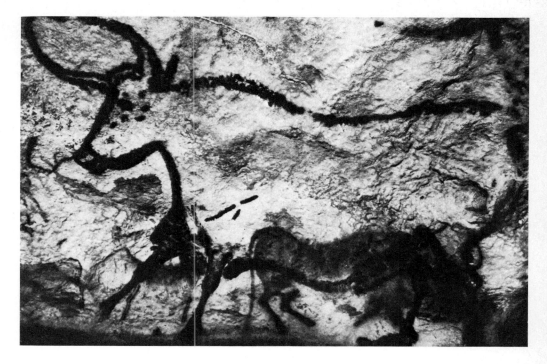

strands. Naturalistic art declined under these conditions and caves received no further decoration; two separate traditions survived however, an extremely schematic one represented by the painted pebbles of Mas d'Azil and a more naturalistic one exemplified by Levantine art. The narrative scenes and the number of human beings shown in the East Spanish shelters have no precedents in Franco-Cantabrian art but their forerunners may be found in the Mediterranean province, while the use of colour wash to fill an outline figure is a technique apparently derived from Magdalenian painting. Eastern Spain is exceptionally dry and the fact that painting is preserved here in daylit shelters is probably due to these unusual climatic conditions. It is possible that Azilian and other hunters and gatherers elsewhere decorated the walls of whatever habitation they used, though we have no record of this. So far as we know, naturalistic mural art in the classic area of Franco-Cantabria disappeared when predominantly microlithic industries replaced the Magdalenian.

In summary, all that we know of Palaeolithic art is its uniformity, its duration, its location and its content; its content being a very restricted inventory of animals, accompanied by groups of schematic signs. The animal species are more

141 Huge bull in black outline, superimposed on a smaller red cow, Lascaux, Dordogne. The bull measures approx. 400 cm.

130

instructive as negative than as positive indicators, since they are neither, by comparison with food debris, the animals principally eaten, nor an accurate record of climatic variation. It is obvious that in a period when an animal is absent from the environmental record, it will not be drawn, but it is also often not drawn when it did exist, and birds, fish and small mammals are always under-represented. Whether there is any significant relationship between animals and signs is an unsolved question, as is the relationship of one species to another. Leroi-Gourhan suggests that bison and horse are in opposition, one representing the female principle and the other the male and each having its attendant complement of other animals and signs, but statistical analysis (Parkington 1969) suggests that the behaviour pattern of the horse in mural art is similar to that of the bison, and not in opposition to it. Looking at the cave walls does little to help solve this question for the strongest impression one receives is that each painting exists for itself, at least within the confines of a panel.

Trying to deduce the meaning of Palaeolithic art is fairly unrewarding. Ethnographic parallels, although they have been much used, are generally misleading, for Palaeolithic art has no real counterpart in any present-day primitive community. Sympathetic magic, restitutive magic, shamanism, house decoration, 'Art for Art's sake', totemism and the duality of male and female have all been proposed as explanations and all are in some way inadequate, usually because each takes account of only some aspects of the whole. For example, sympathetic and restitutive magic (restitutive magic being the replacement, by its image, of an animal killed) both depend upon the species shown being those that the hunters wished to kill and eat, and this is not the case in Palaeolithic art. House decoration and 'Art for Art's sake' are both too trivial an explanation, in addition to being inapplicable to deep caves, while totemism and the proposed opposition of male and female are of the right calibre but are not susceptible of proof. Among contemporary primitive people the totemic symbols of one tribe, whether animal, plant or other object, are usually not adopted by other tribes, but such exclusivity is not found in Palaeolithic art. Particular animals or signs are not, with very rare exceptions, found confined to certain caves or to a circumscribed region, so that it is not possible to regard bison or tectiforms, for example, as indicating the identity of a particular group. At present none of the explanations put forward seems altogether convincing and

perhaps one should consider the possibility of many meanings. For Palaeolithic art in general this is acceptable; obviously the Venuses are a distinct cult and perhaps the signs and symbols in caves have a quite different meaning from the animal art, but one can only accept a variety of meanings with the proviso that the mural art of large animal friezes must have had a consistent meaning throughout its history. There is not enough change in the content, style or layout of sanctuaries to allow any but minor changes in meaning from period to period; in fact the evidence we have is entirely contrary to such a proposition. It is improbable that any part of the decoration of caves is accidental, whether it is an unfinished animal, a tangle of lines, or a row of dots. As a result of Leroi-Gourhan's work we have advanced in our comprehension of Palaeolithic art to a point where we see it as an ordered complex, falling into recognizable patterns, rather than as a random and meaningless scatter of paintings and engravings in a cave. Leroi-Gourhan has described the decoration of caves as a 'mythogram', the animals and signs existing only as a vehicle for other concepts, and Breuil described Palaeolithic art as an 'orthodoxy', producing a uniformity of expression. Both might well have used the term religion, which is what the context of the art suggests, but to go beyond this point is only to embark on speculation. It is very probable that we shall never know the meaning of Palaeolithic art for, although the naturalistic element is potentially comprehensible, the idiomatic and schematic are not. They are simply a language for which we have no vocabulary.

Acknowledgments

I would like to thank many people who enabled me to visit caves either in their possession or their care: Dr Jesus Altuna, M. Louis and M. Robert Bégouën, M. Jean Clottes, Dr J. G. Echegaray, Sr Fernandez Garcia, Dr Jean Gaussen, M. Yves Martin, Professor Manuel Morales, M. Max Sarradet and M. Jean Vezian.

I am also grateful to many of the same and further people who gave me photographs and diagrams or drawings: Professor Martin Almagro Basch, Dr Altuna, M. Robert Bégouën, Professor Magin Berenguer, M. Clottes, Mme L. R. Dams, Dr Henri Delporte, Dr Echegaray, Dr Gaussen, Professor Paolo Graziosi, Professor André Leroi-Gourhan, M. Martin, Mr Douglas Mazonowicz, Dr Léon Pales, M. Alain Roussot, Mlle Suzanne de Saint-Mathurin, M. M.-R. Séronie-Vivien, M. Robert Simonnet, and M. Jean Vertut.

I am indebted to Mr Richard Burleigh of the British Museum for information about Carbon 14, to Mlle de Saint-Mathurin, Dr Mark Newcomer, Mr K. E. Wilson and my husband for reading, correcting, and criticizing my manuscript, to Mrs Catherine Martin for typing it and to Mr Wilson for preparing the index. Lastly I owe a very long-standing debt to the late Miles Burkitt, who was my tutor at Cambridge and who introduced me to Palaeolithic art, not only by way of books but by sending and taking me to the caves in France and Spain when I was an undergraduate.

Select Bibliography

Abbreviations

AIPH	Archives de l'Institut de Paléontologie humaine
BSPA	Bulletin de la Société Préhistorique de l'Ariège
BSPF	Bulletin de la Société Préhistorique Française
CNRS	Centre Nationale de Recherche Scientifique
CIAAP	Congrès International d'anthropologie et d'archéologie prehistorique
CPF	Congrès de la Société Préhistorique Française
UISPP	Union Internationale des Sciences Préhistoriques et Protohistoriques

Cave Art Bibliographies

Fuller bibliographies of the older literature on Palaeolithic Art are available in Graziosi 1960, Laming-Emperaire 1962 and (to 1968) in Schmider (n.d.). Leroi-Gourhan 1968 provides a critical bibliography (to 1964) of individual Cave Art sites, and Naber *et al* 1976 provide a comprehensive bibliography of Parietal Art up to 1974.

Upper Palaeolithic Archaeology and Comparative Studies

Bordes, F. 1968. *The Old Stone Age.* London.

Clottes, J. 1969. 'Le Lot Préhistorique'. *Bulletin de la société des études Littéraires, Scientifiques et Artistiques du Lot*, Vol. XC, pp. 85–105.

Lorblanchet, M. 1969. 'Aperçu sur le Magdalenien moyen et supérieur du Haut Quercy'. *CPF*, XIXième session. Auvergne, pp. 256–83.

Lumley, H. de (Ed.) 1976. *La Préhistoire Française*, Vols I (I) & I (II). *UISPP*. Editions *CNRS*, Paris. An up to date statement of Palaeolithic and Mesolithic Studies in France prepared for the 1976 International Congress. Contains general articles on Upper Palaeolithic society, and detailed regional studies.

Minvielle, P. 1970. *Guide de la France souterraine.* Les Guides Noirs No. 11, Paris.

Pales, L. 1976. 'Les empreintes de pieds humains dans les cavernes'. *AIPH*, Mémoire 36. Paris.

Sackett, J. R. 1968. 'Method and Theory of Palaeolithic Archaeology of South Western France'. In *New Perspectives in Archaeology* S. R. and L. R. Binford (Eds). Chicago.

Sahlins, M. 1968. 'Notes on the original affluent society'. In *Man the Hunter*, R. B. Lee and I. de-Vore (Eds). Chicago.

—1974. *Stone Age Economics.* London.

Schmider, B. (n.d.) *Bibliographie Analytique de Préhistoire pour le Paléolithique Supérieur Européen.* Vols. 1–2 *CNRS*. Paris.

Sonneville-Bordes, D. de 1960. *Le Paléolithique supérieur en Périgord.* Bordeaux. 2 vols.

—1963a. Upper Palaeolithic Cultures in Western Europe. *Science*, Vol. 142, pp. 347–55.

—1963b. Le Paléolithique Supérieur en Suisse. *L'Anthropologie*, Vol. 67, pp. 205–68.

—1966. L'évolution du Paléolithique supérieur dans L'Europe occidentale et sa signification. *BSPF*, Vol. 63, pp. 3–34.

Wendt, W. E. 1976. 'Art Mobilier from the Apollo II Cave, S.W. Africa'. *South African Archaeological Bulletin* 31, pp. 5–11.

Woodburn, J. 1968. 'An introduction to Hadza ecology'. In *Man the Hunter*, R. B. Lee and I. de-Vore (Eds). Chicago. pp. 49–55.

General Surveys of Palaeolithic Art

Breuil, H. 1952. *Four hundred centuries of Cave Art.* (English Edition). Montignac.

Breuil, H. and Saint-Perier, René de 1927. 'Les poissons, les batraciens et les reptiles dans l'art quaternaire'. *AIPH*, Mémoire 2.

Giedion, S. 1962. *The Eternal Present. The Beginning of Art.* New York and London. Contains some of the finest photographs ever taken of Palaeolithic Art.

Graziosi, P. 1960. *Palaeolithic Art.* (English Edition) London. The Italian original *L'Arte dell'antica eta della pietra*, Florence, dates from 1956.

Leroi-Gourhan, A. 1968. *The Art of Prehistoric Man in Western Europe*. (English Edition) London. The French Edition *Préhistoire de l'art occidentale* from which this translation was prepared dates from 1965. (A revised edition was published in France in 1971 and a third edition in 1973.) An up-to-date and comprehensive study of the decorated caves and shelters, it also includes a detailed discussion of the author's theories on the organization of Cave Art.

—1976. L'art paléolithique en France. In *La Préhistoire Française*, Vol. I H. de Lumley (Ed.). *UISPP*. Editions *CNRS*, pp. 741–8.

Naber, F., Bérenger, D. J. and Zalles-Flossbach, C. 1976. *L'Art Pariétal Paléolithique en Europe Romane*, pts 1 & 2 (3 vols). Bonner Hefte zur Vorgeschichte Nos 14–16. Bonn.

Pericot, L., Lommel, A., and Galloway, J. 1969. *Prehistoric and Primitive Art*. London.

Piette, E. 1907. *L'Art pendant l'âge du Renne*. Paris.

Zervos, C. 1959. *L'Art de l'époque du Renne en France*. Paris.

Critical Studies of Mural Art

Bandi, H. G. 1972. 'Quelques reflexions sur la nouvelle hypothèse de A. Leroi-Gourhan concernant la signification de l'art quaternaire'. In *Santander Symposium*, M. Almagro Basch and M. A. Garcia Guinea. (Eds). *UISPP*, pp. 309–19.

Laming-Emperaire, A. 1962. *La Signification de l'art rupestre paléolithique*. Paris.

Leroi-Gourhan, A. 1966. 'Les signes pariétaux du paléolithique supérieur franco-cantabrique'. *Simposio de arte rupestre*. E. Ripoll Perelló (Ed.) Barcelona, pp. 67–77.

—1972. 'Considérations sur l'organization spatiale des figures animales dans l'art pariétale paléolithique'. *Santander Symposium* M. Almagro Basch and M. A. Garcia Guinea (Eds), pp. 281–300.

—1976. 'Les religions de la préhistoire'. In *La Préhistoire Française*, Vol. I (1) H. de Lumley (Ed). *UISPP*. Editions *CNRS*. Paris, pp. 755–9.

Levine, M. H. 1957. Review of 'Lascaux, or the Birth of Art' by Georges Bataille, in *American Anthropologist*, Vol. 59, pp. 949–64.

Parkington, J. 1969. 'Symbolism in Palaeolithic Cave Art'. *South African Archaeological Bulletin*, Vol. XXIV. Part I, pp. 3–13.

Ricol, D. 1973. 'Les animaux en position anormale dans l'art pariétal paléolithique'. *Cahiers du Centre de Recherches Préhistoriques* I. Paris, pp. 29–35.

Sauvet, G. and Włodarczyk, A. 1977. Essai de Sémiologie préhistorique. *BSPF*, 74 *Études et Travaux* Fasc. 2. 545–58.

Ucko, P. and Rosenfeld, A. 1967. *Palaeolithic Cave Art*. London.

Regional Bibliographies

(including studies of individual sites and regional surveys)

Western France

Betirac, B. 1954. 'Les Vénus de la Magdelaine'. *BSPF*, Vol. 51, pp. 125–6.

Capitan, L., Breuil, H., and Peyrony, D. 1903. 'Les figures gravées a l'époque paléolithique sur les parois de la grotte de Bernifal (Dordogne)'. *Revue de L'Ecole d'Anthropologie* XIII, pp. 202–9.

—1910. *La caverne de Font-de-Gaume aux Eyzies (Dordogne)*. Monaco.

—1912. 'Les gravures sur cascade stalagmitique de la grotte de la Mairie à Teyjat (Dordogne)'. *CIAAP*, 16ième session. Geneva, pp. 498–514.

—1924. *Les Combarelles aux Eyzies (Dordogne)*. Paris.

Cheynier, A. 1963. *La Caverne de Pair-non-Pair*. Bordeaux.

Daleau, F. 1896. 'Les gravures sur roche de la caverne de Pair-non-Pair'. *Actes de la Société Archéologique de Bordeaux*, Vol. 21, p. 235.

Dams, M. & L. and Bouillon, R. 1974. 'Les figurations rupestres paléolithiques de la grotte Mayenne-Sciences à Saulges (Mayenne)'. *BSPA*, XXIX, pp. 65–87.

Delage, F. 1935. 'Les roches de Sergéac'. *L'Anthropologie*, Vol. XLV, pp. 281–317.

Gaussen, J. 1964. *La grotte ornée de Gabillou (près Mussidan, Dordogne)*. Publications de l'Institut de Préhistoire de l'Université de Bordeaux, Mémoire No. 3. Bordeaux.

Lalanne, J. G. and Bouyssonie, J. 1941/46. 'Le gisement paléolithique de Laussel'. *L'Anthropologie*, Vol. 50, pp. 1–65 and 117–63.

Laming, A. 1959. *Lascaux, paintings and engravings*. Harmondsworth.

Lemozi, A. 1929. *La grotte temple de Pech-Merle. Un nouveau sanctuaire paléolithique*. Paris.

Lemozi, A., Renault, P. H., and David, A. 1969. *Die Europäischen Felsbilder. Pech-Merle, Le Combel, Marcenac*. Graz.

Lorblanchet, M. 1974. *L'Art préhistorique en Quercy. La grotte des Escabasses (Themines, Lot)*. Saragossa.

Lorblanchet, M. *et al*. 1973. 'La grotte de Sainte-Eulalie à Espagnac (Lot)'. *Gallia Préhistoire*, Vol. 16. 1, pp. 3–62; 2, pp. 233–325.

Martin, H. 1928. *La frise sculptée et l'atelier Solutréan du Roc (Charente). AIPH*, Mémoire 5.

Martin, Y. 1973. *L'Art Paléolithique de Gouy*. St Etienne du Rouvray.

Meroc, L. and Mazet, J. 1953. 'Les peintures de la grotte de Cougnac (Lot)'. *L'Anthropologie*, Vol. 57, pp. 490–4.

—1956. *Cougnac Grotte Peinte*. Stuttgart.

Nougier, L. R. and Robert R. 1959. *Rouffignac. I. Galerie Henri Breuil et grand plafond*. Florence.

Pales, L. and Tassin de saint Péreuse, M. 1969. *Les gravures de la Marche. I Félins et Ours*. L'Institut de Préhistoire de Bordeaux, Mémoire 7. Bordeaux.

—1976. *Les gravures de la Marche. II Les Humains*. Paris.

Roussot, A. 1964. 'Les découvertes d'art pariétal en Périgord'. In *Centenaire de la préhistoire en Périgord*

1864–1964 Bulletin de la Société historique et archéologique du Périgord, XCI, special number, pp. 99–125.

—1972a. 'La découverte des gravures de Pair-non-Pair d'après les notes de François Daleau'. Extrait des *Cahiers du Vitrézais* juillet 1972, pp. 5–7; octobre 1972, pp. 15–17; avril 1973, pp. 22–4.

—1972b. 'Contribution a l'étude de la frise pariétale du Cap Blanc'. *Santander Symposium*, M. Almagro Basch & M. A. Garcia Guinea (Eds), pp. 87–113.

Saint-Mathurin, S. de and Garrod, D. A. E. 1951. 'La frise sculptée de l'abri du Roc aux Sorciers à Angles-sur-l'Anglin (Vienne)'. *L'Anthropologie*. Vol. 55, pp. 413–24.

Sarradet, M. 1969. *Font-de-Gaume en Périgord*. Périgueux.

—1975. *L'Art préhistorique en Périgord*. Studi Camuni, No. 6. Capo di ponte.

Sonneville-Bordes, D. de 1973. 'Étude de la frise sculptée de la Chaire à Calvin (Charente)'. *Annales de Paléontologie*, Vol. 49, pp. 181–93.

—1964. 'Les Industries des Abris et Grottes Ornées du Périgord'. In *Centenaire de la préhistoire en Périgord*. (Bulletin de la Société Historique et Archéologique du Périgord, XCI special number), pp. 167–80.

Windels, F. 1949. *The Lascaux Cave Paintings*. (English edition). London.

Pyrenees

Barrière, C. 1976. *Palaeolithic art in the grotte de Gargas*. Parts I and II. British Archaeological Reports (BAR) Supplementary series 14 (I). Oxford.

Bégouën, H. and Bégouën, L. 1928. 'Découvertes nouvelles dans la caverne des Trois Frères'. *Revue Anthropologique* XXXVIII, pp. 358–64.

Bégouën, H. and Breuil, H. 1958. *Les cavernes du Volp. Trois Frères. Tuc d'Audoubert*. Paris.

Beltran, A., Robert, R., and Gailli, R. 1967. *La cueva de Bédeilhac*. Monografias Archeológicas II. Saragossa.

—1973. *La cueva de Niaux*. Monografias Archeológicas XVI. Saragossa.

Breuil, H. and Jeannel, R. 1955. 'La grotte ornée du Portel à Loubens (Ariège)'. *L'Anthropologie*, Vol. 59, pp. 184–204.

Cartailhac, E. and Breuil, H. 1908. 'Les peintures et gravures murales des cavernes Pyrénéennes III Niaux (Ariège)'. *L'Anthropologie*, Vol. XIX, pp. 15–46.

—1910. 'Les peintures et gravures murales des cavernes Pyrénéennes, IV Gargas V Bédeilhac'. *L'Anthropologie*, Vol. XXI, pp. 129–50.

Clot, A. 1973. *L'Art graphique Préhistorique des Hautes-Pyrénées*. Saragossa.

Clottes, J. 1974. 'Le paléolithique supérieur dans les Pyrénées françaises'. *Cahiers d'anthropologie et d'écologie humaine* II, pp. 69–88.

Clottes, J., and Simonnet, R. 1972. 'Le reseau René Clastres de la caverne de Niaux (Ariège)'. *BSPF*, Vol. 69, pp. 293–323.

—1974. 'Une datation radiocarbone dans la grotte ornée de Fontanet (Ornolac-Ussat-les-Bains Ariège)'. *BSPF*, Vol. 71, pp. 106–7.

Delteil, J., Durbas, P., and Wahl, L. 1972. 'Presentation de la galerie ornée de Fontanet (Ornolac-Ussat-les-Bains Ariège)'. *BSPA*, Vol. XXVII, pp. 1–10.

MacCurdy, G. G. 1915. 'The cavern of the three brothers'. *Science*, Vol. XLI (NS), 782–3.

Plenier, A. 1971. *L'Art de la grotte de Marsoulas*. Publications de l'Institut d'art Préhistorique de Toulouse, Mémoire I. Toulouse.

Sieveking, A. 1976. Settlement Patterns of the later Magdalenian in the central Pyrenees. In *Problems in Economic and Social Archaeology*, Sieveking, G. de G., Longworth, I. H. and Wilson, K. E. (Eds). London, pp. 583–603.

Trombe, F., and Dubuc, G. 1947. '*Le Centre préhistorique de Ganties-Montespan (Haute-Garonne)*'. *AIPH*, Mémoire 22. Paris.

The Basque Provinces and Cantabrian Spain

Alcalde del Rio, H., Breuil, H., and Sierra, L. 1911. *Les cavernes de la région Cantabrique (Espagne)*, Monaco.

Almagro Basch, M. 1973. 'Las pinturas y grabados de la cueva de Chufin'. Riclones (Santander). *Trabajos de Prehistoria*, Vol. 30 (n.s.) pp. 9–68.

—1976. *Los omoplatos decorados de la Cueva del Castillo. Puente Viesgo (Santander)*. Museo Arqueológico Nacional. Monografias Arqueológicas, No. 2. Madrid.

Altuna, J. and Apellaniz, J. M. 1976. 'Las figuras rupestres paleolíticas de la Cueva de Altxerri (Guipuzcoa)'. *Munibe* año XXVIII, Fasc. 1–3.

—1978. 'Las figuras rupestres paleolíticas de la Cueva de Ekain (Deva, Guipuzcoa). *Munibe* año 30 Fasc. 1–3.

Barandiaran, I. 1966. 'L'Art rupestre palaéolithique des provinces Basques'. *BSPA*, Vol. XXI, pp. 48–70.

—1974. 'Arte Paleolítico en Navarra'. *Principe de Viana*, Nos 134–5, pp. 9–47. Pamplona.

Barandiaran, J. M., *et al.* 1964. La cueva de Altxerri y sus figuras rupestres. *Munibe* año XVI 3–4. San Sebastian.

Barandiaran, J. M., and Altuna, J. 1969. La cueva de Ekain y sus figuras rupestres, *Munibe*, año XXI 4. San Sebastian.

Beltran, M. 1971. 'Diffusione dell'arte quaternaria Nella peninsola Iberica'. *Bollettino dell Centro Camuno di studi Preistorica*, Vol. VI, pp. 77–82.

Beltran, A., and Berenguer, M. 1969. 'L'art pariétal de la grotte de Tito Bustillo'. *L'Anthropologie*, Vol. 73, pp. 579–86.

Breuil, H., Obermaier, H., and Alcalde del Rio, H. 1913. *La Pasiega à Puente Viesgo (Santander)*. Monaco.

Breuil, H., and Obermaier, H. 1935. *The cave of*

Altamira at Santillana del Mar, Spain. Madrid.

Casado Lopez, M. P. 1977. *Los Signos en Arte Paleolítico de la Península Ibérica*. Monografias Arqueológicas XX.

Garcia Guinea, M. A. 1969. *Altamira, the beginning of Art*. Madrid.

Gomez Tabanera, J. M. 1975. 'Catalogue des grottes et gisements préhistoriques dans l'est des Asturies'. *BSPA*, Vol. XXX, pp. 29–57.

Gonzalez Echegaray, J. 1953. 'Les oeuvres d'art de la grotte de las Chimeneas'. *BSPA*. Vol. VIII, pp. 75–91.

—1959. 'La cueva de la Cullalvera'. *BSPA*, Vol. XIV, pp. 18–23.

—1960. 'El Magdaleniense III de la Costa Cantábrica'. *Boletín de Seminario de Estudios de Arte y Arqueología (Valladolid)*, Vol. 26: 69–100.

—1971. 'Apreciaciones cuantitativas sobre el Magdaleniense de la Costa Cantábrica'. *Munibe* año 23: 323–7.

—1974. *Pinturas y Grabados de la cueva de las Chimineas (Puente Viesgo, Santander)* Monografias de Arte Rupestre – Arte Paleolítico No. 2. Barcelona.

Jordá Cerdá, F. 1964. 'El arte rupestre paleolítico de la región cantábrica: nueva secuencia cronológico-cultural'. In *Prehistoric art of the Western Mediterranean and the Sahara*, Pericot. L. and Ripoll Perelló. E. (Eds). (Viking publications in Anthropology 39). Chicago, pp. 47–81.

—1972. *Las Pinturas de la cueva de las Herrerias (Llanes–Asturias)*. Salamanca.

Laplace-Jauretche, G. 1952. 'Les grottes ornées des Arbailles'. *Eusko-Jakintsa* (review of Basque Studies), Vol. 6.

Ripoll Perelló, E. 1972. *La cueva de las Monedas en Puente Viesgo (Santander)*. Monografias de arte rupestres. Arte Paleolítico, No. 1. Barcelona.

Rousseau, M. 1973. 'Darwin et les chevaux peints paléolithiques d'Ekain'. *BSPA*, Vol. XXVIII, pp. 49–55.

Séronie-Vivien, M. R. 1974. 'Découverte d'une nouvelle grotte ornée en Pays-Basque: La grotte de Sinhikole-Ko-Karbia (Camou-Cihigue, Pyrénées-At lantiques)'. *BSPF*, Vol. 71, No. 2, pp. 40–4.

Uribarri, J. L. and Liz, C. 1973. 'El arte rupestre de Ojo Guarena, la cueva de Kaite'. *Trabajos de Prehistoria*, Vol. 30, (n.s.), pp. 69–120.

France, Spain and Italy outside the Franco-Cantabrian Region

Breuil, H. 1921. 'Nouvelles cavernes ornées paléolithiques dans la province de Malaga'. *L'Anthropologie*, Vol. 31, pp. 239–53.

Breuil, H., Obermaier, H., and Verner, W. 1915. *La Pileta à Benaojan (Malaga)*. Monaco.

Combier, J., Drouot, E. and Huchard, P. 1958. 'Les grottes Solutréennes à gravures pariétales du canyon inférieur de L'Ardèche'. *Mémoires de la Société préhistorique française*, Vol. 5, pp. 61–117.

Drouot, E. 1953. 'L'Art Paléolithique à la Baume Latrone'. *Cahiers ligures de préhistoire et d'archéologie*, Vol. 2, pp. 11–46.

—1968. 'L'art pariétal paléolithique du Languedoc Méditerranéen'. In *La Préhistoire, Problèmes et Tendances*. Editions *CNRS*, Paris, pp. 145–60.

Giminez Reyna, S. 1965. *The cave of La Pileta*. English version G.W.B. Huntingford. Malaga.

Graziosi, P. 1953. 'Nuovi graffiti parietali della grotta de Levanzo (Egadi)'. *Rivista di Scienze Preistoriche*, Vol. VIII, pp. 123–37.

—1956. 'Qualche osservazione sur graffiti rupestri della grotta dell' Addaura presso Palermo'. *Bullettino di Paletnologia Italiana*. Vol. 65, pp. 285–96.

—1964. 'L'art Paléolithique de la province méditerranéenne'. In *Prehistoric Art of the Western Mediterranean and the Sahara* Pericot, L. and Ripoll Perelló, E. (Eds) (Viking Fund Publications in Anthropology 39), pp. 35–43.

Pericot y Garcia, L. 1942. *La cueva del Parpalló, Gandia*. Madrid.

Ripoll Perelló, E. 1964. 'Para una cronologia relativa del arte Levantino Español'. In *Prehistoric Art of the Western Mediterranean and the Sahara* Pericot, L. and Ripoll Perelló, E. (Eds) (Viking Fund Publications in Anthropology 39), pp. 167–75.

Vicino, G. and Simone, S. 1972. 'Les gravures rupestres paléolithiques des Balzi Rossi (Grimaldi, Ligurie Italienne)', *BSPA*, Vol. XXVII, pp. 30–58.

Central Europe

Absolon, K. 1949. 'The diluvial anthropomorphic statuettes and drawings, especially the so-called Venus statuettes, discovered in Moravia'. *Artibus Asiae*, Vol. XII, pp. 201–20.

Bosinski, G. and Fischer, G. 1974. *Die Menschdarstellungen von Gonnersdorf der Ausgrabung von 1968*. Weisbaden.

Russia

Bader, O. N. 1965. *La caverne Kapovaia*. Academy of Sciences. Moscow.

List of illustrations

Index

Roman numerals refer to the colour plates, those in italic to black and white illustrations; all other reference are to page numbers.